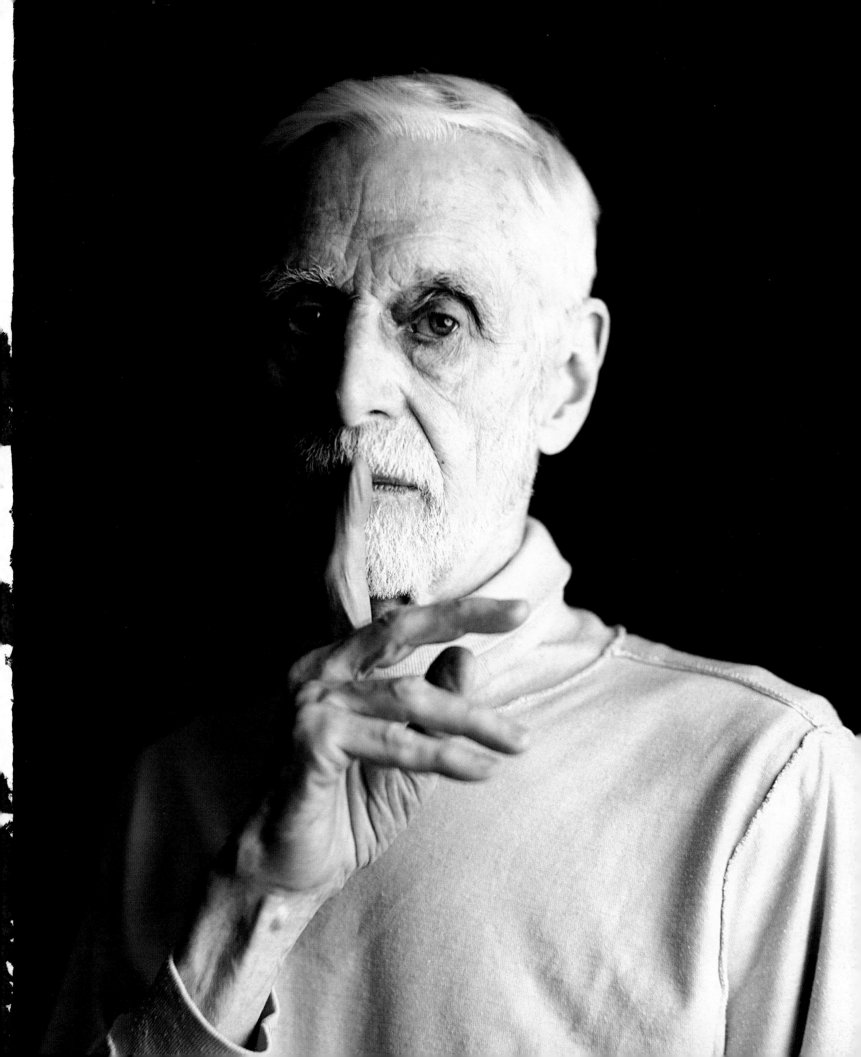

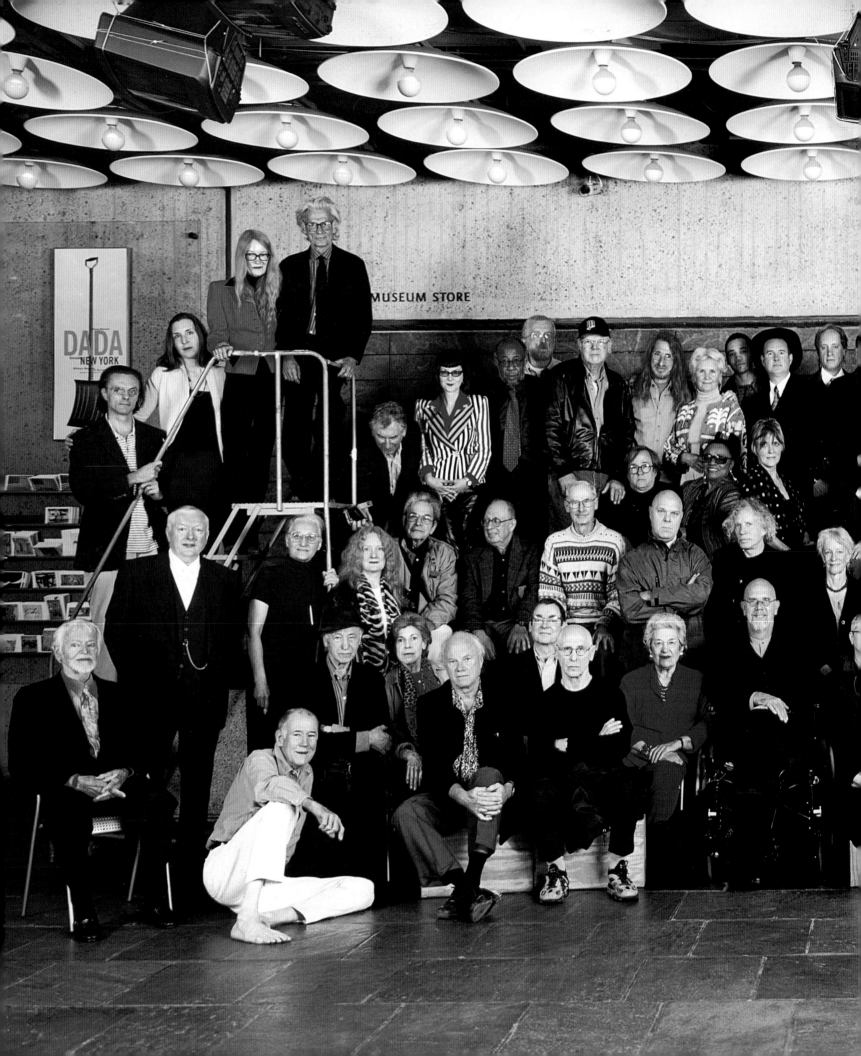

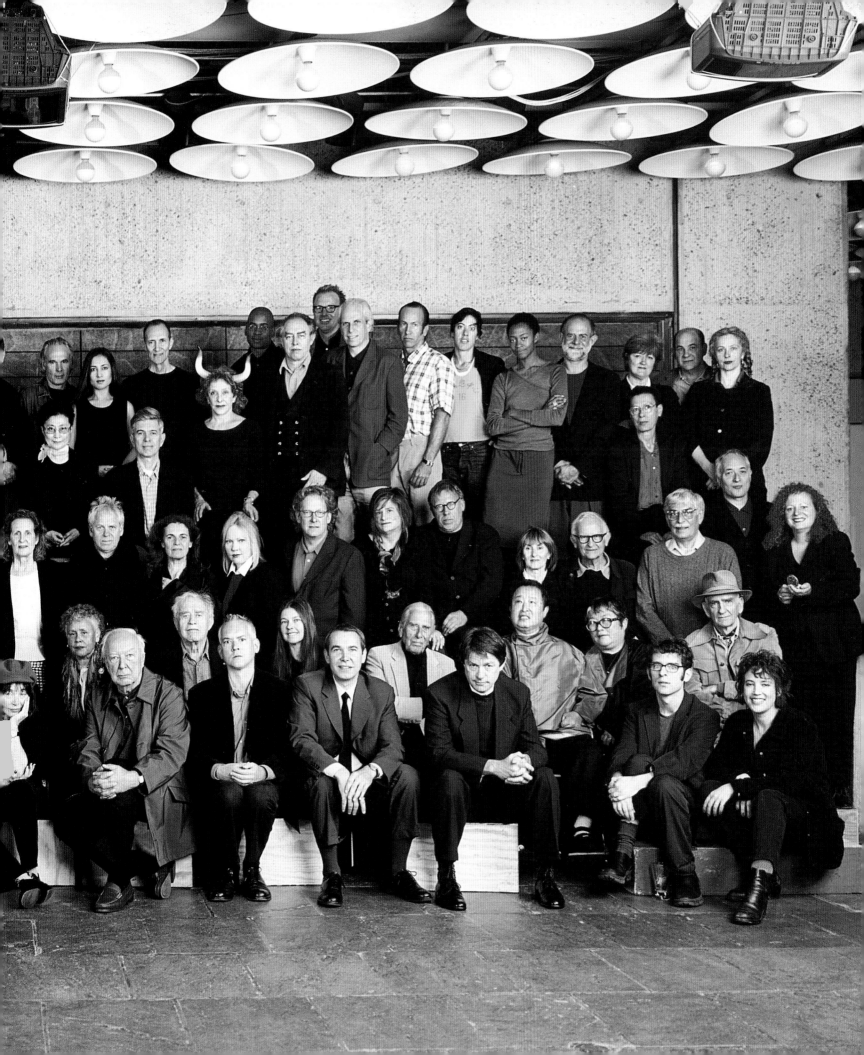

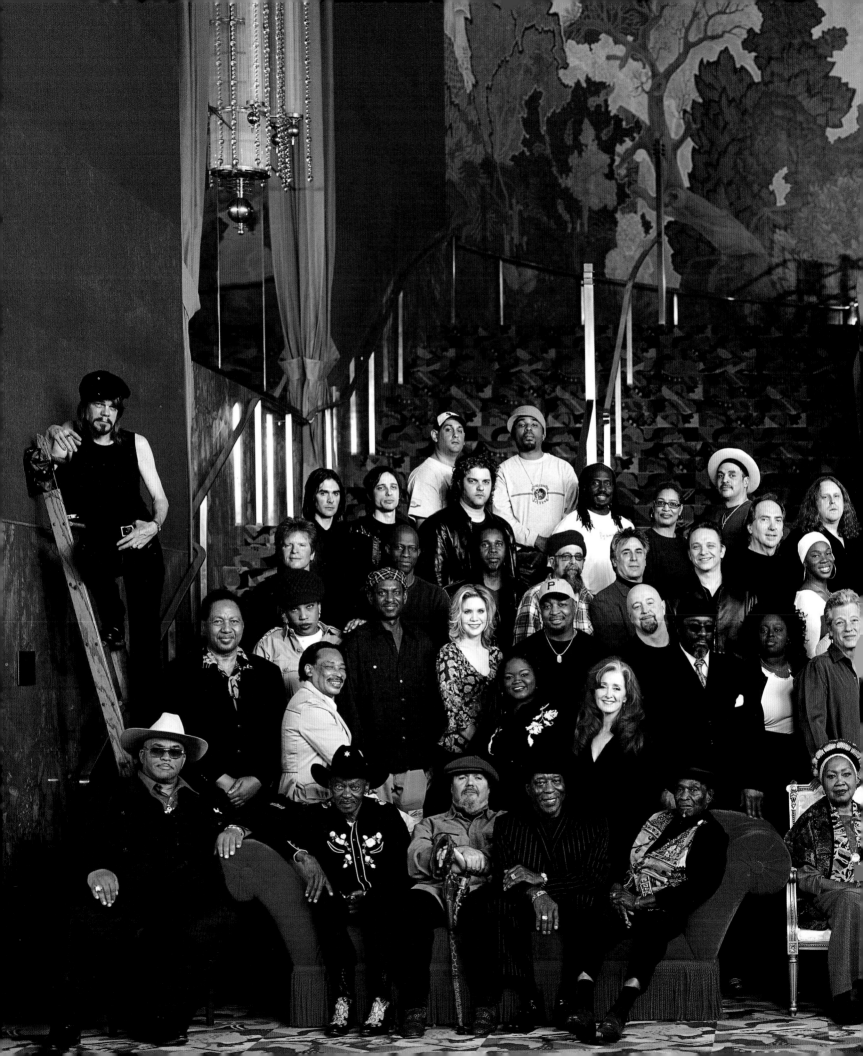

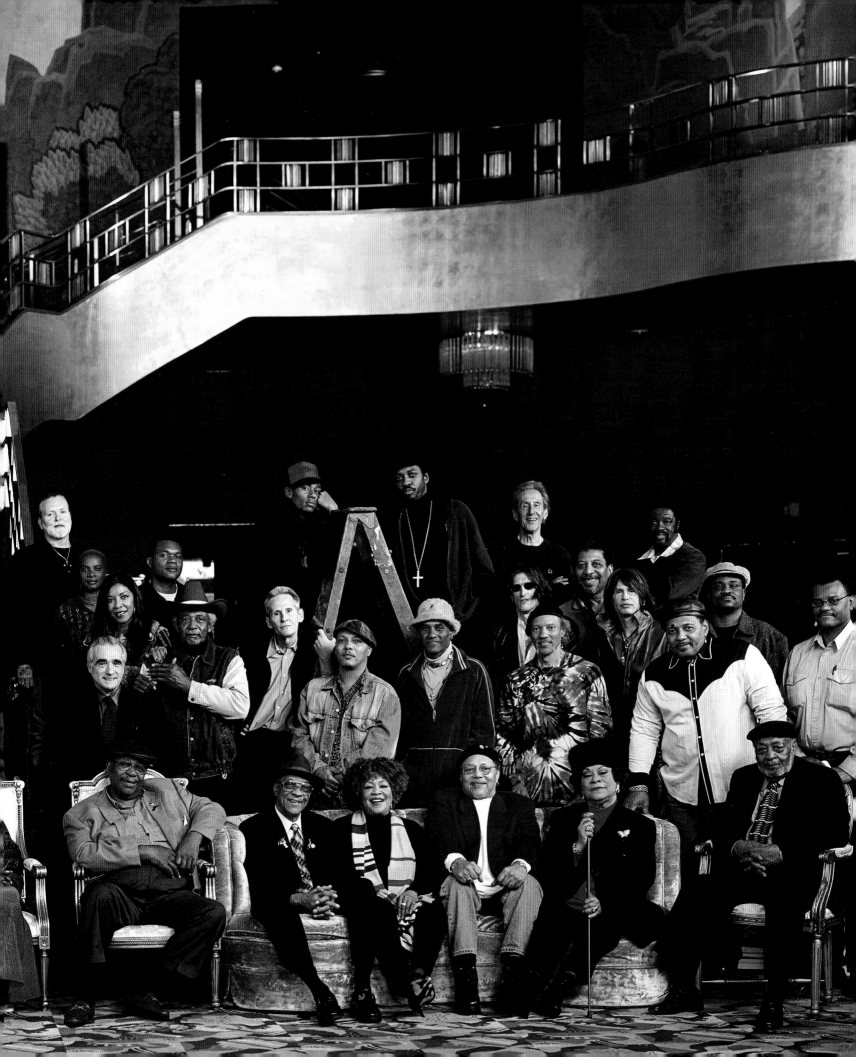

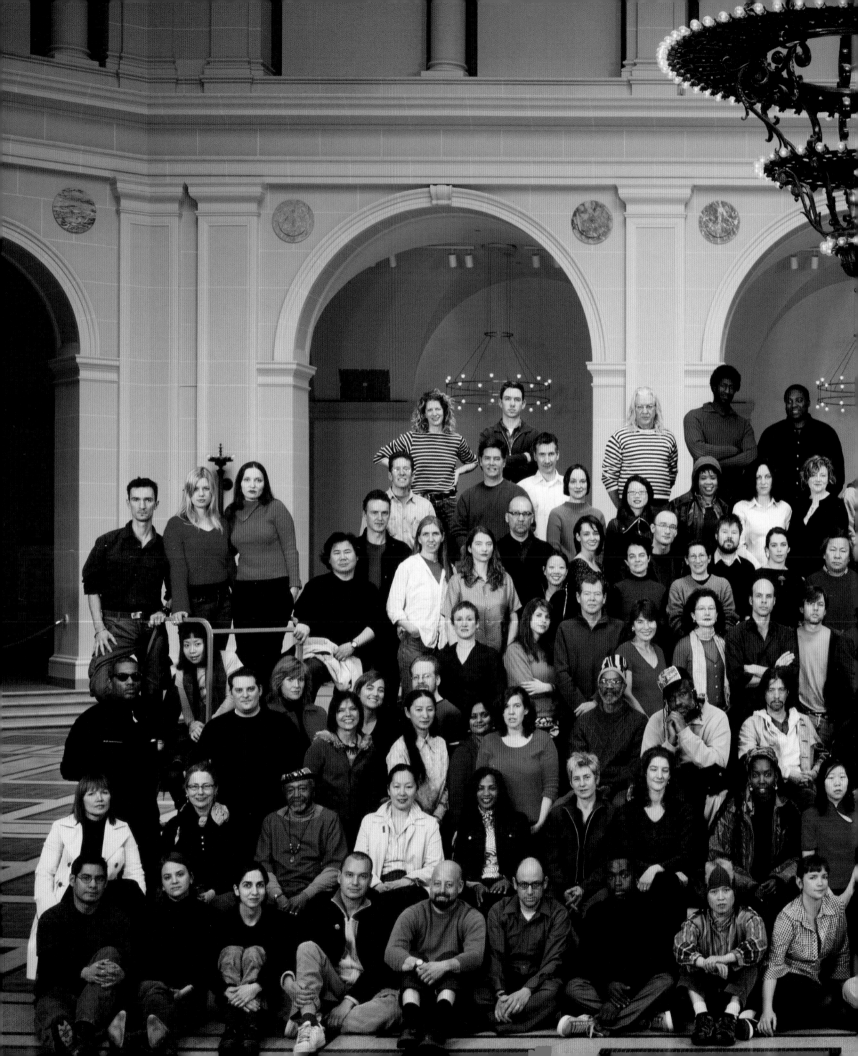

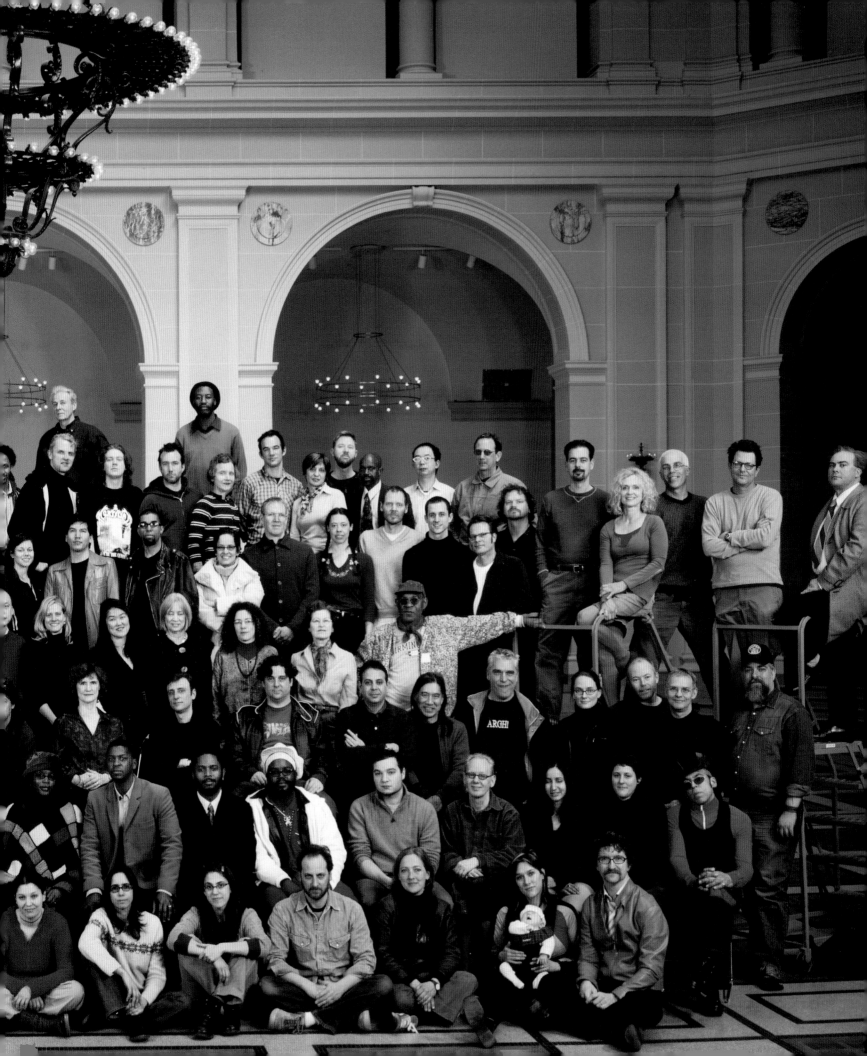

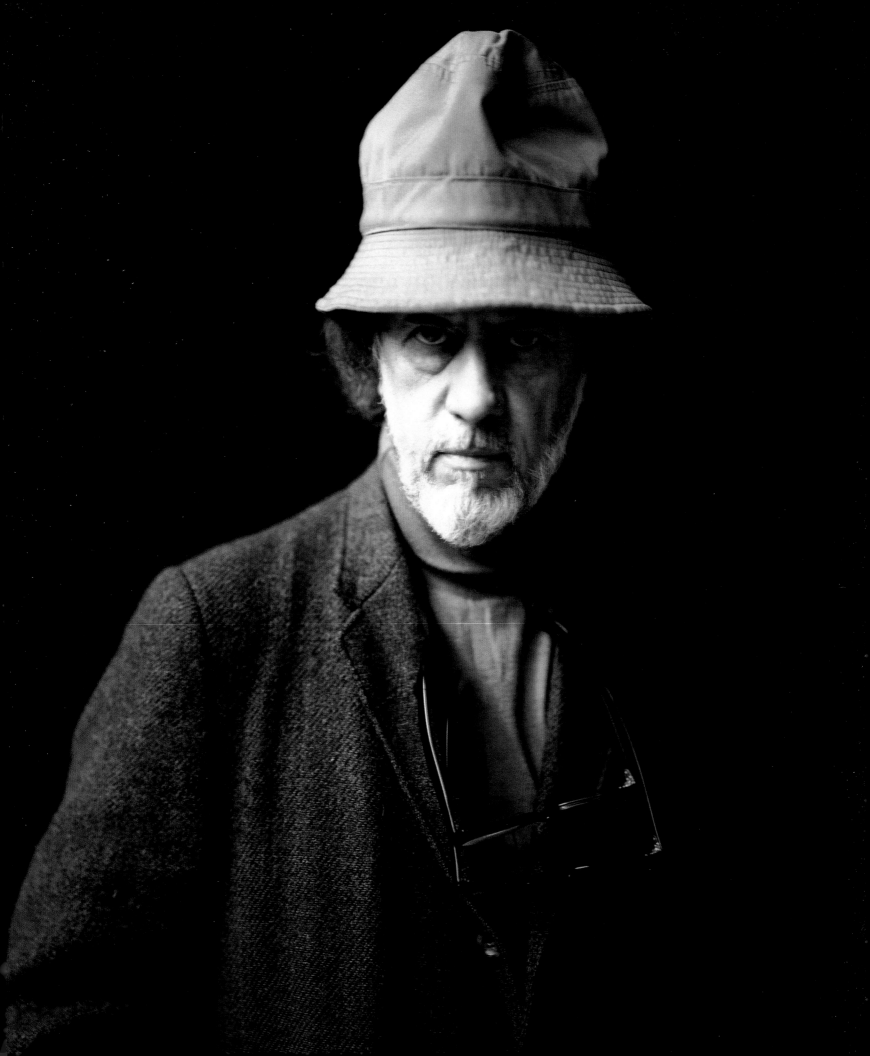

Timothy Greenfield-Sanders
Face to Face

Selected Portraits 1977–2005

Edited by Demetrio Paparoni and Gianni Mercurio

SKIRA

Cover
Self-Portrait, 2002,
black and white contact print, 11 x 14 inches

Page 1
Edwin Denby, poet / critic, 1982,
black and white contact print, 11 x 14 inches

Pages 2-3
Whitney American Century Group, artists,
1999, color transparency, 8 x 10 inches

Pages 4-5
Blues Musicians at Radio City Music Hall,
musicians, 2003, color transparency, 8 x 10 inches

Pages 6-7
Brooklyn Artists in the Brooklyn Museum,
artists, 2004, color transparency, 8 x 10 inches

Pages 8-9
*Agnes Gund with Museum of Modern Art
Artists*, artists, 2002, color print, 11 x 14 inches

Pages 10
Richard Pousette-Dart, artist, 1980,
black and white contact print, 11 x 14 inches

Design
Marcello Francone

Editing
Laura Guidetti

Layout
Luigi Fiore

Translations
Alta L. Price (from Italian into English, texts by
Gianni Mercurio, Mimmo Paladino, Fernanda
Pivano)

First published in Italy in 2005 by
Skira Editore S.p.A.
Palazzo Casati Stampa
via Torino 61
20123 Milano
Italy
www.skira.net

Printed and bound in Italy. First edition
ISBN 88-7624-542-1

Distributed in North America by Rizzoli
International Publications, Inc., 300 Park
Avenue South, New York, NY 10010.
Distributed elsewhere in the world by Thames
and Hudson Ltd., 181a High Holborn, London
WC1V 7QX, United Kingdom.

Contents

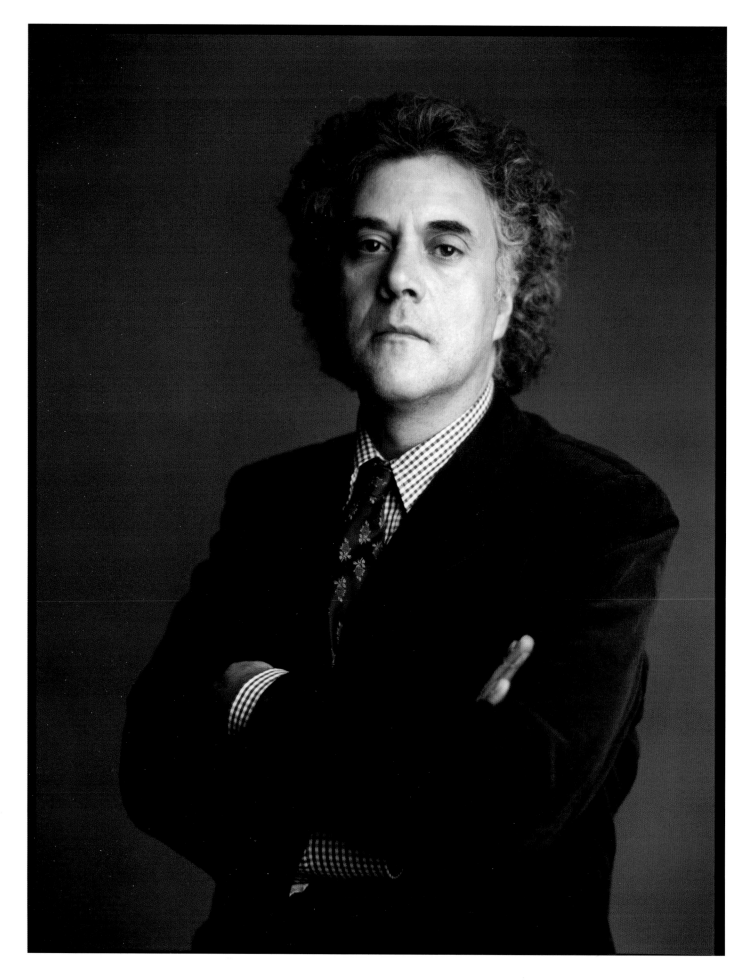

Mimmo Paladino, artist, 1991, black and white contact print, 11 x 14 inches

The Eye and the Chair

Mimmo Paladino

Timothy Greenfield-Sanders works with portraits like an ancient painter. Thanks to his Fulmer & Schwing (1905) and Deardorff (1940) 11 x 14 inch cameras, old wooden boxes that he uses as though he has a palette and paintbrush, he obtains minutely detailed, though not psychological, portraits. In this way he proved that it is possible to portray someone without pathos and still bring out their soul.

Greenfield-Sanders is not interested in the fleeting moment, but rather the limited time of the pose. He asks little of his subjects, allows them to naturally assume a portrait pose, intervenes with a few suggestions, and allows the composition to emerge on its own. To those who pose for him he offers his stool—the same on which everyone sits, and where each leaves a part of himself. In this sense he is not a modern portraitist, like the painter Lucian Freud, who, working on the dramatic aspects of the figure, inserts so much of himself into the work so as to transform it into an abstraction.

Some of Greenfield-Sanders' works could appear hyperrealistic, but he looks much more to the European tradition. His recent use of the diptych also demonstrates this. His attention is turned toward celebrity and popular icons, just as Rembrandt and Velázquez did when portraying the great figures of their own time; perhaps a future turn in his work will be to look to the common, anonymous people, as Caravaggio did.

His interest in popular icons ties Greenfield-Sanders to Warhol, whom he admires, but he does not follow Warholian poetics. The brilliant Warhol used Polaroids, a modern medium without expressive qualities that requires no special knowledge to use; anyone can shoot a Polaroid. Greenfield-Sanders instead uses a sophisticated wooden camera that imparts the quintessential flavor that defines his unmistakable signature.

In black and white portraiture Greenfield-Sanders has a style very close to that found in cinema; a few of the foregrounds recall Fritz Lang. His strength lies in not wanting to invent a photographic form. In color he seeks the incarnate, the strength of tones and contrasts, he seeks the perfection of chromatic quality and surprising juxtapositions—as in the beautiful portrait of Nicole Kidman, where the fabric of her red gown, the unlit red background, and the pink of her face merge, leading only the eyes and hands to emerge.

Undoubtedly one of Greenfield-Sanders' greatest attributes is how he eliminates the distance that separates the portrait from its viewer. This is most uncommon.

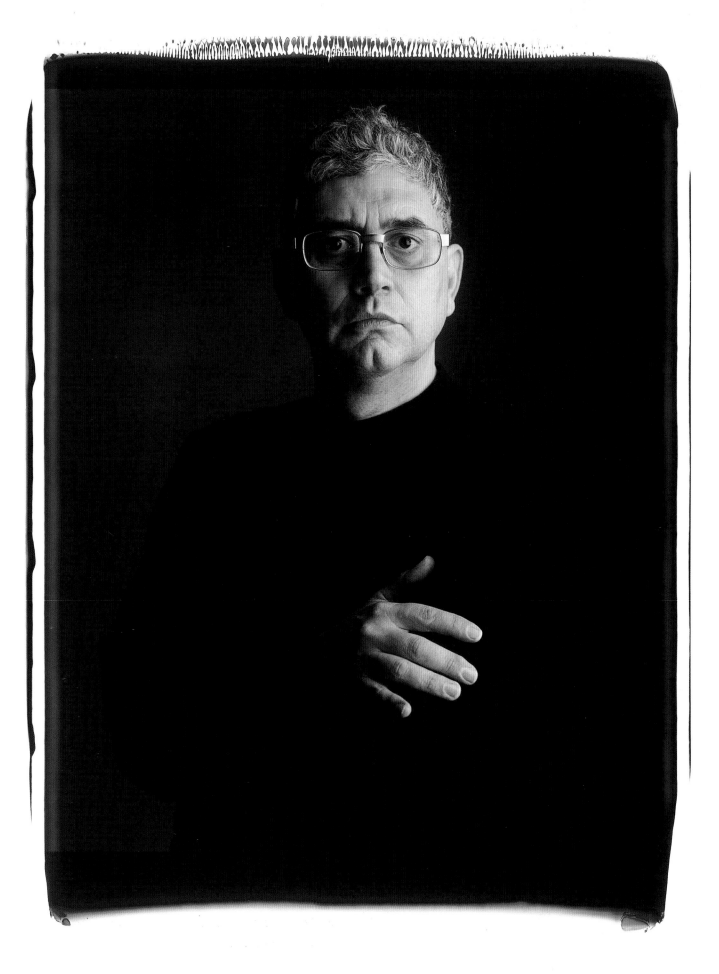

Demetrio Paparoni, art critic, 2001, color Polaroid, 20 x 24 inches

Timothy Greenfield-Sanders. History's Icon

Demetrio Paparoni

Timothy Greenfield-Sanders may have inherited his interest in portraits from his father, a Harvard-educated lawyer. Arnold Merrin Greenfield painted on weekends in the garage and never thought of exhibiting his art publicly, which is surprising given the quality of a self-portrait he painted in 1996, the year of his death, a canvas now hanging in the office of his daughter-in-law Karin. Timothy Greenfield-Sanders himself said to me: "My father mostly painted landscapes and street scenes, but I was more interested in his portraits, often of us children. Strangely enough, he sometimes painted portraits of people he didn't like. I think it was a way of getting them out of his mind."[1]

In Miami, where the family lived, Arnold Greenfield was also a friend of local artists like Eugene Massin and Audrey Corwin Wright, and he often took his son Timothy along when he went to see them in their studios. "My father never loved practicing law," Greenfield-Sanders recalls, "he really wanted to be an architect, but he never stopped painting ... His paintings were all over the house. A few are very good."

Both of Greenfield-Sanders' parents grew up in Miami, and both had been students in Paris, where his mother, Ruth, studied the piano with Nadia Boulanger (also the teacher of Leonard Bernstein and Aaron Copland) and Arthur Schnabel. "My mother was much more the artist in the family," Greenfield-Sanders continues. "She was constantly playing, composing, and working on concerts ... at one point she had three grand pianos in the living room: it was a very large house. People would come to perform with her, or she'd hold small concerts ... it was music, music everywhere."

Possibly more importantly, in 1951, Ruth Greenfield opened the first integrated school of music, art, dance, and drama in the Southern United States. This was a time still marked by widespread racial prejudice: the end of segregation would only be mandated by the Supreme Court in 1954. Timothy made several lasting friendships there that would influence his creative life.

Another influence was Timothy's uncle, David Wolkowsky, who lives in Key West where the family roots go back to the 1880's. "Uncle David has always been a great friend and patron of the writers who winter in Key West. My grandfather knew Hemingway, of course, and when I was in my early teens my brother Charles and I used to take the bus to Key West to fish and hang out. Sometimes we'd end up sharing our catch with Tennessee Williams or Truman Capote at my uncle's house." In short young Timothy was brought up in an environment where art and culture were daily staples.

At eighteen, Greenfield-Sanders decided to study art history at Columbia University in New York. In his senior year he met Karin Sanders, the daughter of the painter Joop Sanders, who had been one of the founders of the Abstract Expressionist movement and one of the ten original members of the "club." As a young man, Joop Sanders had left the Netherlands for New York, and had become friends with Elaine and Willem de Kooning—a 1945 portrait of Joop Sanders by Elaine de Kooning hangs in the Greenfield-Sanders' living room. He also made friends with other Abstract Expressionists and exhibited together with them in the famous *9th Street Show* of 1951. Karin's father introduced

Arnold M. Greenfield, *Self-Portrait*, 1996, oil on canvas, 9 x 12 inches

18

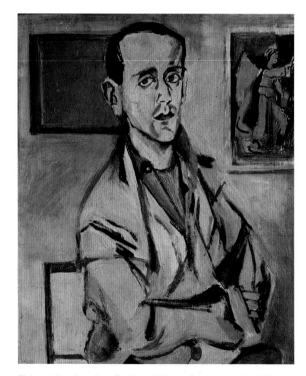

Elaine de Kooning, *Joop Sanders*, 1945 ca, oil on canvas, 14 x 18 inches

several artists of his generation to Timothy, many of whom, including the de Koonings, Larry Rivers, and Robert Rauschenberg, became Timothy's first portrait subjects.

For Greenfield-Sanders portraits are more than mirror images, they represent the acceptance of the idea that an individual exists beyond his everyday reality. It has to do with the sheer humanity borne by existence. Barnett Newman once said to Joop Sanders, "Of all the painters working in color field painting, to me you seem to be the only one who concerns himself with the humanist spirit in painting like I do."[2] This concept is also important to Greenfield-Sanders as he explores the relationship of the individual to the plethora of rules that govern the behavior and social conventions of our age.

A series of portraits of well-known or potentially well-known people in a given field calls up the idea of "success." Now, success, one of the pillars on which advanced capitalism is based, reveals two sides of this society: On the one hand, it is a statement about power, on the other, by reducing private space, it puts a stranglehold on the individual. But, as we know, success can be ephemeral. The faces of the famous can only remain permanently recognizable when they are transformed into icons. The first one to fully realize this dialectic principle was Andy Warhol, who, in the Seventies, investigated the power of icons and their capacity to render the subject portrayed immortal, whoever or whatever it was: a politician, an actor, a can of bean soup, an electric chair or a road accident. From Warhol onwards the artists' portrait and the film image have gained a new symbolic importance. By using images appropriated from mass media and transforming them into their equivalent icons, Warhol demonstrated that to become part of history you had to first become a celebrity and then immediately push for ultimate fame.

Greenfield-Sanders' gallery of portraits underlines that the course of history is determined by single individuals capable of memorable actions. If you see artists, scientists, actors, musicians, architects, writers, art dealers or politicians as projections of their own endeav-

ors, then they become "heroes" of modernity. They are no longer seen for their role in daily life, but for the meaning of their deeds. This vast library of faces with all its load of humanism therefore makes clear how the individual today has no protective horizon to refer to. He has to be the maker of his own destiny, just as happened in the late Middle Ages, on the threshold, that is, of the Humanistic-Renaissance ideal—as Jacob Burckhardt documented so well in his classical study of the Renaissance in Italy. It is not by chance that the sociologist Ulrich Beck has recently discerned a parallel between the visions of the late Middle Ages and Postmodernism.

Greenfield-Sanders' humanism consists of privileging the power of art as discovery and intuition, and in placing this against success. On the one hand he recognizes the value of success, on the other he also inserts in his pantheon not very famous but talented artists. This is why the subjects crowding his pantheon are so numerous, and why along with so many well-known faces there are also many that are not so well known but who are present because of the intrinsic value of what they have done. Unlike Warhol, Greenfield-Sanders sets a poetic vision of existence against the ideal of those who consider success an essential part of the value of art. This humanism can be seen in the work of Peter Halley, another important contemporary artist who has also chosen to place the individual and his relationships with society at the core of his abstract-geometric painting. Greenfield-Sanders' friendship with Peter Halley goes beyond mutual respect to a complicity based on an analysis of contemporary man in which both descriptive and critical dimensions interact. The choice of the young Timothy Greenfield and Karin Sanders to join their names when they got married in 1977, is emblematic of this attitude: It was an usual decision which expressed a desire that equal dignity be given to both parties.

Greenfield-Sanders is one of the most representative portraitists of the postmodern age which he represents in an extreme way both for

Karin Greenfield-Sanders, lawyer (wife of the artist), 1974, 35 mm snapshot

19

Joop Sanders Painting in His Studio, late Seventies, black and white print, 11 x 14 inches

the elegance of his photos and for his unbiased ability to use different contrasting traditions. He has originated a style that does not want to be new and yet is new just the same. In his portraits we find reminders of Félix Nadar's technique and determination to catalogue the characteristic faces of such an age of great inventions as the second half of the Nineteenth century. But we also see the lesson of Andy Warhol quite clearly. Greenfield-Sanders' idea of juxtaposing Nadar and Warhol led to a new and unexpected harmony that renders his portraits immediately recognizable and identifies them as being photographs made by him and no one else.

Greenfield-Sanders has no problem in acknowledging his debt to Nadar and Warhol. In the Paris of the Nineteenth century, Nadar photographed the protagonists of the cultural world like Charles Baudelaire (whom he photographed as often as Greenfield-Sanders photographed Francesco Clemente, Peter Halley, Jasper Johns, Cindy Sherman, Mike and Doug Starn, and Lou Reed—each of them with his/her predilections), Hector Berlioz, Camille Corot, Gustave Courbet, Honoré Daumier, Eugène Delacroix, Gustave Doré, Alexandre Dumas, Victor Hugo, George Sand, Gérard de Nerval, Edouard Manet, and Jean-François Millet. In the New York of the Seventies, those who posed for Warhol included Leo Castelli, Brigitte Bardot, Gianni and Marella Agnelli, Yves Saint-Laurent, Bianca Jagger, Brooke Hopper, and the cheered fashion designer Halston. Warhol, though, replaced Nadar's concept of "personality" with that of "presence." For him consumerist exhibitionism, dressing stylishly, being seen at the most fashionable parties and the most important openings, knowing the trendiest places, being featured in the top magazines—in short, being rich and famous—were merits that went far beyond the intrinsic value of an individual in the years when Pop was flourishing in New York. He was only interested in something or someone who had first been legitimized by the mass media, and his subjects seemed to agree. Eventually, they paid to pose for him simply to be a part of history.

Like Nadar, Greenfield-Sanders has dedicated himself to building a pantheon of contemporary celebrities, and like Warhol he is attracted by the charisma of successful or powerful people. He looks at history with the eyes of one who evaluates, catalogs, and classifies according to a personal measure. In this way he embodies the figure of an artist who is also a critic and a historian. For this reason he excludes overt sexual signifiers and avoids exaggerated musculature or other elements that might introduce too much situational narrative into the image. This attitude is what most differentiates him from Robert Mapplethorpe. In 2004 Greenfield-Sanders created *XXX*: a series of thirty portraits of porn stars, photographed both clothed and naked in the same pose, and then shown life-size. This project does not originate from an interest in sex and its public and blatant manifestations, but on the contrary it comes from Greenfield-Sanders' obsession with cataloging contemporary talents. The porn stars are portrayed as actors capable of communicating sexuality through the body language. In this series Greenfield-Sanders also carefully included in his selection a range as wide as possible of ethnic groups and genders.

Cataloging has been a foundation of the history of human knowledge, from the earliest Babylonian temple inventories to the Eighteenth century *Encyclopédie*, from Ptolemy's eight *Geography* books of the Second century AD to the latest CD-ROMs. Obviously we also find significant catalogers in recent art: Marcel Broodthaers, Christian Boltanski, Haim Steinbach, Philippe Thomas, and Mark Dion, just to mention a few. In the world of pure photography, Greenfield-Sanders could be placed with Hilla and Bernd Becher, who, from the second half of the Sixties on, have recorded and catalogued water tanks, coal mines, industrial storehouses, smokestacks, and so on, archiving a quickly-vanishing industrial landscape.

At first glance, the difference between the work of the Bechers and that of Greenfield-Sanders might seem great, if only for the fact that the former have been considered "concep-

Kirk Varnedoe, art historian, 1986, black and white contact print, 11 x 15 inches

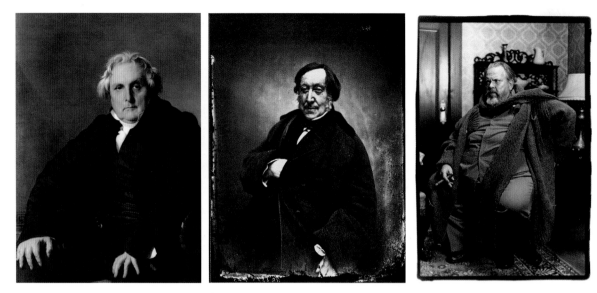

Jean-Auguste-Dominique Ingres,
Louis-François Bertin, 1832, oil on canvas, detail

Félix Nadar (Gaspard-Félix Tournachon),
Gioacchino Rossini, 1856

Timothy Greenfield-Sanders, *Orson Welles*,
film director, 1979, print from 35 mm negative

tualists" and they photograph architecture, while the latter is interested in more purely formal matters and concentrates on human subjects. Yet their body of work has some noteworthy points in common with Greenfield-Sanders'. For instance, both projects work in opposition to the experimental photography of the Twenties and the subjective photography of the Fifties. Both think the subject determines the way in which it is photographed. Both avoid transferring their own emotions onto the subject. Both shun reportage because they are artists, and yet end up doing it. And industrial landscapes grow old and die just like people do. "What stimulated us was the idea that these industrial landscapes are not in the least eternal," Hilla Becher said. "They have an average life of about fifty years during which time, though, they continue to change. It is nomadic architecture that changes and follows its own cycles just as nature does."[3] We can conclude, therefore, that they are icons, just like Greenfield-Sanders' subjects are. But above all, the Bechers share with Greenfield-Sanders a conviction that it is not necessary to insert a subject into a composition—even though, when

photographing an industrial site, no matter how much you want to isolate it, you must "underline its links to the surrounding environment."[4] One can fix something photographically in the same spirit with which Diderot and D'Alembert cataloged knowledge.

Greenfield-Sanders called his show at the Mary Boone Gallery in New York in 1999 *Art World* and not *The Art World*, and this difference suggests that the art scene the show cataloged was not considered complete. Still, the vast number of people portrayed—seven hundred—reveals a desire for universality. Had it been possible, Greenfield-Sanders would have included all the members of that world without distinction. Those who died before he even began cataloging the present—Jackson Pollock and Franz Kline, for instance—and some he has not yet been able to portray are missing. But even so, he is clearly aiming, like Nadar and the Bechers before him, at an encyclopedia, that is the *Great Book* through which, in the Eighteenth century, the first secular systematization of the knowledge of an age was embodied. In fact the *Encyclopédie* by Diderot and D'Alembert represents

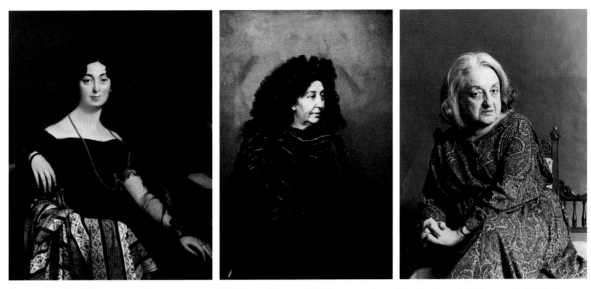

Jean-Auguste-Dominique Ingres, *Françoise Poncelle Leblanc*, 1823, oil on canvas, detail

Félix Nadar (Gaspard-Félix Tournachon), *George Sand*, 1864

Timothy Greenfield-Sanders, *Betty Friedan*, writer, 1984, print from 2¹/₄ x 2¹/₄ inch negative

the most significant attempt at offering, in a better way, the knowledge and the tools that the rising merchant and artisan classes needed to remove themselves from the constraints of clerical teaching and dogmatic interpretations.

Greenfield-Sanders has never relied on technology as an aid to obtaining flashy formal results; he has never wanted to dazzle us with the possibilities offered by the latest, state-of-the-art equipment. Around 1975, when he was a student at the American Film Institute in Los Angeles, he used Super-8 film for his short movies and a Nikormat 35 mm for his photographs. In 1977, he added the Nikon F2 and also began using a Hasselblad. Later that year he happened to discover a 1905 Fulmer & Schwing 11 x 14 inch view camera hidden by piles of books in a friend's library. He bought it from him for a few dollars. He wanted to have it first because he liked it as an object and only secondly because he understood it would have been possible with it to make large-format photos.

But once he had replaced the original, unusable lens with a "new" one—found in an old camera junk shop in Hollywood—the repaired camera seemed to offer a solution to several questions he had been wrestling with in his portraiture. There were also other problems, the first of which was lighting. "After the first few shots," the artist told me, "I figured out a way to hook up a strobe light to the lens and was able to work with more light and a quicker exposure time. The old way of shooting was, of course, with natural light, with long exposures of several seconds. With my handmade shutter-switch I was able to reduce the exposure to one thirtieth of a second." Even so his subjects had to stay still because movement could take them out of the narrow depth of focus. Greenfield-Sanders wants his light to be as similar to natural light as possible, so he lights his subject sparingly from one side, with minimal fill. Before finding the Fulmer & Schwing, he usually shot numerous small-format photographs, but with it, he began shooting just two or three exposures per sitting. This was not just because of technical limitations, but because the type of large-format film he used was hard to find and extremely expensive. "When I shot Cindy Sherman in 1980," he remembers, "I took only one expo-

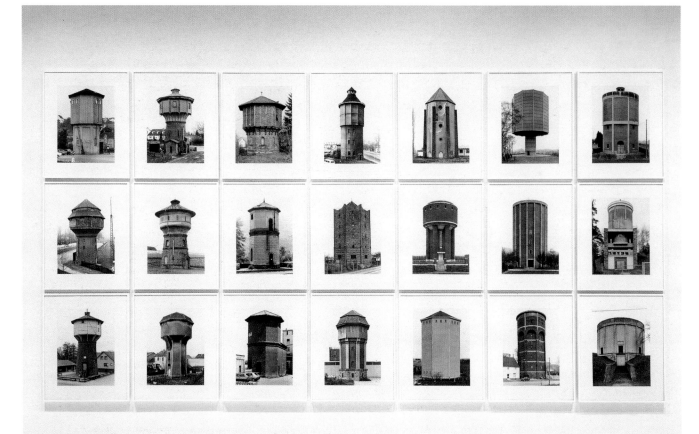

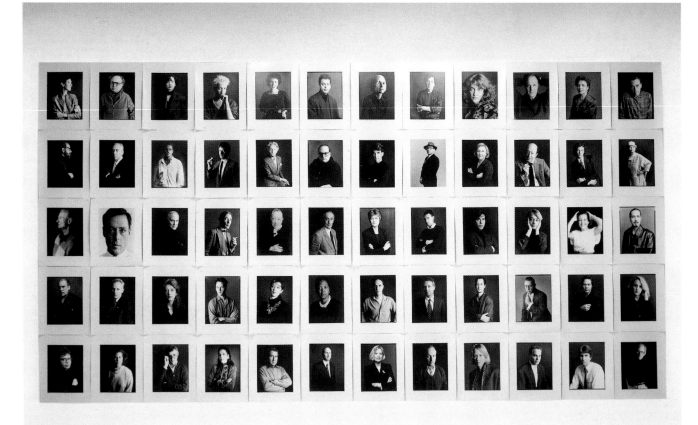

Above: Bernd and Hilla Becher, *Water Towers*, 1988, 67 x 129 inches. Courtesy Sonnabend Gallery, New York
Below: Timothy Greenfield-Sanders' exhibition *Art World*, Mary Boone Gallery, New York, 1999

sure!" This, in turn, obliged him to reconsider the theory underlying his methods: To get the best response from the subject at the first go, the photographer needs to concentrate at his best and to get rid of nervousness.

The formal layout would have to be decided on ahead of time. Peter Halley described all this most succinctly: "Greenfield-Sanders' lighting is quite simple. In the studio, he almost always lights his subject from the upper right. Despite the apparent repetitiveness of this technique, he is able to achieve endless nuances of sculptural effect ... only a narrow two-dimensional plane in his three-dimensional space is in focus. Usually the sitter's eyes are in sharp focus, while the hands, clothing, and even other parts of the face are more or less blurred in relation to their distance from the focal plane. Formally, Greenfield-Sanders is very much a minimalist. As with any successful minimalism, each seemingly simple element must carry multiple levels of meaning. Thus, the out-of-focus lens rivets our attention to the sitter's eyes; at the same time it makes us aware of the transformation of physical space onto a two-dimensional plane."[5]

So the need to leave a part of the subject out of focus is an important element in Greenfield-Sanders' art. This technique is very frequent in contemporary portraiture but its origins can be found in the Seventeenth, Eighteenth and Nineteenth century masterpieces, where the focus on the image creates a natural effect. Think for example, at the buttons on the purple robe of the portrait of *Innocent X*, which Velázquez painted in 1650: If they are seen close up, it is difficult to perceive them clearly, they look like an abstract mass. From a distance, however, the lighting adds depth to the folds of the robe and gives the buttons form, but they still cannot be counted. They are right in front of you and yet, you cannot tell how many they are.

Similarly, the definition of the subject's eyes in a Greenfield-Sanders photo forces the viewer to look into the portrait's gaze. Let's return a moment to Velázquez' *Innocent X*: the pope's forearms, leaning on the arms of his

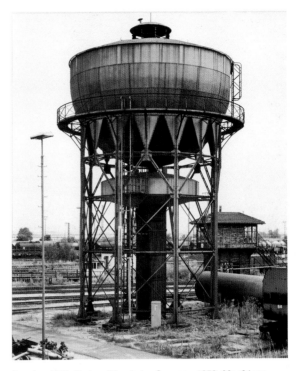

Bernd and Hilla Becher, *Mannheim*, Germany, 1978, 20 x 24 cm.
Courtesy Sonnabend Gallery, New York

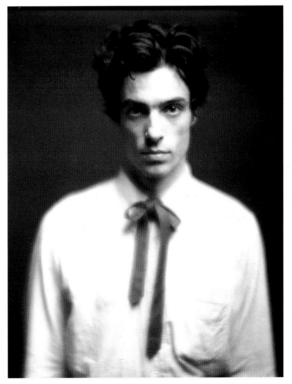

Brian Goodfellow, actor, 1979, black and white contact print, 11 x 14 inches

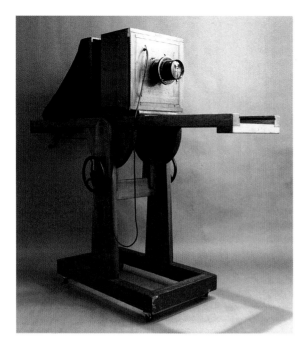

First 11 x 14 inch camera, 1978, black and white print, from 2¹/₄ x 2¹/₄ inch negative

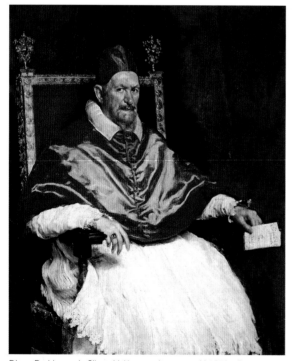

Diego Rodriguez de Silva y Velázquez, *Innocenzo X*, 1650, oil on canvas

chair, are two sides of a triangle, with his hat as the apex. By intersecting with the pope's gaze, these two axes give greater intensity to his expression and force the observer to concentrate on the eyes, which come to the foreground "in perfect focus."

This comparison is used to demonstrate the complexity of Greenfield-Sanders' work. His portraits are rich in details that recall ancient art: Look, for example, at the 1990 portrait of Howard Hodgkin and then compare it to Rembrandt's *Self-Portrait* of 1669, or compare the 1989 photo of Julian Schnabel to Caravaggio's *Saint Matthew and the Angel* of 1602. In the portraits of the two American artists, the red of Hodgkin's scarf and Schnabel's cape has the same expressive force as it had in the art-historical paintings. Furthermore, in these photos, light pours over the subject in a way that is reminiscent of Nineteenth century portraits, those by Ingres above all. And Ingres could be seen as something of a common denominator between Nadar and Greenfield-Sanders. In the work of all three artists, the subjects are always fixed, almost expressionless, against a homogenous background with a lack of theatrical gesture. Peter Halley's comments about Greenfield-Sanders could apply to the other two as well: "Greenfield-Sanders' attitude is respectful. He does not probe or look for flaws in his subject. Yet from the formal, controlled situation in which he works, images of great psychological power emerge. While some photographers try to capture one moment or one expression, a Greenfield-Sanders photograph defines its subject in a more atemporal way."[6]

American critics of Greenfield-Sanders' work have seldom investigated its relationship with the art of the past, tending to focus their critical, formal and theoretical comparisons on the connection with Warhol. Wayne Koestenbaum's penetrating analysis likens the photographer's artistic world to "Warhol's screen test of Marcel Duchamp, his silk-screens in homage to Robert Rauschenberg ... his lifelong desire ... to perpetuate the hard, unpsychological face, anyone's face, especially a face that can pay for it,

or a face that can be recognized."[7] Even the attitude, or rather the ritual, of those who pose for Greenfield-Sanders reminds him of the attitude of those who posed for Warhol: "Show up at the Factory, chat, hang out, sit before the movie camera while the master walks away, having first instructed you not to blink ... No overt pressure compels the victim to perform: In fact, the casual set-up communicates an indifference to the sitter, who must manufacture a personality in a void, or else must stoically (or hostilely) attempt to withhold personality, to give nothing to the camera."[8] The accent is on Greenfield-Sanders' unexpressionist attitude and his tendency to set his subjects beyond the constrictions of time and narrative. Now, does my analysis concerning the relationships between Greenfield-Sanders and Ingres' and Warhol's subject disagree with Koestenbaum? Not at all. Greenfield-Sanders' attitude is truly postmodern, as opposed to Warhol's, which was, if anything, closer to the dynamic avant-garde of the first half of the Twentieth century.

Greenfield-Sanders does not see the work of his predecessors as something to outdo, but as a world to be accessed and deployed in flashes of intuition and memory. After all, what postmodernism distrusts most is the concept of "coherence." Did postmodern architects restrain themselves from combining fragments of Greek temples and bits of Baroque, and remixing them into a kind of rationally geometric form? Of course not. But then why should they have?

Once, in 1997, I asked Greenfield-Sanders to mention a photographer of the past. He laughingly and, I think, instinctively referred to a painting by Rembrandt. It was only later that he mentioned Nadar, Julia Margaret Cameron, August Sander, and Irving Penn[9]. That he could be fascinated by an extraordinary painter like Rembrandt is not surprising, but what relationship can his photos have with those portraits of often sweaty flesh? It is easy enough to understand the other references. I've already mentioned the relationship between the photos of Nadar and of Greenfield-Sanders[10]. Julia Mar-

Luigi Ontani, artist, 1999, black and white contact print, 11 x 14 inches

Philip Taaffe, artist, 1986, black and white contact print, 11 x 14 inches

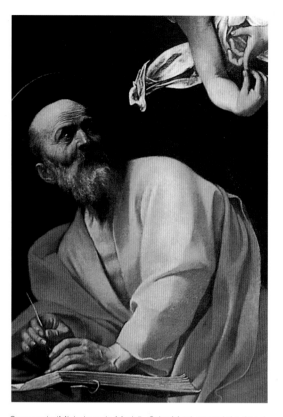

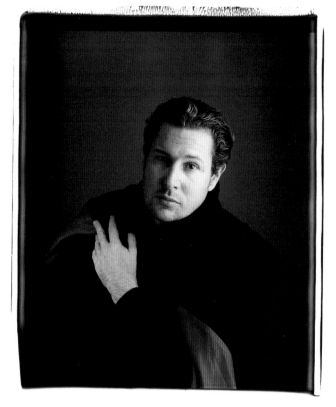

Caravaggio (Michelangelo Merisi), *Saint Matthew and the Angel*, 1602, oil on canvas, detail

Julian Schnabel, artist / filmmaker, 1989, color Polaroid, 20 x 24 inches

28

garet Cameron no doubt interests him for her romantic intensity, and Irving Penn for his formal elegance. The similarities to Sander are clear[11], especially in his respect for a subject who, like Nadar's, is always in a pose and a "role" that the subject himself chooses. But Rembrandt? Since we know the unconscious mind talks and reveals hidden passions and desires, his references to Rembrandt allow us to truly assert that Warhol's work is to Matisse's as Greenfield-Sanders' portraits are to Rembrandt's. Warhol's large, flat brushstrokes of color are influenced by Matisse, just like the uniform backgrounds and the fixed pose of Greenfield-Sanders' photographs are (also) indebted to certain portraits by Rembrandt.

In these photos we are not aware of any particular avant-garde influences. However, we must remember that the heroic iconoclastic attacks made by the avant-garde against tradi-

tion over the past century have slowly become institutionalized, resulting at times in sterile scholasticism. The return to painting in the Eighties, on the one hand, and "academic" minimalism and conceptualism, on the other, have meant that today the typically avant-garde aim of shocking through the creation of disturbing works is less potent due to an overload of ideas and images. The past preeminence of formal and conceptual complexity in art no longer has a monopoly on its current landscape. Art has been freed from the need to use a currency inflated by the effigies of Duchamp, Warhol, or Beuys.

First published in Demetrio Paparoni, ed., *Timothy Greenfield-Sanders*. Milano, Italy: Alberico Cetti Serbelloni Editore, 2001. Essay edited in 2005.

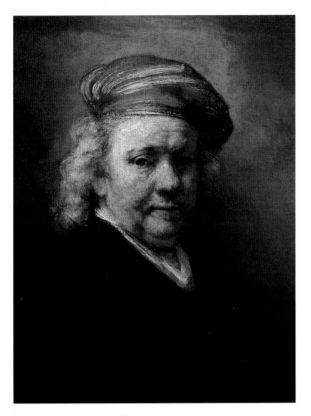

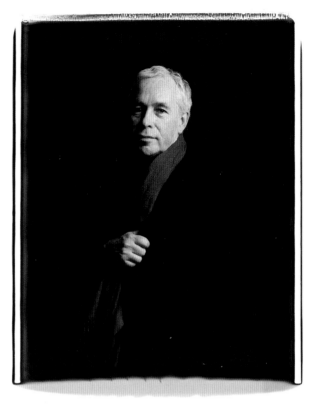

Rembrandt, *Self-Portrait*, 1669, oil o canvas, detail

Howard Hodgkin, artist, 1990, color Polaroid, 20 x 24 inches

[1] The quotations from Greenfield-Sanders in this essay refer to conversations with the author between November 1991 and January 2001.

[2] Barnett Newman quoted by Lawrence Campbell in "Joop Sanders at Alfred Kren," *Art in America*, May 1987.

[3] Hilla and Bernd Becher, "Conversation with Jean-François Chevrier, James Longwood and Thomas Struth (21.1.1989)," Jean-François Chevrier, James Longwood, *Un'altra obiettività / Another Objectivity*. Exhibition catalog (Centre National des Arts Plastiques, Paris, March–April 1989; Museo d'Arte contemporanea "Luigi Pecci", Prato, June–August 1989). Milano, Italy: Idea Books, 1989, p. 57.

[4] Ibidem, p. 59.

[5] Peter Halley, "Timothy Greenfield-Sanders," Peter Halley, ed., *Timothy Greenfield-Sanders, Selected Portraits 1985–1995*. Exhibition catalog. Köln: Kunst-Station Sankt Peter, reprinted in *Tema Celeste International*, No 61, March-April 1997, pp. 47–49, reprinted in Demetrio Paparoni, ed., *Timothy...* cit., pp. 190–192.

[6] Ibidem.

[7] Wayne Koestenbaum, "Art's Hard Face," *Art World: Timothy Greenfield-Sanders*. New York: Fotofolio, 1999, reprinted in Demetrio Paparoni, ed., *Timothy...* cit., pp. 212–216.

[8] Ibidem.

[9] Demetrio Paparoni, "Timothy Greenfield-Sanders," *Il corpo Parlante dell'arte*. Roma: Castelvecchi, 1997, pp. 146–152. The full interview is included in Demetrio Paparoni, ed., *Timothy...* cit., pp. 193–196.

[10] See Robert Pincus-Witten, "Timothy Greenfield-Sanders: Portraits of the Artist," 1991, published in Peter Halley, op. cit., and 1999 "TG-S," *Art World: Timothy Greenfield-Sanders*, cit. Both are reprinted in full in Demetrio Paparoni, ed., *Timothy...* cit., on pages 184–186 and pages 210–211. See also "S'io fossi Nadar / If I Were Nadar," interview with Greenfield-Sanders by Doug and Mike Starn, first published in *Tema Celeste Arte Contemporanea* and *Tema Celeste International*, No 61, March–April 1997, pp. 47–49. Reprinted in Demetrio Paparoni, ed., *Timothy...* cit., pp. 187–189.

[11] Mentioned again by Pincus-Witten in the above-mentioned articles, and by Jerry Saltz and Jeremy Gilbert-Rolfe in the articles "Collective-Memory Lane" (*The Village Voice*, 7 December 1999) and "A supplementary Note on Assertiveness, Pointlessness, and the Sycophantic" (*artnet.com online*, 15 January 2000), reprinted and translated in Demetrio Paparoni, ed., *Timothy...* cit., pp. 217–218 and 219–221 respectively.

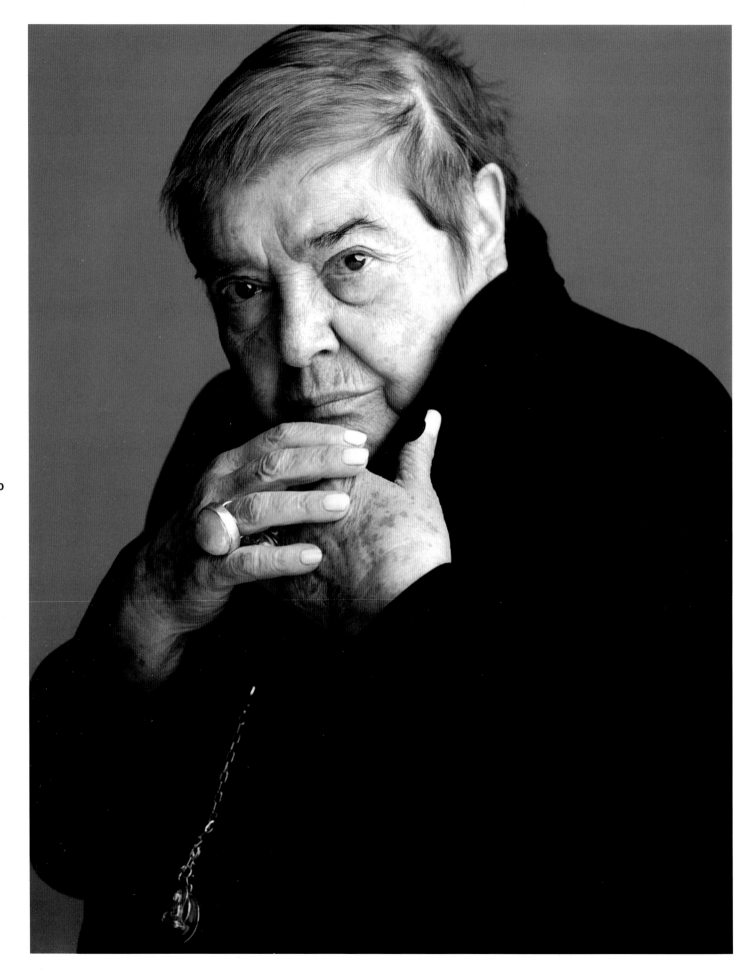

Fernanda Pivano, writer, 2004, color Polaroid, 8 x 10 inches

Timothy Greenfield-Sanders and My Beat Friends

Fernanda Pivano

The last time I was in New York was November of 2004. I had to write a piece for the *Corriere della Sera* about the new MoMA and I was staying at the Hilton. My art critic friend Demetrio Paparoni was the one who scheduled a meeting for me with Timothy Greenfield-Sanders so he could take my portrait. I knew that Timothy Greenfield-Sanders has his portrait studio on the ground floor of his home in New York's East Village, where he first serves tea and chats with whom he is to photograph until he sees his subject completely relaxed.

A few of the people he has portrayed—people I have the privilege of considering my dear, close friends—told me all this. From their descriptions, and from their stories, I knew that he uses a monochromatic backdrop, a single light, gives little prominence to narrative elements, such as particular clothing or gestures, and above all avoids, though not always, that the subject strikes a pose. He then takes a few shots with his 1905 Fulmer & Schwing 11 x 14 inch camera.

These friends told me that Greenfield-Sanders never let them act out their characters as they were often accustomed to in front of the media, but that he brought them into such a natural situation that they ended up as individuals alone in front of themselves. In the end, he was photographing them not because they were celebrities, but because they had talent, and to him only those who possessed talent were of interest as photographic subjects.

Recently Greenfield-Sanders has worked on a theme he had not previously published: He chose famous porn stars, centering on their celebrity and portraying them both clothed and nude, in two identical images, almost mirrors, aside from the fact that in one the subject is nude and in the other is clothed. I saw those porn star portraits at the Mary Boone Gallery precisely as I was in New York for the opening of MoMA. That day I had an appointment with Lou Reed, who had invited me to lunch at a Japanese restaurant not far from the gallery; thus, also because the show had been noted by some other friends, I went by around noon.

The porn star photographs were life-size. For a woman of my age it made a real impression on me to see nude men, because this is something that had no part in my Victorian upbringing. The nude women made little impression—quite the contrary—I was finally seeing, all together, many women of the sort that men like.

Greenfield-Sanders came to me soon after; Lou Reed had also invited him. He told me that he wanted to take my portrait. The idea terrified me.

That same afternoon I went to Greenfield-Sanders' place, on the ground floor of an old church converted into a residence. He put me at ease with his gentleness, but I thought he needed women like those I had seen on exhibit in the gallery, not me. Exceptionally skilled, most kind, and incredibly sweet, he made me take a seat in front of a backdrop and arranged some scarves on me. His assistant Mark maneuvered about around us. The portrait itself was done quickly, and afterwards he took me up to the second floor, where he showed me his collection of famous artists' paintings and offered me tea.

On the table was his book *XXX*, the one with portraits of porn stars nude and clothed, with a preface by Gore Vidal.

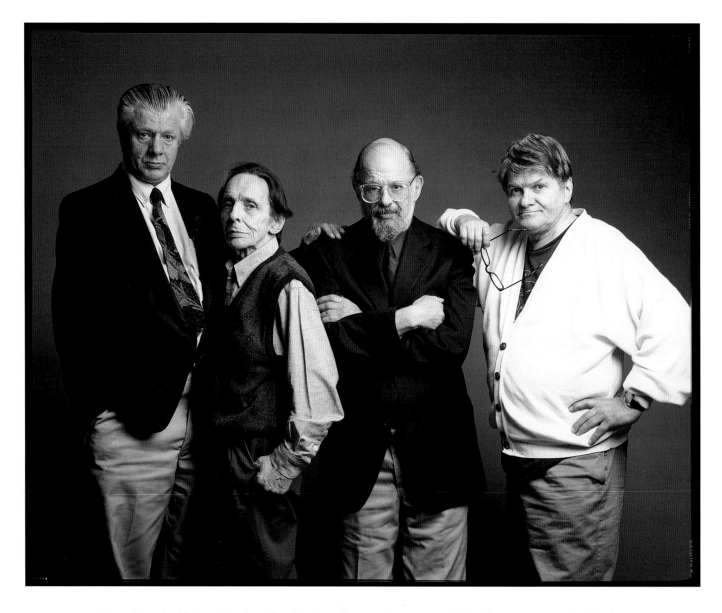

Peter Orlovsky, **Herbert Huncke**, **Allen Ginsberg**, **Gregory Corso**, poets, 1992, color transparency, 8 x 10 inches

Gore Vidal once said in a book that he had gone to bed with Kerouac, and that he had been on top. Another time, in an interview published in *Gay Sunshine*, the most serious sex magazine in America, he spoke at length of his characters regarding their sexuality. There is no doubt that Gore Vidal knows a lot when it comes to sex, and he writes with great competence. For all of the little things I know about this sweet friend of mine, I think I am able to say, at least theoretically speaking, that when he talks of sex he is absolutely trustworthy—just as trustworthy as when he talks about the historical problems of America: I think very few American historians have made revelations as confirmed and provable as his.

For the Greenfield-Sanders book, Gore Vidal wrote a beautiful essay he wanted to entitle "The Origins of Erotic Jokes." He cites, for example, the fact that men are just as promiscuous as women for the same biological reasons. Naturally, I would not even consider doubting the words of a specialist like him, especially since he is among those I most respect.

I am no sexual expert, and these splendid photographs are certainly a page in the history of sexual photography. These are subjects that make one think they truly like to show off in the nude. This is probably because these young women know they are beautiful, but above all because they know that that way of posing their beauty impresses other individuals, both married and unmarried.

Greenfield-Sanders' true cunning was his juxtaposition of women both nude and clothed like schoolgirls. I imagine that schoolgirl uniforms do not change the theme, given that such clothing renders even prostitutes more bewitching. Naturally this definition of "prostitutes" is all too easily applied, because then one would have to question whether the goddess Astarte, who had entire temples dedicated to her, were a prostitute. In reality she was a porn star of her own day, in front of whose altar prostitutes had to couple with priests.

Frequently, Astarte or no Astarte, porn stars are easily mistaken for prostitutes, but there is a fundamental difference between the two—professions—because porn stars work very hard to reach a level of professionalism. Prostitutes, on the other hand, limit themselves to moves that they may not even have had to learn, since they are part of the beloved game of life.

It is perfectly legitimate to ask oneself why I speak only of the young women photographed by Greenfield-Sanders instead of the male protagonists. I believe it is rather clear that a Victorian old woman like myself has no experience of that sort of male professional, even if I have happened to meet a few of them, merely by chance. These were gigolos who lent themselves more as the occasional escort, private chauffeur, and chivalrous fashion advisor, even if just so-so; all lies for women who wanted to believe them, even well-intentioned white lies.

The splendid male specimens photographed by Greenfield-Sanders interest him not as porn stars or prostitutes, but for their talent in front of the movie camera and still camera. In the end, in front of emblematic nudes of gorgeous millionaire boys or poor dockworkers, one asks the same questions. This is to say that sex is in any case the same.

I am no photo critic; my interests lie principally in poetry and literature, specifically American poetry and literature. In the portraits of Greenfield-Sanders, however, I rediscovered, with nostalgia and love, the images and realities of some of my friends, a few of my dear colleagues—like Allen Ginsberg, Gregory Corso, Peter Orlovsky—and others, not quite as close but who were familiar and remain dear to me: John Cage, Lawrence Ferlinghetti, Jonas Mekas, Merce Cunningham, and William Burroughs.

One of these photographs shows Allen Ginsberg, Gregory Corso, Peter Orlovsky, and Herbert Huncke. It was taken in 1992, the same year in which Michael Schumacher had published a biography of Allen Ginsberg, *Dharma Lion*, when Greenfield-Sanders was forty years old, Allen Ginsberg was sixty-six, Gregory Corso was sixty-two, Peter Orlovsky was fifty-nine, and Herbert Huncke was seventy-seven. They were already devoured by their passions, consumed by their diseases, resigned to their losses. They were already clamorously famous, Ginsberg with *Howl* of 1956,

Lawrence Ferlinghetti, poet, 1995, black and white contact print, 11 x 14 inches

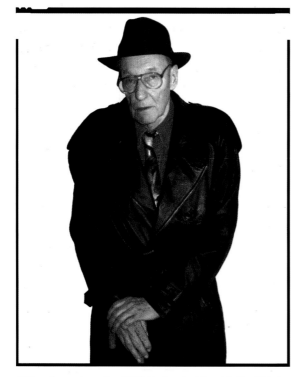

William Burroughs, writer, 1993, black and white print, 11 x 14 inches

Corso with *Gasoline* of 1958, and they would all be dead within a few years, Ginsberg in 1997, Corso in 2000, and Huncke in 1996. Peter Orlovsky's blonde hair had grown white, Ginsberg's had fallen out, and Corso's had managed to resist the cruel disease that tortured him.

Greenfield-Sanders shows us Allen Ginsberg in his final phase, when he dressed in the usual professorial garb, with jacket and tie, because he had become a Brooklyn Professor. A professorial attitude was evident also in the pose he assumed, which was not Buddhist. Ginsberg usually held his hands in the position of the Buddhist greeting of peace; here, instead, he holds them lower. In this sense what we see is not the Ginsberg of the Beat generation, but what he had later become, the guru of the Beat generation, the world's highest authority of that movement. Here Ginsberg has an ironic smile, he is a man conscious of what he and his peers had been, but also of how in that moment, in front of the camera lens, they were different with respect to how they had been in the Seventies and Eighties. The sheer fact of posing as a group in a photographer's studio would have been unthinkable in other times.

In this sense there is a difference between Ginsberg and the others, who lacked his sense of irony. He had invented the Beat generation and certainly had a degree of irony in looking at the photographer's lens, above all because he and Gregory Corso had spent blood, sweat, hard work, and pain to affirm their idea. Together with a close-ly knit group of road-trip mates they had taken hold of the collective imagination of America and Europe, and Allen Ginsberg, who Gore Vidal defined their spokesman and poster boy for a rea-son, was already spending long periods in China, to promote his dream of communicating on all lev-els everywhere. Gregory Corso, poetic cherub, was anything but a spokesman, but for reasons too long to explain wanted to be outside America for awhile and had come to Italy, where he had created a sort of legend with his Roman escapades, and above all with a small collection of splendid poetry, published in Italy and virtually impossible to find. When he had left Rome and was settled into his home on Horatio Street in

New York, with the protection of a Japanese painter friend of Allen Ginsberg, he was soon operated on and cared for by one of his daughters, who in the terminal phase of his illness had taken him to Minneapolis for care in the hospital where she was the head nurse.

Greenfield-Sanders' group portrait is from 1992, and Corso died soon thereafter. When we worked together in the Seventies he was still a strong man, in this photograph the signs of age are strong, he is already a finished man. In this photograph they are all finished men, Peter Orlovsky is reduced to an outline of himself, quite different from the man with long blonde hair cascading over his shoulders that I had known years ago.

Peter Orlovsky, too, knew Rome well, where he had stayed for a time when he had come with friends for some festivals, one in Castelporziano and others in Piazza di Siena. At the time this photograph was taken he was constructing a life independent of Allen Ginsberg, who had protected him ever since meeting him when he was eighteen years old and modeling for the painter Robert La Vigne in San Francisco, and kept Orlovsky with him through decades of living together, which had recently caused some intolerance between them. Peter Orlovsky was overwhelmed by this intolerance, and while Allen Ginsberg wearily traveled the globe between one crisis and another of his disease, Peter Orlovsky went from clinic to clinic, victim of amphetamines and nervous breakdowns.

Herbert Huncke joined their friendship in 1944, when he had met William Burroughs, and Jack Kerouac used him in *On the Road* as a model for Elmer Hassel. For all of them Herbert Huncke was an "honest criminal" and Allen Ginsberg had welcomed him as a long-term houseguest in his New York apartment despite the fact they all knew he hid stolen loot there. It was Herbert Huncke who first used the term Beat with Jack Kerouac, who then passed it on to John Clellon Holmes, to describe their generation, and in 1990 published an autobiography entitled *Guilty of Everything*.

William Burroughs, whose portrait Greenfield-Sanders took when he was seventy-eight years old, looks at us from this photo with a vaguely perverse expression, and Burroughs, who died in 1997, was indeed a very disturbed man. He rose to fame in 1959 with the terrible novel *Naked Lunch*, which led him to be considered by many the founding father of a certain postmodern writing style, such as that of Thomas Pynchon in his 1973 *Gravity's Rainbow*. In the photograph his face has innumerable wrinkles and traces—not just those left by his experience with drugs, both regular and hallucinogenic, which imparted telepathic effects; not just of his involvement with unsettling esoteric sciences—but above all traces of human tragedies, like the accident in which he killed his adored wife Joan Vollmer, or the kidney transplant which killed his adored son, a death for which William Burroughs felt responsible up to the very end, because in some way it was caused by the drug use the boy had learned from his own family.

Greenfield-Sanders did not include Lawrence Ferlinghetti in this group, whom he had photographed in 1995 at seventy-six years old, who had become the privileged publisher of Allen Ginsberg since 1956 when he published *Howl*, but also a famous poet in his own right, with his collection *Pictures from a Gone World* published in 1955 as the first volume of a series with City Lights, a new publishing house dedicated exclusively to paperbacks. This was the first ever such publisher, and he co-founded it with Peter Martin shortly after the bookstore of the same name had opened in 1953.

He had graduated from the Sorbonne in Paris with a thesis entitled *The City in Modern Poetry: In Search of a Metropolitan Tradition*, and finished another degree at Columbia University in 1947; he settled in San Francisco in 1953 after doing service with the United States Navy, arriving at Nagasaki a few weeks after the bomb had been dropped. When Ginsberg had read *Howl* at the famous 1955 reading at the Sixth Gallery, he sent a telegram modeled on the one sent by Ralph Waldo Emerson to Walt Whitman when he self-published *Leaves of Grass*, "Greetings at the beginning of a long career," and he had published his poetry in the fourth volume of the City Lights series, confronting a lawsuit for obscenity from which he had been absolved thanks to the testimony of the key intellectuals of the moment (and which established a

precedent for the defense in other poet's lawsuits). His status as national celebrity was born in 1958 with his best-selling collection *A Coney Island of the Mind*, which sold over one million copies.

His popularity in San Francisco is fabulous. One day I was at the corner of Columbus Avenue, where his bookstore still stands, looking in vain to stop a taxi: Ferlinghetti saw this from one of his windows, came out to my side, and four unsolicited taxis stopped to ask if we needed anything. But popular or not, in his day he had chosen not to publish *On the Road*, *Naked Lunch*, or *Bomb*. I have never understood why.

Nor did Greenfield-Sanders include Jim Carroll in their group, the great star of this Underground, here photographed in 1997 at forty-seven years old. Already famous in American media since the age of nineteen, he was nominated for a Pulitzer Prize in *Rolling Stone* magazine when he was twenty-two. Already an Underground hero when he was twenty-eight (and in 1978 his book *The Basketball Diaries* was published), he was even more of an international star at thirty with his *Catholic Boy*, the most popular pop-music album of 1980 (with the song "People Who Died"), which in a certain sense commemorated the death of John Lennon in December of 1980, and brought him recognition on television with Lou Reed on the show "The Roots of Rock," and got him cited by a photographer for *Oui* as the "Dylan of the Eighties."

It has been said that Jim Carroll's success was created by the combination of rock'n'roll with his poetic sensibility, and his ability to describe his own experience with a personal style that mixes past and present: Carroll once said to a journalist, "There ain't much time left, you're born out of this insane abyss and you're going to fall back into it, so while you're alive you might as well show your bare ass."

His life had mythic proportions: He came from three generations of Irish Catholic bartenders, but was born on the Lower East Side of New York, where he studied and kept his diary of being a good student, a basketball star, and heroin addict from the age of thirteen. At thirteen he was judged

"a born writer" by Jack Kerouac and William Burroughs, he published a collection of poetry at sixteen, had decided at twenty-three, in 1973, to enter detox, and was chosen to accompany Patti Smith on the stage, where in 1978, when he was twenty-eight, she introduced him to the public saying: "He taught me to write poetry."

In 1980, 1982, and 1984 he made three albums which met with instant fame, and he went on vacation, but not before having published six books that became immediate best-sellers and inspiring a new generation of writers and film directors: His book *The Basketball Diaries* is considered a classic of American adolescent literature, and has been made into two films, one in 1980 and the other in 1997, and his work is studied in universities together with that of Bob Dylan and Lou Reed. In 1993 he read his poems in a video directed by one of Bob Dylan's children, and after Kurt Cobain's suicide he read his "8 Fragments for Kurt Cobain" on television, which was then published on January 1, 1995, in *The New York Times* and included on his most recent album, *Pools of Mercury*, in 1998.

Greenfield-Sanders also did not include the Lithuanian Jonas Mekas in his Underground group, though he photographed him alone in 1997 at seventy-five years old, survivor of a Nazi concentration camp outside of Hamburg who came to America in 1949. He immediately took up cinema, producing a film with his brother Adolfas, and started the Underground cinema movement. He invented the film column of *The Village Voice* under the title "Cinema Diary," and published a volume of his critical works in 1972. In 1955 he founded the newspaper *Film Culture*, in 1962 founded the Film Makers' Co-op, and was winner of the French Legion of Honor.

To the columnists he said he chose to express himself with film because in America no one understood his Lithuanian language; he used his language to write poetry and has published a few books. He came to Europe twice, including Italy, to present his films, which soon everyone was calling "Underground," and which I was proud to introduce in Turin and Milan. Frequently one of his "stars" also came, Taylor Mead, with

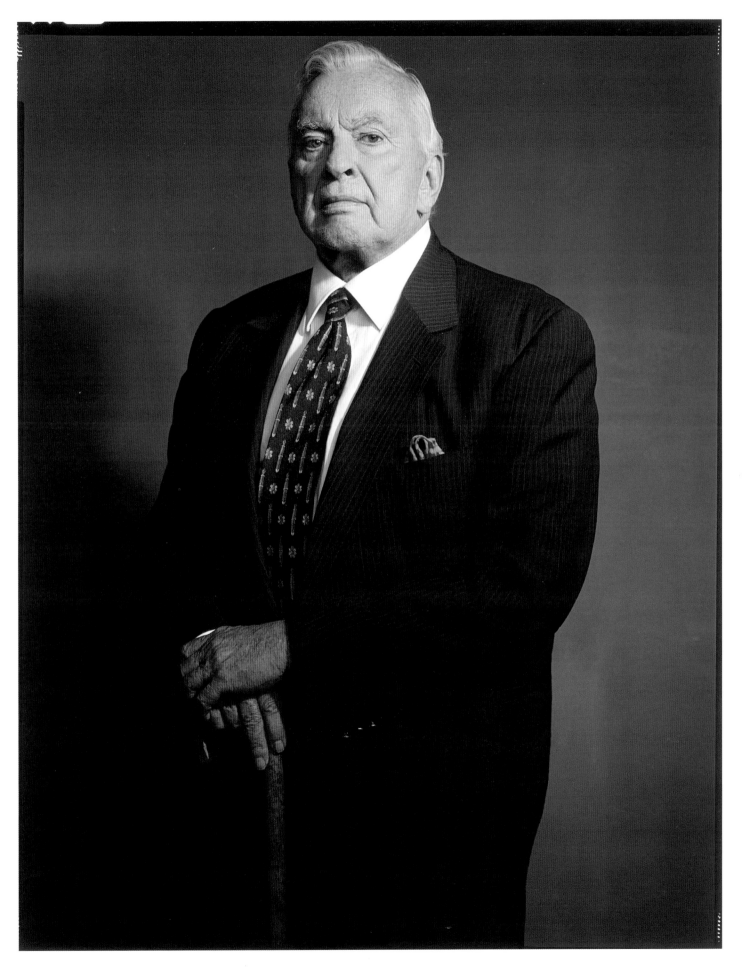

Gore Vidal, writer, 2003, color transparency, 8 x 10 inches

Leo Castelli, gallerist, 1989, color Polaroid, 20 x 24 inches

Sandro Chia, artist, 1991, color Polaroid, 20 x 24 inches

his film "The Flower Thief," where to save film he made only a single take with each subject to be photographed.

Another group captured by Timothy's lens is that of John Cage, Merce Cunningham, and Jasper Johns, portrayed in 1989, when John Cage was seventy-seven years old, Merce Cunningham seventy, and Jasper Johns fifty-nine. John Cage and Merce Cunningham had worked together since 1944 and had toured in Europe as well, where Merce Cunningham did innovative choreographies and invented new dance techniques. They taught courses together at Black Mountain College in North Carolina in 1948 (and in that same period Richard Buckminster Fuller had worked with them also as he constructed his geodesic domes) and had worked on a *pièce* by Erik Satie of seven scenes with six characters, with seven piano sonatas played by John Cage, and the six characters included a monkey played by Merce Cunningham.

I recall meeting them at St Paul de Vence on August 6, 1966, and Merce Cunningham was already quite damaged by the arthritis that stole the elasticity from his legs: He was rigid on the stage, circled by ballet dancers dressed in costumes designed by Robert Rauschenberg, who later explained his innovative techniques to me: He had begun to work on them while dancing with Martha Graham between 1940 and 1955, before forming his own dance company in 1953, and which he brought to completion working with John Cage.

His first solo concert with John Cage came, as I mentioned earlier, in 1944, John Cage was at the height of his electronic inventions and had studied dodecaphonic music with Arnold Schoenberg; already in 1939 he had invented the "prepared piano," placing objects between the strings of a grand piano, thus creating a percussive orchestra led by two hands. Since then Cage had always composed music for Merce Cunningham's dances and continued to publish books explaining his inventions, while he studied Zen with Henry Miller and looked to the I-Ching to decide future events; but he was still at Black Mountain College with Cunningham when he thought up their first

performance, and soon after, when he had gone to work at Harvard University, made his discoveries regarding silence, which inspired his famous book *Silence*, published in 1961.

The third artist Greenfield-Sanders joined with John Cage and Merce Cunningham is Jasper Johns, who exploded onto the celebrity art scene in 1954 when he painted his first American flag, signed only later, in 1955, and considered the developmental key of Minimal Art, inspired by the influences of Cage, Cunningham, and also Robert Rauschenberg. Through 1972 he was also artistic advisor to Cage and Cunningham.

So Robert Rauschenberg had worked together with them. Timothy had photographed Rauschenberg in 1988 when he was sixty-three years old, he had studied in Kansas City and Paris until in 1949 he went to Black Mountain College and had worked with them, intensifying his collaboration with them between 1954 and 1965 and in those same years moving his studio near that of Jasper Johns. In 1962 he had begun to use his technique of mixing objects into the paintings, and in 1963 the Galerie Sonnabend, still in Paris, organized his first European retrospective, spreading his work internationally.

Next to the photograph of Robert Rauschenberg, this volume of Timothy's work had shown a photo of Roy Lichtenstein, taken in 1992 when he was sixty-nine years old and already famous for including comic strip and advertising imagery in his paintings after meeting Allan Kaprow and Claes Oldenburg in 1960. In 1963 he moved to New York and was hired by the architect Philip Johnson to complete several large-scale paintings for the New York pavilion at the New York World's Fair.

Since then he had gone from one show to the next traveling the world, supported by the galleries of Leo Castelli and Ileana Sonnabend. He was the one to attack, in a series of merciless critical essays, Jackson Pollock's popularity, who together with Willem de Kooning had pioneered Abstract Expressionism.

Together with the photograph of Roy Lichtenstein this book presented that of Willem de Kooning, photographed in 1986 at eighty-two years old, already suffering from Alzheimer's. After two years of work with the Federal Art Project in 1936 and 1942 he turned thirty-eight and had his first group shows at the Museum of Modern Art, he had his first solo show in New York in 1948, and his first retrospective in 1953 at the age of forty-nine. Many of his works, including the famous *The Wave* and some of his famous *Woman* series are in the collection of the Hirshhorn Museum, along with many of his portraits, together with some portraits of his wife Elaine (photographed in 1980 by Greenfield-Sanders: Her portrait, next to that of her husband, is published in the photographer's monograph, edited and published by Demetrio Paparoni with an introduction by Francesco Clemente), with her blonde bangs and dry, dramatic face.

By this time Leo Castelli had taken command of the art scene; photographed by Greenfield-Sanders in 1989 at eighty-two years old, ten years before he died at ninety-one, Castelli was a hero of modern art, the first in New York to show Warhol, whose *Campbell's Soup* cans more or less marked the launch of Pop Art painting and therefore more or less the launch of American Modern Art in the world.

Castelli was born in Trieste, son of a Jewish Hungarian banker, graduated in Law in Milan, and married the Romanian heiress Ileana, also an art dealer. In Paris he had met the Surrealists, and in 1939 opened his first gallery; during the war he fled to New York and began to sell the works of Kandinsky he had brought with him from Paris. He soon became the promoter and successful art dealer of Abstract Expressionism, in which the artists of Pop Art, Minimalism, and Conceptual Art initially emerged: "his" artists included Andy Warhol, Robert Rauschenberg, Jasper Johns, Roy Lichtenstein, Claes Oldenburg, James Rosenquist, Dan Flavin, and Kesten Sonnier. Greenfield-Sanders had a one-person show at Leo Castelli Gallery in 1987, showing the *New York Artists of the 50's in the 80's*.

Among the Italian artists Greenfield-Sanders has photographed are Francesco Clemente, in 1982 and again in 1987, at thirty and thirty-five years old, Sandro Chia in 1991 at forty-five, Mimmo Paladino in 1991 at forty-three, and Enzo Cucchi in 2000 at fifty-one. I certainly would not

Allen Ginsberg, poet, 1992, color transparency, 8 x 10 inches

deign to speak of them in a critical fashion: I name them because, for example, Francesco Clemente illustrated some of Allen Ginsberg's texts—Ginsberg loved and respected him enormously—and also because I recall seeing some of his paintings in Ginsberg's apartment, in addition to his decorations that beautified the Palladium, and I remember his sophisticated books made in Madras, perhaps the source of Allen Ginsberg's love. Of Sandro Chia I remember the illustrations for one of Gregory Corso's books, which the author probably wanted so that he, too, would have an illustrated book from such a "contemporary" painter. In a certain way these unions tempt one to define the paintings of some of the Transavanguardia as being connected to the Underground, but I will not venture into this possibility.

Some of the musicians studied by Greenfield-Sanders were also clearly Underground, such as Patti Smith, photographed in 1997 at fifty-one years old, inspired by Lou Reed's Velvet Underground and Andy Warhol, adored by Gregory Corso, born a Beat poet, who reached fame with her version of a Jim Morrison poem, and inspired by Arthur Rimbaud and William Burroughs. The media photographed her while she read poetry with Gregory Corso at Allen Ginsburg's funeral.

Also David Bowie, pseudonym of David Robert Jones, the beautiful White Duke, is present in this album, photographed in 1997 at fifty years old. In 1972 he produced some albums with Lou Reed and above all toured the United States with his creation Ziggy Stardust; he became so close with America that in 1994, along with Brian Eno, he made the album *Outside*, published in Italy in 1995 thanks to Arianna d'Aloja's organization. On this album he addresses the electronic manifesta-

tion of the cut-ups created by William Burroughs in 1959 in his book *Minutes to Go*. With this technique he tells, says Bowie in the album's subtitle, the story of Baby Grace Blue's assassination, butchered in the style of Herman Nietzsche, the Austrian sculptor of horror and bloodshed. The album presents itself as the fictitious diary of detective Nathan Adler, and Tito Schipa Jr. translated it with fabulous skill. I had presented it in a brief introduction, moved that my friend William Burroughs had won over the sophisticated David Bowie.

Timothy Greenfield-Sanders' portrait gallery is so filled with images, ideas, and human histories that I would find no end to the traces of my American friends. One of the portraits I have not recalled here is that of Lou Reed, rock musician but also, and perhaps above all, poet, and photographed by Greenfield-Sanders an infinite number of times (the first shot dates back to 1978). In a photograph from 2000 he appears with Laurie Anderson.

The critic Demetrio Paparoni, to whom Greenfield-Sanders owes his notoriety in Italy and the most extensive essay on his work, wrote that he "looks at history with the eye of one who evaluates, catalogs, and classifies. In this way he incarnates the artistic figure who encompasses the figures of critic and historian as well." Above all Paparoni points out which, and how many, relations these portraits have with the work of painters of the past and photographers of this century, a testimony of how Greenfield-Sanders leaves nothing to chance, concentrating on characters who are, before anything else, people—heroes who do not boast of their success, men who believe that talent and intelligence, independently of notoriety, will give us a better world.

42

Jenna Jameson, porn star, 2003, archival digital print, 58 x 88 inches each print (diptych)

Gianni Mercurio, curator, 2005, color transparency, 8 x 10 inches

Man as a Whole. Greenfield-Sanders

Gianni Mercurio

Timothy Greenfield-Sanders, by photographing porn stars in his latest portrait series, has gone a step beyond his previous portraits, all completed in just a few shots in front of a monochromatic backdrop and a single, direct light. First of all, he has created a diptych, showing the same subject, in the same pose, both nude and clothed, thus pointing out that the individual—each single individual—has more than one soul, more than one single interpretation. This double-identity opens one's point of view to a condition of near-schizophrenia, inasmuch as it portrays two distinct moments of existence; two moments that cannot, however, be singled out from one another, nor do they completely reveal themselves. A porn star is, essentially, a person just like any other, yet his social identity is both subjected and susceptible to the judgment of others. Presenting a porn star in casual clothing is the equivalent of rendering him anonymous; portraying one nude, on the other hand, makes him recognizable, allowing consideration of the commercialized, marketable good within. Juxtaposing the two pictures essentially creates a play of linguistic references which cause one to doubt—and at the same time confirm—the multiplicitous identity of the subjects. The thirty porn stars portrayed by Greenfield-Sanders are a cross-section of humanity in all its facets and lifestyles—even if the "lens" of the artist appears in this case to limit the field of vision: men and women, heterosexuals and gays, young and old. In apparent divergence from all his work done up to that moment, it can be said that the porn stars are the first artistic nudes portrayed by Greenfield-Sanders. His homage to Goya's painting in which the subjects, both nude and clothed, are portrayed in the same identical position, is clear. The work as a whole says a lot, even speaks volumes, about its subjects. After having seen them clothed, seeing them once again nude constitutes a kind of revelation, a type of epiphany.

The additional fact that these porn stars are shown life-size, together with the candor of the colors, proves that the subject, before being an icon, is a real individual. Much like a game in which the subject is ultimately defined in its continuous self-reflection in three separate mirrors that compose the image in a kaleidoscopic manner, the porn stars of Greenfield-Sanders escape all attempts at banalization and summary categorization.

The fact that in this cycle of photographs each picture in every set of double portraits seems to be, given how the subjects are posed, a specular image of the other leads the viewer to choose which of the two he sees himself in. This choice is not always the most obvious: Paradoxically, regardless of the fact that the nude bodies of the subjects are more or less all the same, it is precisely in subjects of this sort—porn stars who professionally sell their services in the flesh—that clothing comes to create a dimension of anonymity around the subject itself.

Is pornography an art? What could lead an artist to wonder about it? I believe that pornography is art only if used as a metaphor of something else. In the specific case of Timothy Greenfield-Sanders, pornography is the metaphor of an individual contradiction that becomes, at times, profound; the contradiction of one who lives a "normal" life off the set, but who nevertheless continues to be viewed as though he were to live twen-

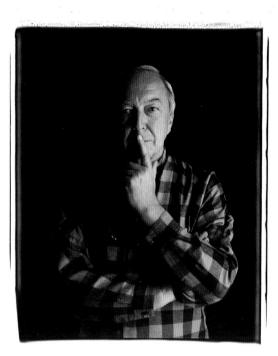

Jasper Johns, artist, 1990, color Polaroid, 20 x 24 inches

Andres Serrano, artist, 1992, black and white contact print, 11 x 14 inches

ty-four hours a day in front of a video camera. The metaphor is clear: appearance superimposes itself on being, the semblance contrasts the essence.

This question involves not only the double-portraits of the porn stars, but includes the work of Greenfield-Sanders in its totality. His interest has always been to document worlds which at first glance can seem incredibly different from one another—the art world, the music world, the political world, Hollywood, and now the world of porn—but which then, once seen in their entirety, seem almost to lose the barriers which separated them. The portraits of Greenfield-Sanders come to speak in a unique way about our culture, and they tell us something about the world in which we live. One gets the impression that Greenfield-Sanders, in a certain sense, is cataloging this world, and what emerges is an image of completion. His subjects possess an aura—given by the backdrops, the poses, the lighting, and the lack of narrative details—that shows how each one of them is satisfied by what he does. Greenfield-Sanders' photographic subjects are, in fact, "lead characters"—not only of their own lives, but of a scene they represent. They are representative characters that discover they have two faces, the private one (equivalent to nudity), and the public one, in which clothing—just as pose—determine and indicate the victorious personality. With porn stars, Timothy Greenfield-Sanders pushes to an extreme the schizophrenic dimension of the personalities and existences of the stars. They may have a great public success, but this does not rule out the possibility that, in private, just as all "mere mortals," they can succumb to a harrowing depression.

Nevertheless, because only the heroic dimension of success or talent is the facet that emerges in Timothy Greenfield-Sanders' portraits, regardless of the fact that they differentiate themselves from one another by their distinct personalities, in the end the subjects photographed possess common aspects. This renders Greenfield-Sanders' stylistic signature immediately recognizable, in such a way that as soon as one sees one of his photographs it is immediately understood that it is one of his portraits. In a certain sense, it is almost

as though it is not the subject who gives itself to the camera lens, but the camera lens which defines the personality, exactly as painters have always done with the still-life; a basket of fruit is merely a basket of fruit, but if painted by Cézanne it will be something profoundly different from the basket of fruit painted by Caravaggio. Greenfield-Sanders does not dedicate any particular attention to the technological aspect of his work, but does totally focus his attention on the goal of bringing out the best in the subject he is photographing. The tools, instruments, and technology have not much meaning for him. Greenfield-Sanders wants to put the subjects he is portraying at ease—his aim is to make their humanity emerge in full force through the portrait. This is something that technology alone cannot do, at least not without the fundamental contribution of the photographer, who understands—even psychologically, on an almost empathetic level—the subject in front of him, and at the same time knows perfectly how to reach the predetermined goal.

As the times change, so does the concept of style and beauty. Greenfield-Sanders has such a strong sense of style and beauty that in his photographs, in the end, style and beauty are brought to the foreground with respect to the subject itself, becoming an inseparable part of it. Artists have always done this, regardless of the period in which they worked: They have singled out a personal way of seeing the world and have asked—or even demanded, with the strength of their vision—that the world yield itself to their aesthetic canons.

There is one of Greenfield-Sanders' portraits that has always struck me: the gigantic Polaroid of Jasper Johns. The artist is wearing a checkered shirt, and his hand rests on his chin as he looks at you. Johns is a notoriously introverted character, and is not much inclined to be around others. He prefers to communicate through his own art. In this photograph the artist has a finger on his lips, almost as if to indicate the need for silence. Now, if one stops to think of how Greenfield-Sanders rarely introduces narrative elements into his portraits—hence the importance of the foreground, as in the works of Warhol and Close—one understands how the subject would have wanted to add his own silence to the silence already offered by the photograph itself. Hence, tautology and minimalism: Each element, in these portraits, recalls the strength of the personality. Everything is distinct, yet at the same time the portraits in their entirety as shown on the gallery walls become a whole whose parts are interchangeable, the exact opposite of what the Minimalists did when they made previously unseen works using inevitably the same modules. In the case of Greenfield-Sanders, the modules are always different, but the whole is always the same. It is the same because the whole is none other than man, with his personality.

Timothy Greenfield-Sanders has always avoided falling into the trap of the stereotype. He shuns type-casting people in a continuous struggle aimed at the veracity of representation—a struggle which is appreciated precisely because it never makes itself felt when one observes one of his portraits: The choice of pose and background assure that from his shots only an unmitigated, natural sense emerges that inevitably moves the viewer. His latest work on porn stars is proof of this: It is an attempt, dazzling in its simplicity, to show the various sides of the personalities portrayed, with the use of the double and the specular as an ingenious observational stratagem.

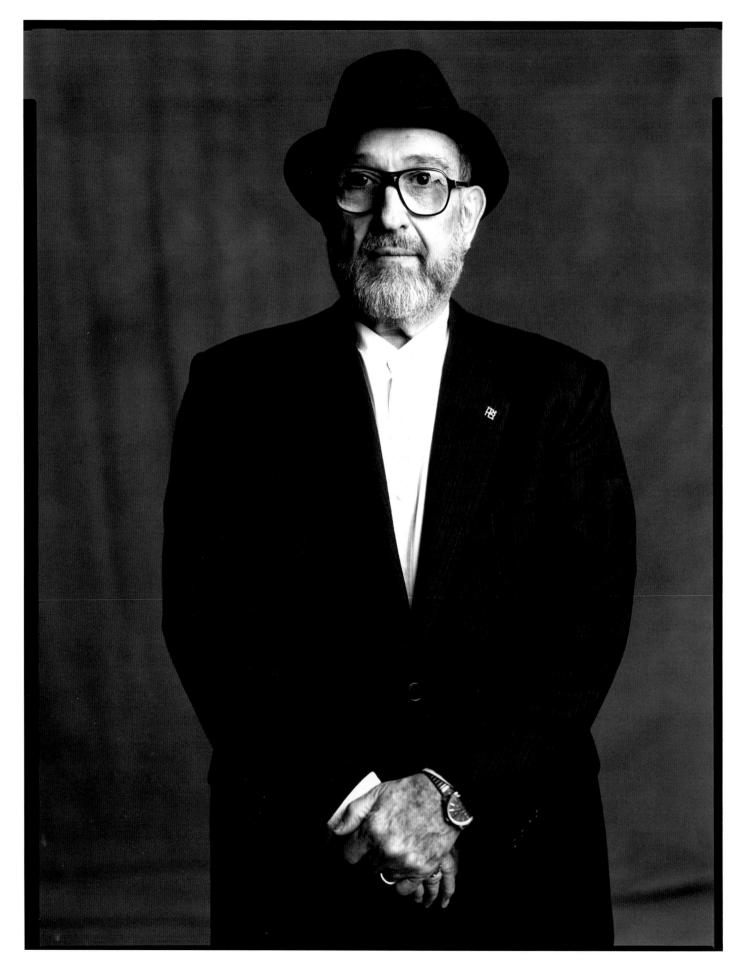

48

Arturo Schwarz, art historian, 1994, black and white contact print, 11 x 14 inches

Timothy Greenfield-Sanders, a Humanist

Arturo Schwarz

There is an event in Timothy Greenfield's biography which, in some way, already points to his philosophy of life which, in turn, will govern his artistic activity. Timothy was twenty-two when he first met Karin Sanders whom he will marry three years later, on June 18, 1977, adding her own name to his. The double name—in a society where married women are usually known only by their husband's name, and in a world as androcentric as our own—reveals an outlook which rejects a hierarchical man-woman relationship and emphasizes, on the contrary, the complementary aspect of the couple's components. At another, and more general level, it also reveals Timothy Greenfield-Sanders's refusal of the authority principle, which, in turn, will condition the choice of his working tools, of his technique, of the ethical, and humanistic background of his work. This individual approach to the problems of his profession will enable him to achieve—with each of his portraits, which are unmistakably his—a personal result, so much so that his images are unique for their aesthetic appeal which finds its source in the artist's profound involvement.

There is another, quite symptomatic, event traceable in Timothy Greenfield-Sanders' response to a question. When asked: "If you would have to choose a photographer from the past, who would it be?," his answer was, unhesitatingly, "Rembrandt," adding then, with a short laugh, "Nadar, Cameron, and then, somewhat later, August Sander, and in the Fifties, Irving Penn"[1]. I have always wondered whether it is more difficult to paint a portrait with colors (which the modern artist now finds readymade in tubes) on canvas, or with light on paper. Frankly speaking, and bearing in mind the surprising technical skill reached today by a diligent art student (one has only to go to the Louvre Museum, for instance, to check how students are able to faithfully copy the world's most well known portraits), I believe it is more difficult to "paint" a portrait with light (even though we have today excellent color films) because light is at one and the same time, an extraordinary medium but is also extremely difficult to really master. But before dwelling on his art, a brief biographical sketch will enable us to better grasp the background in which his activity developed and the main episodes of his most eventful life.

Timothy could not have been born in a more favorable environment. His father was a Harvard educated lawyer whose *violon d'Ingres* happened to be painting, while his first choice was to become an architect. His mother, Ruth, like his father, had studied in Paris, and was a talented pianist who was trained by Nadia Boulanger—who was also the teacher of Leonard Bernstein, Aaron Copland and Arthur Schnabel. As important, Ruth Greenfield had opened in 1951 the first integrated school of music, art, dance, and drama in the deep racist Southern United States. Another meaningful influence was that exerted by his uncle, David Wolkowsky. Timothy Greenfield-Sanders recalls "Uncle David has always been a great friend and patron of the writers who winter in Key West ... I was in my early teens when my brother Charles and I used to take the bus to Key West to fish and hang out. Sometimes we'd end up sharing our catch with Tennessee Williams or Truman Capote at my uncle's house."[2]

In 1970, Timothy Greenfield-Sanders is eighteen and decides to study art history at Columbia

University, he lives at the Experimental College, works in 35 mm and Super-8 film and is interested in experimental film and music. Three years later, another event will prove to be decisive, he meets Karin Sanders whose father, Joop Sanders, had been one of the founders, with ten other artists, of the abstract expressionist group's historic forum, "The Club." In addition to introducing Timothy to the artists of the older generation, Elaine and Willem de Kooning and Milton Resnick, he also presented him to Larry Rivers, Robert Rauschenberg and others of the younger generation, who were also to become among Timothy's first portrait subjects.

I mentioned above that Timothy's approach to the art of portraiture was highly humanistic. It is precisely this quality which he appreciated in Joop Sanders, his future father-in-law, to whom Barnett Newman once said: "Of all the painters who work in Color Field Painting, to me you seem to be the only one who concerns himself with the humanist spirit as I do."[3] This humanistic outlook was responsible for the goal he has aimed at—and succeeded—to attain, namely, to create a *catalogue raisonné* of the contemporary creative minds in all fields it might exercise itself, whether artists, poets, writers, musicians, actresses, actors, porn stars, architects, or art dealers and politicians. He has thus assembled a dazzling gallery of images—over five thousand—which tell tales more about the life and customs of our time than any written chronicle, justifying thus the Chinese saying, an image is worth a thousand words. "Nadar's photographs represent a certain period, they document it. In a hundred-year time I hope that my photos will be viewed similarly. They serve to record and document the world in which I have lived, the art world."[4]

But let us go back to Timothy Greenfield-Sanders's biography where chance had a winning hand. In 1975, aged twenty-three, he was attending the American Film Institute and was asked to photograph the people who came to lecture—which really meant meeting and learning from some of the most inventive directors—Alfred Hitchcock, Ingmar Bergman, François Truffaut, Satyajit Ray, Steven Spielberg, etcetera—and

some of the most talented actresses and actors, among them, Bette Davis, and Henry Fonda. It was Bette Davis, for instance, who gave him the advice never to shoot from below, while Hitchcock revealed to him some of his lighting tricks. During his early years, Timothy had no assistants—he could not afford them—but, more importantly, he also enjoyed doing everything alone. He found filmmaking a collaborative art form while portraiture was a solitary endeavor. "We never make mistakes, we learn" this pragmatic American proverb found a perfect illustration with Timothy who, in addition, benefited from the counsel of some legendary figures. As his career mushroomed he ended up often using ten or fifteen people when confronted with more complex assignments: Thus, in 1998, thirty people collaborated for a *Vanity Fair* photo shoot. "In a funny way I left film because I wanted to do everything by myself," Timothy wrote to me, adding "but success has often forced me to stage huge portrait productions which resemble the scene on a movie set. However, I really try, whenever possible, to keep my portrait sessions small and intimate."

Among the many series Timothy Greenfield-Sanders produced, I would like to single out the ones concerning the Abstract Expressionists (1979–1981); that same year (1979) *Life Magazine* commissioned him to shoot the portrait of Orson Welles and John Huston. The following year *The Soho News* asked him to produce a series dedicated to Emerging Artists (David Hammons, Julian Schnabel, Cindy Sherman were among the ones chosen); the same periodical published, centerfold, his portrait of Orson Welles. In 1980 he will also shoot Aaron Copland, the first of the many composers and musicians he will photograph. He is thirty-four in 1986 when another interesting commission will have him try his hand, and most successfully, in the field of fashion portraits. Rei Kawakubo (whom he will also portray in 1992) of *Comme des Garçons* asks him to photograph his art world friends wearing her clothes. This series will give us the portraits of many of the time's foremost protagonists: John Ashbury, Willem de Kooning, Peter Halley, Hilton Kramer, Joseph Kosuth, Brice Marden, Robert Ryman, Julian Schn-

abel, Mark Strand, Philip Taaffe, among others.

By 1987, his reputation is so well established that, for important assignments, his name is among the first that comes to mind, while laudatory recognitions and personal shows in leading public and private venues are almost yearly events. In the summer of 1987, Leo Castelli, to commemorate the thirtieth anniversary of his gallery, exhibits Timothy Greenfield-Sanders's series *New York Artists of the 50's in the 80's*. The following year Mary Boone exhibits his first photos made with a giant 20 x 24 inch Polaroid camera. His portraits, after 1988, are ever more frequently used by leading periodicals, often for their cover page: *Mirabella* (New York), *The New York Times Magazine*, *The London Times Magazine*, *People* (New York), *Cover Magazine* (New York), *Time Magazine*, portraying Monica Lewinsky (1999) became justly famous. He then joins *Vanity Fair*, and *GQ Magazines* as contributing photographer while in the first year of the third millennium he starts the new digital photo column for *Index Magazine*, "Timothy's Page."

In 1990, *The London Times Magazine* commissions the 20 x 24 inch Polaroid series of British Art Dealers. This is supplemented then by a collaboration with the Anthony d'Offay Gallery who asks him to portray also the leading personalities of the British art world, giving him the opportunity to give us an unforgettable gallery of its preeminent figures, among them, Michael Andrews, Frank Auerbach, Gilbert and George, Damian Hirst, R.B. Kitaj, Richard Long, Bridget Riley, David Sylvester (art historian who authored, among many momentous essays, Magritte's *Catalogue Raisonné*) and Nicholas Serota (then Director of the Tate Gallery).

Authoritative politicians and eminent personalities of the cultural world will gladly pose for him: Hillary Clinton (1994); Jimmy Carter (1995), Madeleine Albright (1996), Václav Havel (1997), Barbara Bush (1997), George Bush (1997), Al Gore (1998), Edward Kennedy (1998), Steven Spielberg (1998), Yves Saint-Laurent (1999). In 1998 he also photographs the participants to Václav Havel White House State Dinner in Washington. In January 2003, Madeleine Albright asks Timothy to photograph her for the cover of her autobiographical

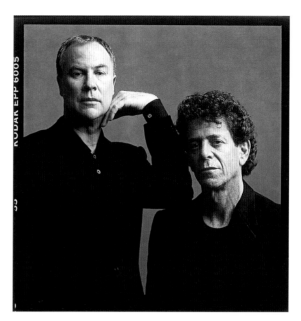

Robert Wilson and *Lou Reed*, artists, 1997, color print from 2¹/₄ x 2¹/₄ inch transparency

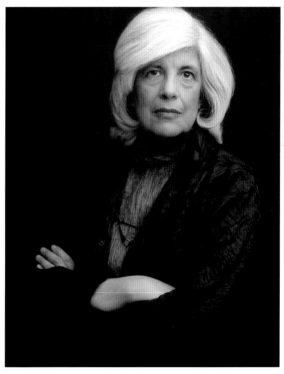

Susan Sontag, writer, 1999, color transparency, 8 x 10 inches

book. And, in the summer of 2004 amidst the bitter political campaign for U.S. President, Timothy Greenfield-Sanders photographs George W. and Laura Bush at the White House in Washington, D.C. and John and Teresa Kerry at their home in Pittsburgh. All of this occurs while he is putting the final touches onto the *XXX* project.

Hardly any of the most meaningful contemporary artists have not been caught by his introspective lens.

In 1997 he starts working on what will become a classic, his film on Lou Reed. Timothy serves as director, producer, cinematographer and conducts thirty-five interviews for the movie. His wife Karin writes the film and is the senior researcher. *Lou Reed: Rock and Roll Heart* wins a Grammy Award for the best music documentary of the year.

The portraits of actresses, actors, porn stars, dancers, composers, musicians, architects, poets and writers, are also among his most striking portraits, revealing as they do, their intimate personality. Paradigmatic of his introspective ability is his very latest endeavor, his dazzling double-portraits of porn stars which "strip them bare" of the scandalous glamour of their profession, and reveal them as they really are: endowed with the weaknesses, strength, and dignity of a simple human and humane being.

And the same may be said for the art dealers, collectors, curators and critics who have not escaped this impressive gotha of our times.

I believe it is time, by now, to dwell on Timothy Greenfield-Sanders's instruments, technique, and poetics which all contribute to make each of his portraits, a unique existential experience both for the artist and his model. When I think about Timothy Greenfield-Sanders's choice of his working instruments, and of his idea of what should be the role of a photographer, two reflections of Man Ray come to my mind: "A certain amount of contempt for the material employed to express an idea is indispensable to the pure realization of this idea."[5] He also added: "Books and magazines are full of advertisements for cameras—it's a racket … What matters is the idea, not the camera."[6] Thinking about Timothy Greenfield-Sanders's vision of

his art, I remembered another Man Ray statement, "After all photography is not restricted to the mere role of a copyist. It is a marvelous explorer of aspects that our retina will not register."[7]

I suspect that when, in 1978, Timothy Greenfield-Sanders purchased from a friend, for a few dollars, an antiquated 1905 Fulmer & Schwing 11 x 14 inch view camera—he had in mind Man Ray's opinion, that what is of importance is not the instrument but who handles it. He was attracted to this museum piece by its historic aura and certainly not by its performance, obviously modern cameras are much better equipped, require a shorter pause-time, and have a deeper focal range, so much so that he had to change its unusable original lenses (he found the right one in a Hollywood old camera junk store) and had to adapt a new, his own, handmade shutter-switch to reduce the exposure time to one thirtieth of a second. The great advantage of this camera was, however, that he was able to obtain contact prints without having to enlarge the negative. Before having this camera he had used a classic Nikormat 35 mm, to which he later added a Nikon F2. Occasionally he used a Hasselblad when he needed a sharper focus (as was the case for Clemente's portrait). Later, in 1988, as he became increasingly interested in color photography, he began renting a giant and cumbersome 20 x 24 inch color Polaroid camera which he had first experimented with in the course of a three-day "artist's grant" provided by Polaroid.

Greenfield-Sanders revealed the very essence of his ambition when, he stated "I try to show people the way they see themselves. No gimmicks. I'm a minimalist. A basic camera, basic lights, let the person come out … I'm aware of how to make a person comfortable in front of a camera … I tend to let people do what they want to do."[8] These intentions entailed, in the first place, to make the sitter feel at home, as comfortable and relaxed as possible, thus the sittings usually started with a cup of coffee sipped in the kitchen of his East Village studio. The lighting apparatus is also the simplest so as not to distract or embarrass the model: It usually consists of a single upper right light. The background is equally minimal. The sitter is instructed not to force him-

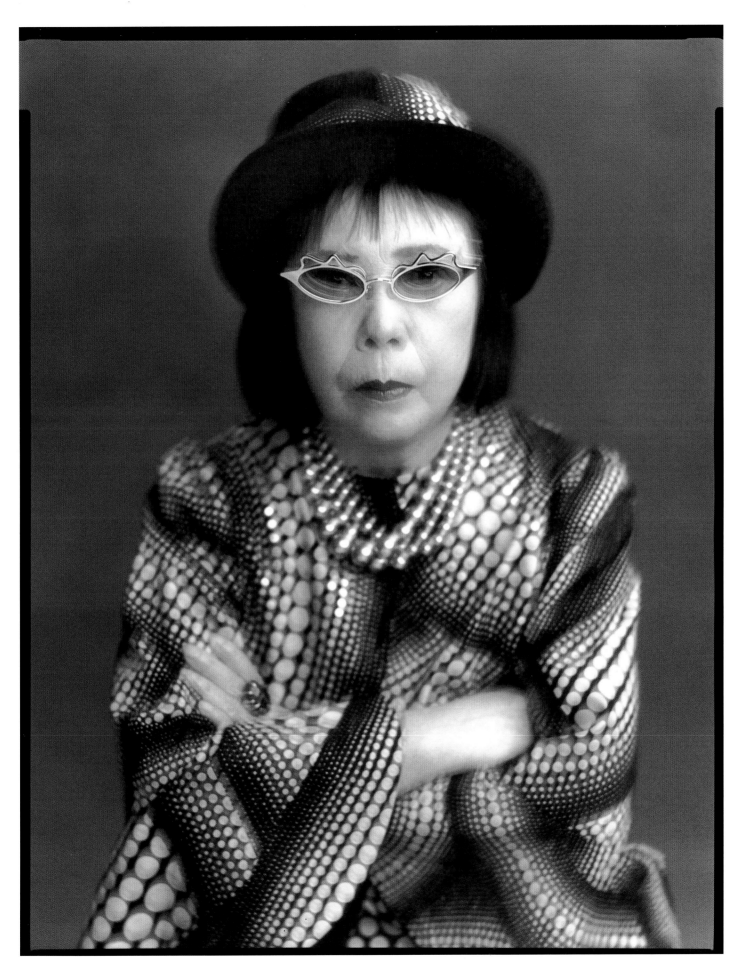

Yayoi Kusama, artist, 2002, black and white contact print, 11 x 14 inches

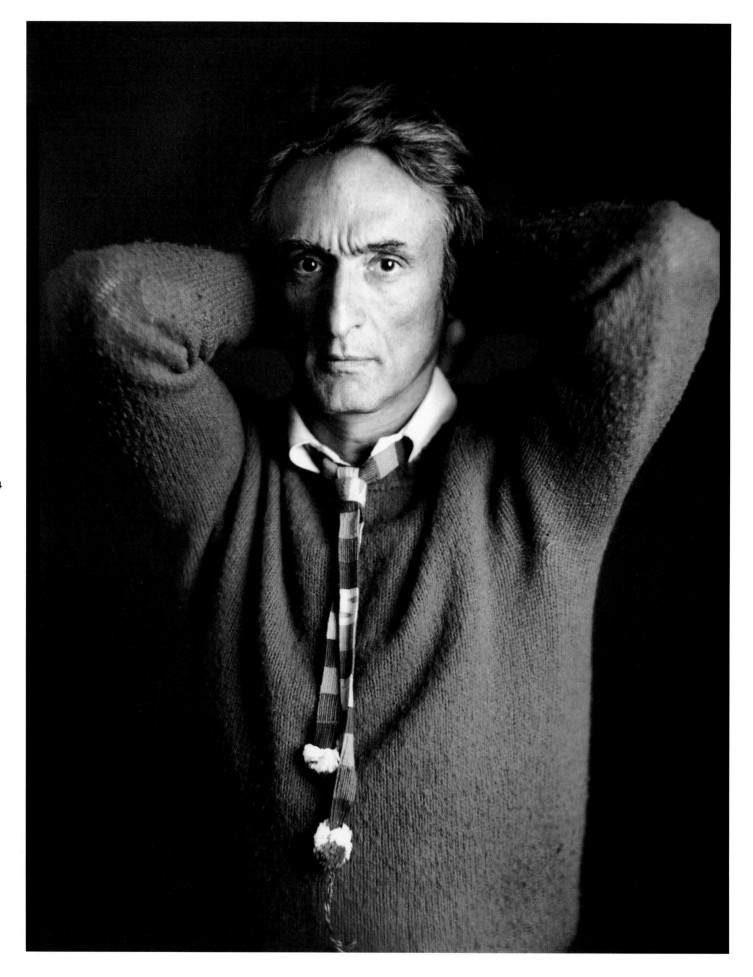

54

Larry Rivers, artist, 1981, black and white contact print, 11 x 14 inches

self to smile, to be as natural and spontaneous as possible, to avoid self-dramatization, in a word, to *become* himself, to give free reign to the expression of his own, deeper personality. Wayne Koestenbaum pointedly noted that the artist "wants his subjects to relax their faces … to leave the bones and flesh at liberty to speak their unpremeditated complexity … [they must] empty their minds of every thought but the prospect of their own immortality."[9] It comes as no surprise therefore that in all his portraits what is in sharper focus are the sitter's eyes, eyes being—as the popular saying goes—the mirror of the [immortal] soul.

Given these premises, and following these hints, making a portrait might sound easy, but knowing the alphabet does not transform oneself into another Shakespeare. As mentioned at the start, what counts is the person behind the camera. Let us dwell, to conclude, on what makes his work a unique chronicle of our time. I believe that the main reason is that his portraits succeed in being "images of great psychological power"[10]; thus it is clear that Greenfield-Sanders' attention is drawn to the psychological rather than to the physical traits of his models. He has the rare gift of being able to decipher and understand their inner personality just by reading the light in the eyes and translate the signs left by life on the sitter's face.

Sanskrit poetics have familiarized us with the notion that we cannot faithfully mirror one's model unless we identify with it. And Plotinus underscored that "the eye would never see the sun if it did not already contain the sun[11]; remarking, furthermore: "All can see the beauty of things but not all are equally stimulated: He who perceives it better loves with a true love."[12] Thus, Timothy Greenfield-Sanders's extraordinary perception of the visible derives from his humanistic ideological background which commands a total involvement with the person who wishes to be portrayed. And so urgent is this participation—which borders with complicity—that he is able to capture both the sitter's inner turmoil as well as his "invisible harmony [which] is greater than the visible."[13] The seventeenth-century theosophist Jacob Böhme assert-

ed: "The outward visible world [here the sitter's face, *N.o.A.*] is an image of the inward spiritual world … whatever is internally has its character externally."[14] An artifact is bound to be a creative response and a reflection (in both senses, optical and mental) of an outer reality. The Greek *aletheia*, generally translated as "truth," rather means to "unveil" (*a-letheia*: un-veil). And this is what Timothy Greenfield-Sanders brilliantly achieves with each of his portraits which give us a glimpse of eternity, as well as of the truthful inner reality of the person facing his mind and his lens.

First published in Arturo Schwarz, *Timothy Greenfield-Sanders. Portrait photographs*. Exhibition catalog. Tel Aviv: Tel Aviv Museum of Art, 2005.

[1] Demetrio Paparoni, ed., *Timothy Greenfield-Sanders*. Milano: Alberico Cetti Serbelloni Editore, 2001, p. 194.

[2] Ibidem, p. 19.

[3] Lawrence Campbell, "Barnett Newman to Joop Sanders," *Joop Sanders at Alfred Kren*, "Art in America", May 1987.

[4] Demetrio Paparoni, ed., *Timothy…* cit., pp. 194–195.

[5] Man Ray, "The Age of Light," *Man Ray Photographs 1920–1934*. New York: Random House; Paris: Cahiers d'Art, 1934, u.p.

[6] Arturo Schwarz, *Man Ray. The Rigor of Imagination*. New York: Rizzoli International; London: Thames and Hudson, 1977, p. 230.

[7] Man Ray, *Apparences Trompeuses in Man Ray's Scrapbook*. 1926, quoted in Arturo Schwarz, *Man Ray…* cit., p. 228.

[8] Lou Reed, "Portrait Artist," *Surface* (San Francisco), No 19, Fall, 1999, reprinted in Demetrio Paparoni, ed., *Timothy…* cit., pp. 205–208.

[9] Wayne Koestenbaum, "Art's Hard Face," *Art World: Timothy Greenfield-Sanders*, New York: Fotofolio, 1999; reprinted in Demetrio Paparoni, ed., *Timothy…* cit., pp. 212–216, p. 213.

[10] Peter Halley, "Timothy Greenfield-Sanders," Peter Halley, ed., *Timothy Greenfield-Sanders, Selected Portraits 1985–1995*. Exhibition catalog. Köln: Kunst-Station Sankt Peter; Italian translation in *Tema Celeste International*, No 61, March-April 1997, pp. 47–49, reprinted in Demetrio Paparoni, ed., *Timothy…* cit., pp. 190–192.

[11] *Enneads* V:8. *The Essential Plotinus. Representative Treatises from the Enneads*. Selected and translated by Olmer O'Brien, New York: Mentor Books, 1964. The text quoted here, was translated by the author from the original Latin, it differs slightly from O'Brien's version.

[12] Ibidem, I, 6:4.

[13] Heraclitus, [Diels 41], *The Cosmic Fragments*. Edited by Geoffrey Stephen Kirk. Cambridge: Cambridge University Press, 1954[1], 1962[2].

[14] Jacob Böhme, *De Segnatura rerum. Von der Geburt und Bezeichnung aller Wesen*, 1621. Translated as *The Signature of All Things*. Cambridge and London: James Clark and Co. Ltd., 1969, p. 91. The text quoted here, was translated by the author from the original Latin, it varies slightly from Clark's version.

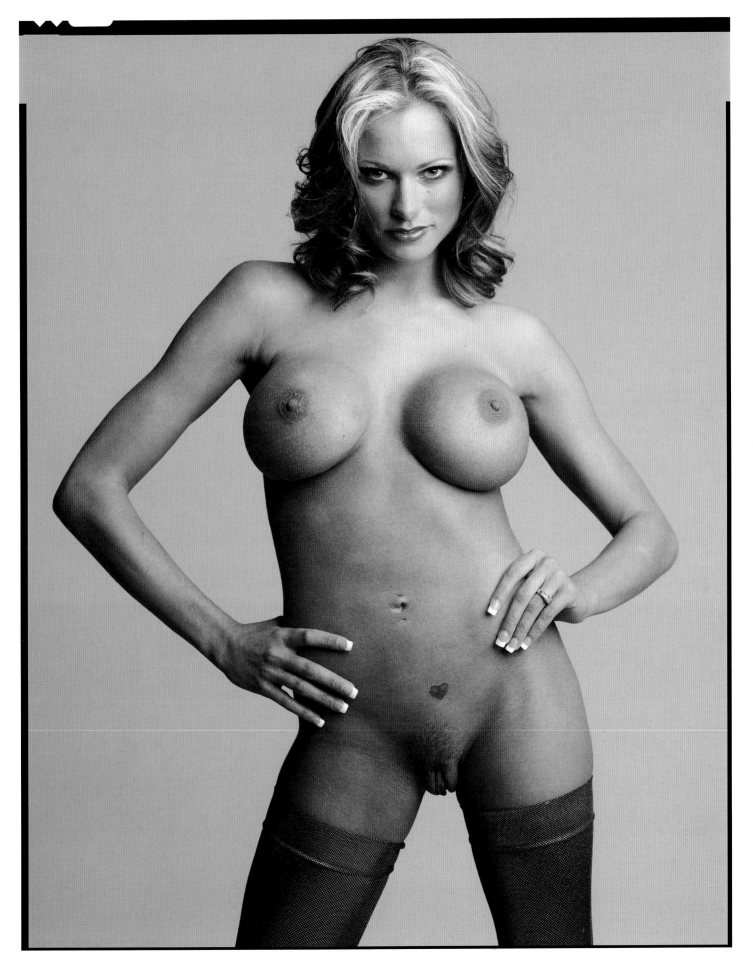

Briana Banks, porn star, 2004, archival digital print, 58 x 88 inches each print (diptych)

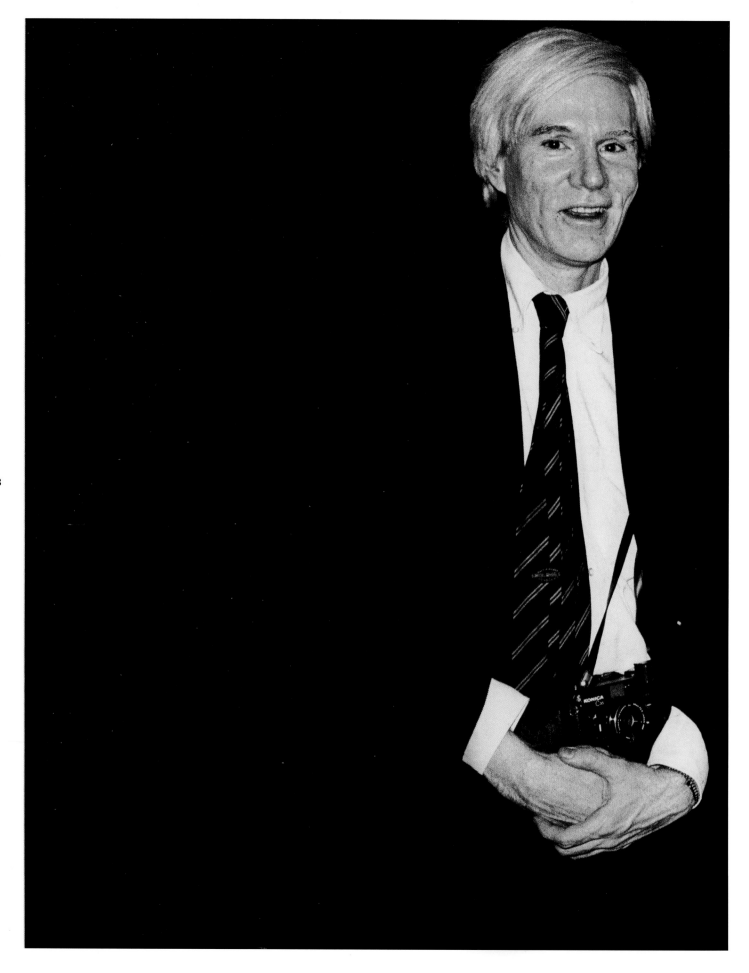

Andy Warhol, 1977, black and white print from 35 mm negative

Truth and Illusion Are the Same

Timothy Greenfield-Sanders and Ida Parlavecchio

Ida Parlavecchio *Your work was made in the context of New York in the Eighties and Nineties. In what way have the dynamics of this scene influenced you? What I mean to say is, would things have been different if you had remained in Miami where you were born, or had stayed in Los Angeles where you studied at the American Film Institute?*

Timothy Greenfield-Sanders In many ways New York has been the center of the art world for the last twenty-five years. One could argue that New York has been the center of the world for the last twenty-five years. Certainly other cities are influential but New York continues to be a powerful creative force in the arts, humanities, fashion, finance, politics and music ... to name just a few. Could I have shot in Miami or Los Angeles the portraits that have made me so well known? I highly doubt it. Clearly being from New York, exhibiting here, being a part of the scene here, adds to my work.

IP *Your subjects are almost always heroes of our times, successful or at least talented men and women, people who can assume important roles. Evidently you believe that in our times people are to be valued for what they do. Does photographing people and planning a pantheon of contemporary fame coincide with an idea that history is made by individuals rather than by the masses? Don't you think that history is also made by people who will never be photographed because they are happy to live in the shade, but that even so they might have a determining role?*

TG-S I am not an historian and can't accurately answer this, but my personal opinion is no.

There are very few "behind the scenes" figure who influence culture.

IP *Italian critics have held that your work has a humanistic attitude that is shown by placing people and their relationships with society at the centre of collective experience (Paparoni, Schwarz). Schwarz in particular, in his catalog for your show in Tel Aviv, has said that every portrait by you gives a flash of eternity, the genuine interior truth of the person you have in front of your camera. This way of considering your work seems to be completely different from that of American criticism. Why do you think there is this difference in interpretation?*

TG-S In general, European critics are more inclined to see the importance of a humanistic attitude. I always find it fascinating what American critics see as important in a work as opposed to what a European sensibility would focus on. Demetrio Paparoni's great essay on my work in the Timothy Greenfield-Sanders' monograph was so much from a European perspective.

IP *You photographed both people from cinema and theater. What difference do you find between these two languages? Performance introduced theatrical elements in art and the video has contaminated with the cinema. Do you think that the cinema should be considered a more modern language than theater? And I don't mean it because theater is older, of course ...*

TG-S It used to be that movie actors were considered "serious" if they retained a connection to the theater. "Going Hollywood" was a put down for an actor who left the "theater" (New York) for "film" (Los Angeles). East Coast was intellectual and West Coast was a sellout for

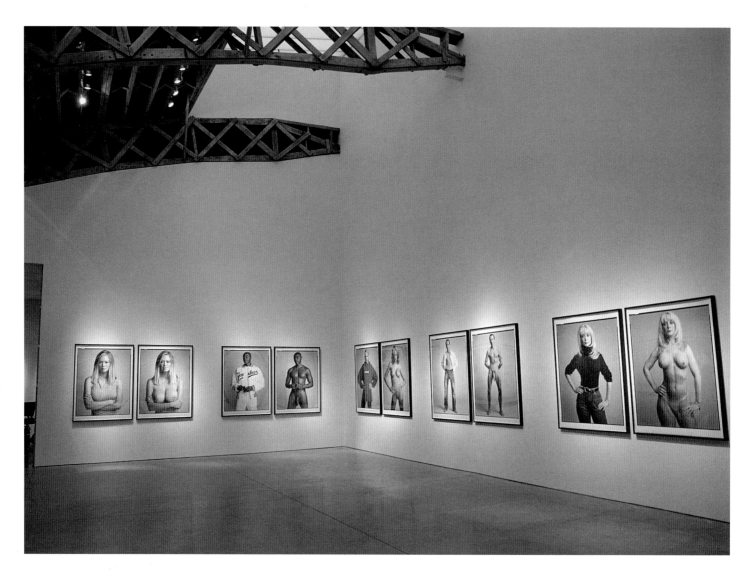

Mary Boone Gallery, installation of *XXX: 30 Porn-Star Portraits*, 2004

money. And to some extent this is still true. Hollywood stars perform on Broadway in plays because it gives them the appearance of being intellectual and shows that they care about their "craft."

I doubt that most actors are aware of performance art or of people like Karen Finley. I don't think there is a lot of influence from the art world in that way. What I do think however is that cinema has replaced the study of language itself. People study film now the way they used to study English literature. Film is the language of the new century.

IP *The subject of your latest series of works is thirty well-known American porn stars who you have portrayed both naked and dressed. Each portrait is shown twice and, if it weren't for the fact that nudity is juxtaposed with the clothed model, the two photos would seem identical. This is the first time you use the diptych form. What made you choose this comparison of individuals with themselves?*

TG-S The concept for the diptych came about mostly by accident. I originally imagined the porn star series as clothed portraits. I thought that seeing porn stars clothed was a more radical idea. One is accustomed to seeing porn stars nude so I thought that clothed images would be more interesting, more challenging, more unexpected. But when I met my first porn star he insisted on being photographed nude. I didn't really know how to pose him so I came up with the idea of shooting him in the same position as the clothed shot. Of course it was a nod to Goya and his *Maja Vestida / Maja Desnuda* paintings. But the next day when I viewed the developed film I instantly understood how powerful the diptych would be for this series. It just felt right.

IP *In this way you have confronted pornography with the same rigor that you reserve for more serious arguments. From the proud composure of these subjects we see that you give them the same dignity that you confer on artists, politicians, and theater and film actors. Or am I mistaken?*

TG-S No, you are correct. I absolutely made a point of treating the porn stars as kindly as I would the President of the United States ... and in the case of the current President, probably with even more respect. But don't get me started on that! I always want my subjects to feel special, to feel that I care about them and how they will look in the portrait. My interest in them, my "humanistic" approach, tends to show up in the photographs themselves. I suppose with someone like the current President, whom I photographed last summer, it was much harder for me to show that "interest" than with the porn stars. But I was a guest in his house, the White House, and I had to act like a guest ... so I did.

IP *So you wanted to place these* VIPs *of pornography on the same level as well-known celebrities in the field of culture or politics?*

TG-S Sure, why not? They are the top people in their profession. I found their drive, their intelligence, their charm to be on par with many of the other major figures that I have photographed over the years.

IP *But when you photograph actors, athletes or rock stars you never juxtapose an image of them in their work clothes and another of them dressed more formally.*

TG-S The *XXX* series is a departure for me in the sense that these are diptyches but the attention is to be focused mostly on the heroic quality that I find in all my subjects, be they porn stars or politicians or artists or actors. This is a constant within my body of work. I am always hoping to portray people the way they would like to see themselves ... at their best. That look in the mirror we all know when you turn a certain way and say, "I don't look so bad today ...". As for clothes, I have never been too concerned with them, other than that clothes can be distracting or even annoying in a portrait. I want the viewer to look at the face, the eyes, the expression, not at the Versace dress. if I could dress my subjects in Jil Sander or Armani I would do that so that the clothes become neutral, not dominant.

IP *The cover photo of XXX, the book containing your recent photos of porn stars, reminds me of advertising or fashion images, but also of a Raphael Madonna. Does the fact*

that there is no contradiction between one inter-pretation and another make you a post-modern photographer?

TG-S The cover image of Jenna Jameson is an extremely complicated portrait because Jenna has one of the most amazing personalities in front of the camera. She has a face that says many things to many different people. It's quite weird in a way and rare as well. I've found this quality in only a few other subjects … a face that loves and is loved by the camera and is at the same time interactive with the viewer. Jodie Foster and Cindy Sherman have it … this myste-rious quality.

IP *In Raphael's portraits there is an explicit relationship between being and existing. Is this also so in your portraits? I would like to know if you confront yourself with some painter of the past in particular.*

TG-S I once replied to Demetrio Paparoni, in answer to the question who was my favorite photographer, Rembrandt. I meant it only partial-ly as a joke. Rembrandt's intensity, his use of light, his power to convey a sense of the person … all things that I hope might come out in a por-trait. Of course Irving Penn is a great artist whom I admire enormously. His simplicity is wonderful as is the dignity he brings out in his subjects. Nadar, Richard Avedon, Julia Margaret Cameron, August Sander … Andy Warhol of course. Andy Warhol was a huge influence on my work and my life for that matter … in particu-lar his *Screen Tests*. They were brilliant. The idea was to put the subject in front of the camera and make him simply stare into the lens for three minutes without any direction. That concept is always in the back of my mind.

IP *What are you saying is curious. Not only you leave the subject in front of the camera, but—quite the opposite—you pamper it. Your presence is similar to the presence of a psychia-trist who has to be able to put the patient at ease. Don't you feel like a theatrical director who determines the posture?*

TG-S When I started out as a photographer, I was much more true to the Warhol concept of just leaving the subject alone and then seeing

what will happen. But the more I learned about taking a portrait the more I subtlety manipulate the situation. I am very delicate in my intru-sions, but I do a lot more of them than the sub-ject realizes.

IP *What is your relation with theater? There has been some text or theatrical realization that influenced your work?*

TG-S Not really. Despite living in New York where there is often great theater, I really don't see too much of it. I love certain classic plays like *Who's Afraid of Virginia Woolf* (which I saw recently with Kathleen Turner as Martha and she was brilliant by the way) … or *Street Car Named Desire*, Tennessee Williams' masterpiece. But in reality I'm one of those people who only remem-bers how much he loves the theater when he is there watching it from the audience. Getting me there is difficult. I just have too many other interests.

IP *A photo of a porn diva inevitably evokes the idea of the body as an instrument for work based on sex, and of sex as a means for becom-ing notorious. It isn't by chance that each of them is a celebrity in their own field. What does seem strange in these portraits is that porn stars are in* working clothes *when they are nude. Quite the reverse of the case of the rest of us. Do you think that, with respect to any other pro-fession, porn stars have inverted the relationship between their public face and their private one?*

TG-S Sure, that is true. And that was why I wanted to shoot them with their clothes on in the beginning. But the diptych became the per-fect venue for reinforcing this perception as well as showing their power and control when nude. It's really extraordinary … the role reversal.

IP *Was it this that led you to photograph them twice and then place them together sym-metrically with obvious allusions to Goya's* Majas *painted twice in the same pose, once dressed and then nude?*

TG-S It wasn't totally conscious. As I said before, I started out wanting to shoot the porn stars with their clothes on, but they wanted to pose nude. I didn't know how to pose them so I thought the same pose, an homage to Goya,

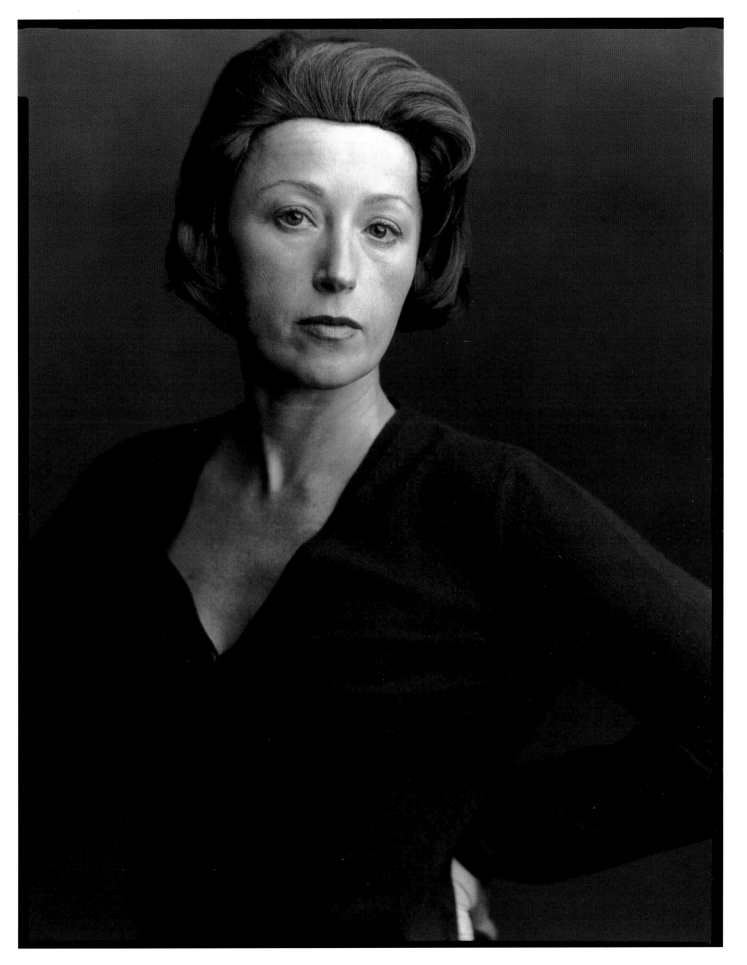

Cindy Sherman, artist, 2002, black and white contact print, 11 x 14 inches

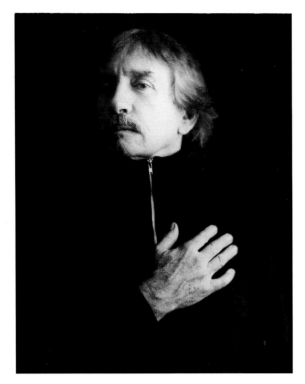

Edward Albee, writer, 1987, black and white contact print,
11 x 14 inches

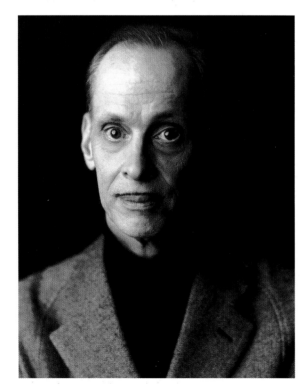

John Waters, filmmaker, 2004, black and white contact print,
11 x 14 inches

would be amusing ... until I had a better idea of how to pose people nude. But when I viewed the films the following day, the diptych was clearly the way to go with this series. It was just obvious ... staring me in the face. My experience is not with the body but with the power within a person. That comes through in the nudes, don't you think?

IP *Sure. Why did you print these subjects life-size? You have never done this before. And you've also used color, though it isn't the first time. The visual impact of your show of the porn stars at Mary Boone was quite different from your previous show which made me think of a kind of black and white cataloguing of the art world.*

TG-S These portraits screamed out to be *big*. In addition I was not locked into my large format contact print ... the 11 x 14 inch negative in black and white that I had been shooting for twenty-five years. Those images, the 11 x 14 inch negatives were always printed one to one on the photographic paper as a contact print. In this case, instead, I was planning to shoot in color, in 8 x 10 inches, with the intension of blowing the images up after scanning them. I knew that I could print them as large as I wanted. I will never forget seeing the first prints ... 58 x 88 inches each. They were just magnificent. I just love these prints. They are amazing. Gabe Greenberg in New York did a brilliant job of printing them on an Epson printer. All archival of course. But the size is heroic. These images deserve the size. Sometimes photographers blow up photos to big sizes for no good reason ... just because they can. But the porn stars deserved to be big.

IP *Why are you saying that?*

TG-S As the porn star Nina Hartley says in my film *Thinking XXX*: "Porn is like a cartoon character, everything is exaggerated ... big hair, big breasts, big penises, big, big, big." It seemed perfectly natural and appropriate to have very big prints for this particular work.

IP *We are continually bombarded with messages about sex, from advertising to political news. Your portrait of Monica Lewinsky tell us a lot about this. It can't be denied that sex is*

everywhere, and not only in porn films. Your choice of turning your camera on some of the best known people in the world of pornography seems motivated by your interest in anyone who has talent. What I mean to say is that apparently these photos seem directly linked to the hardcore images we find in many Internet sites or in specialized magazines, but in fact they are quite unlike any form of pornographic imagery. It is as though you have, with some margin of sympathy, given back humanity to a world which is usually considered a sub-culture or, at most, is considered dehumanizing.

TG-S You're right, Ida. I wanted the humanity to come through. I don't think these photos are particularly erotic. They are more about the person standing there staring back at you with dignity and strength.

IP *I read that the idea of this series of photos came to you when you heard of the death of Linda Lovelace, the famous star of Deep Throat. She was only fifty. Was it a sense of loss that led you to give eternity to these hardcore talents? Did you want them to be fixed for ever in an image? But then isn't their image already fixed in their professional videos? Why do you think that isn't enough in itself to keep their memory alive?*

TG-S I had been thinking about the porn star series for a number of years and had only shot a few of the images. I was stuck and unable to move forward with the work. When Linda Lovelace died, I realized that I'd better get moving on this series if I was going to do it at all. Here I had just lost one of the most famous porn stars of all time and felt that it could happen to another. So I picked up the phone and got started. On a more personal level, I had also been quite depressed about the world in general. The insane war in Iraq, the Bush administration's use of the war to manipulate the American public … so many things were going wrong in the States. I suppose shooting porn stars was a way to get my mind out of the gutter of politics and back to art where it belonged!

IP *My impression is that your objective gaze at these porn stars ends up by laying them bare*

in a far more meaningful way than do their directors and agents. Many of the subjects you photographed betray, through almost imperceptible changes of expression, a certain embarrassment at being photographed in their everyday clothes, and yet their poses seem proud. But at the same time their nonchalance is mixed with a veil of perplexity, and this makes them vulnerable. Do you agree with my sensation?

TG-S Yes. I think the porn stars brought so much of themselves to these shoots and were extremely open to me and my camera. I am still surprised by the power of these images. One would expect the nudity to get in the way but it quickly becomes incidental.

IP *Whenever we think of the nude in photography, Mapplethorpe comes to mind. Do you think it is an exaggeration?*

TG-S No. I don't think there is really much of a connection between this work and Robert's. His nudes were much more classical and formal than mine. I always found Mapplethorpe's photographs to be very geometric. He also was concerned with the sculptural qualities of the body and with perfection. I'm much more interested in the person, in his or her human strengths and weaknesses. We are really very different in our approach to portraiture.

IP *We understand art through comparisons, by comparing the works of different artists and analyzing the differences and the points of contact. I would like you to talk about your portraits in relation to those of Nan Goldin, Cindy Sherman, and Sherrie Levine. I am not referring to them in particular because they are women like me, but because they represent, in a significant way, three different ways of relating to the subject they photograph.*

Let's start with Nan Goldin. Her photos are avowedly autobiographical and highly emotive, something emphasized by the color saturation and the blatant use of artificial lighting. Her settings are places where life is experienced, in the sense that they are scenarios for private dramas. She leaves nothing out, from the traces left of relationships between people and the things that surround them. You instead do not try to capture

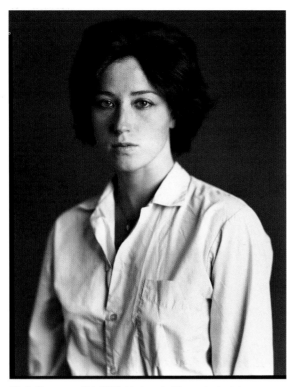

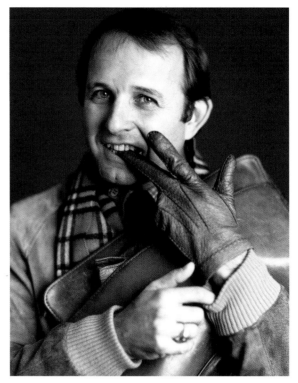

Cindy Sherman, artist, 1980, black and white contact print, 11 x 14 inches

Robert Pincus-Witten, art historian, 1981, black and white contact print, 11 x 14 inches

the narrative dynamics of what happens around you: You photograph in the studio against a monochrome backdrop, almost always the same, and using just one lamp so as to obtain an effect similar to natural light. Why have you excluded narration and reportage from your work?

TG-S I find that for me, narration and reportage are distracting. I want the viewer to focus on the face. In the *XXX* series, more than just the face of course, but still the person, not the surroundings. I love Nan's work. She is a brilliant artist and I admire her enormously but we have nothing in common visually, other than the fact that she manages to bring out the humanity of her subjects … so we have that in common. We just do it in different ways.

IP *Let's move on to Cindy Sherman. She builds her scenes and photographs herself. You have photographed her. How did she react compared to other artists you have had in front of your camera?*

TG-S Well, as I mentioned earlier, Cindy Sherman is one of the greatest faces I have ever photographed. The camera truly loves her. It is a great delight to shoot her. It's so easy. I could shoot her with my eyes closed and the photographs would be perfect. She brings more to the photo than almost anyone I know.

IP *I enjoy Cindy Sherman's work because she imbues her scenes with a sense of their being a place for simulation. She photographs herself as though in a game of infinite mirroring in which she is both the director and the protagonist. Her sharp recreation of the elements of the photographic set defines, with all the precision of a Flemish painting, an apocalyptic vision of the postmodern age. Have you ever been tempted to construct an artificial scene? What has led you to make such different choices from those of Sherman?*

TG-S I have never thought of shooting the way that Cindy shoots. It's just not me. So much of what I do is about the relationship I establish

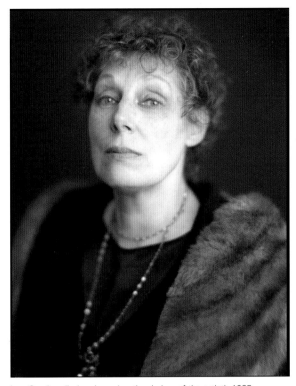

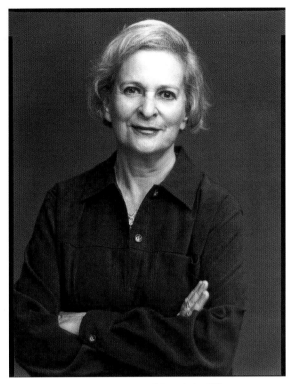

Isca Sanders, lieder singer (mother-in-law of the artist), 1985, black and white contact print, 11 x 14 inches

Ruth Greenfield, musician (mother of the artist), 1999, black and white contact print, 11 x 14 inches

with my subject. I do this quickly and often without the subject quite realizing what I am up to. My method involves creating a psychologically conducive mood for the photo session itself. I strive to make my subjects feel at ease in what is really a very artificial moment ... a photo session.

IP *And now let's talk about Sherrie Levine. Like Cindy Sherman she also places the relationship between the original and the copy at the center of her work. By reutilizing images by other people she puts into doubt the authenticity of the work and raises questions about its autonomy. In this way she investigates the principle of truth in the work of art. Your work tends not to interpret the subject which is shown for what it is. Is this the equivalent of showing the truth? What, for you, are* truth *and* falsity?

TG-S As Edward Albee's marvelous character Martha says in *Who's Afraid of Virginia Woolf* ... "truth and illusion George ... don't you know the difference yet? Well, just maybe, Truth and Illusion are the same."

Louise Bourgeois, artist, 1980, black and white contact print, 11 x 14 inches

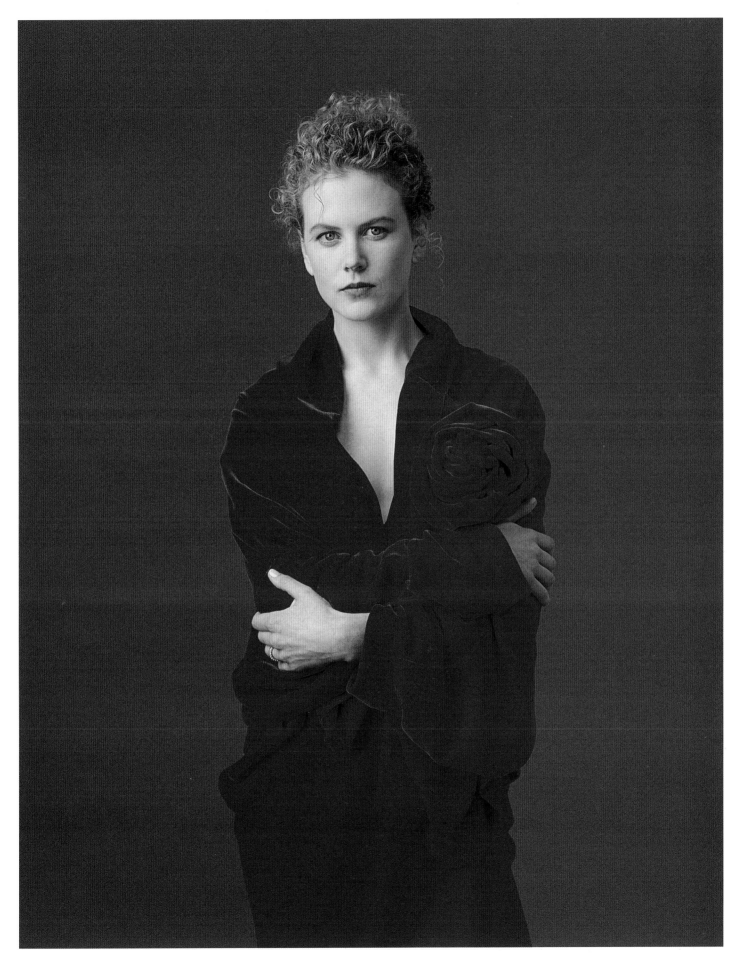

Nicole Kidman, actress, 1991, color transparency, 2¹/₄ x 2¹/₄ inches

Constance Baker Motley, judge, 2004, color transparency, 8 x 10 inches

Sayoko Yamaguchi, artist / model, 2000, color Polaroid, 20 x 24 inches

72

J.T. Leroy, writer, 2003, color transparency, 8 x 10 inches

Salman Rushdie, writer, 2005, color transparency, 8 x 10 inches

Robert de Niro, artist, 1981, black and white contact print, 11 x 14 inches

Thelma Goldin, museum director, 2002, black and white contact print, 11 x 14 inches

Ann Hamilton, artist, 1991, black and white contact print, 11 x 14 inches

Gary Indiana, writer, 2005, color transparency, 8 x 10 inches

Sarah Ferguson, British royalty, 2005, color print, 11 x 14 inches

Sean "Puffy" Combs, entrepreneur, 2005, color print, 11 x 14 inches

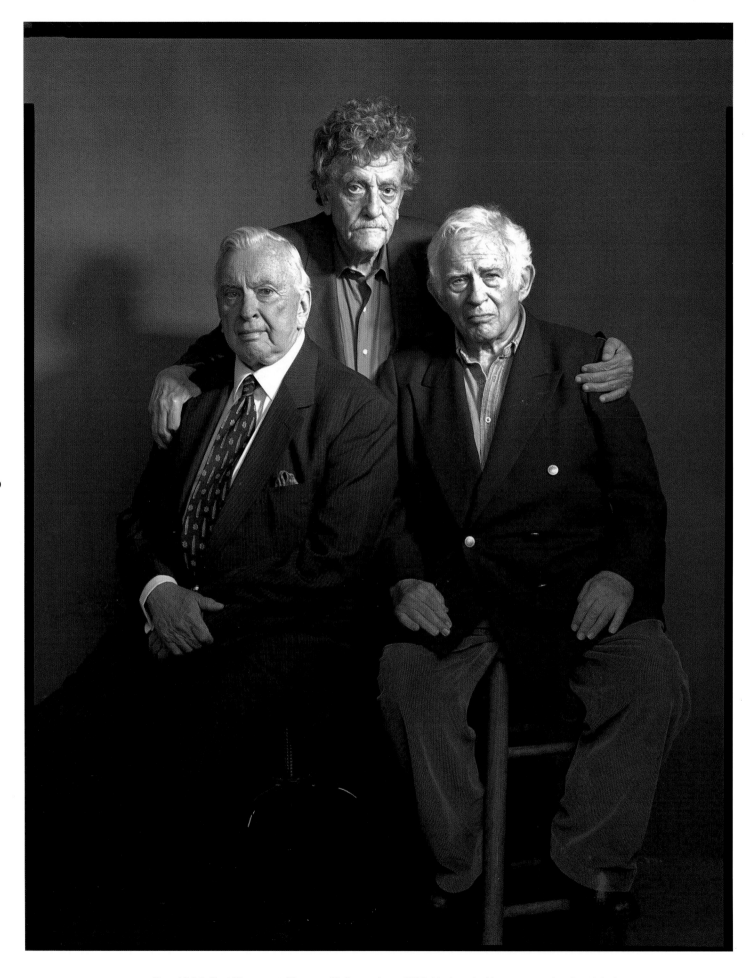

Gore Vidal, **Kurt Vonnegut**, **Norman Mailer**, writers, 2003, black and white contact print, 8 x 10 inches

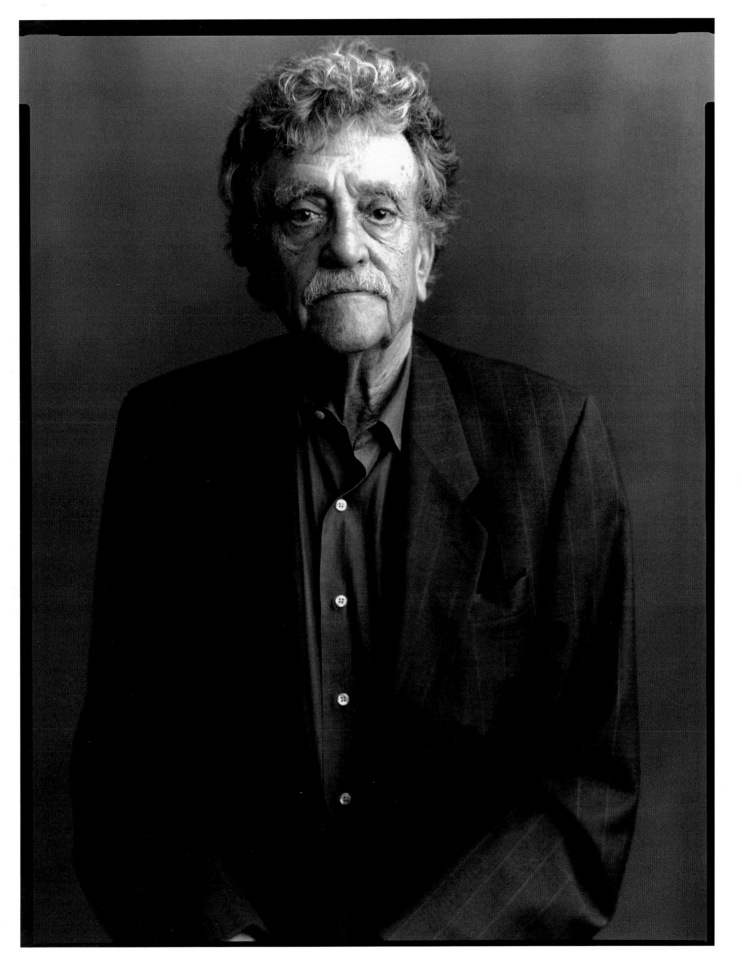

Kurt Vonnegut, writer, 2003, black and white contact print, 8 x 10 inches

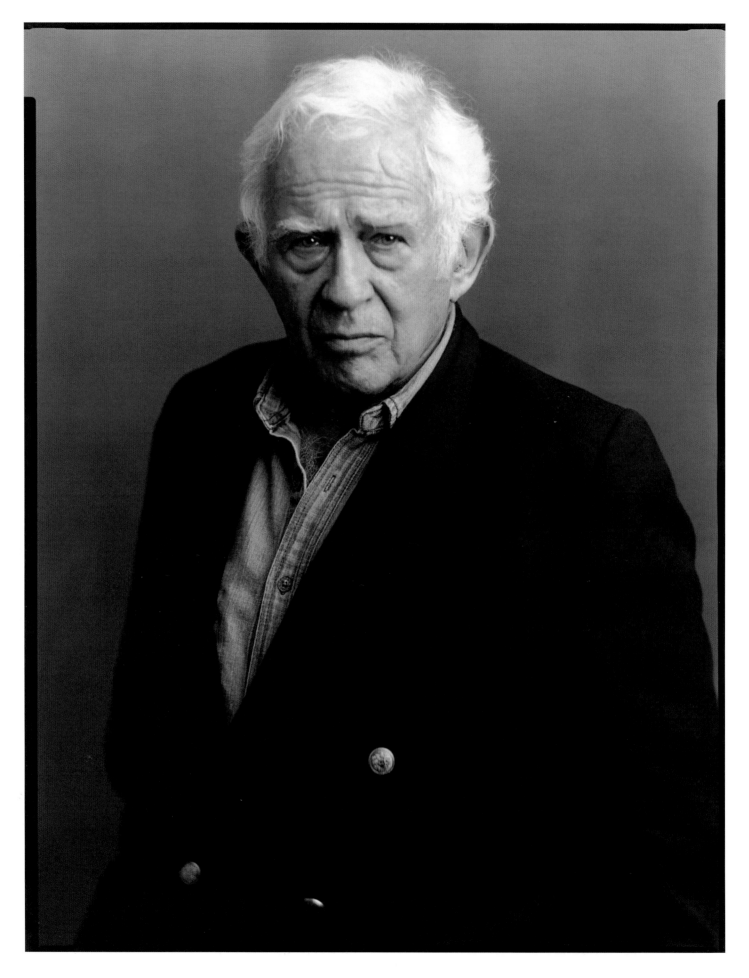

Norman Mailer, writer, 2003, black and white contact print, 8 x 10 inches

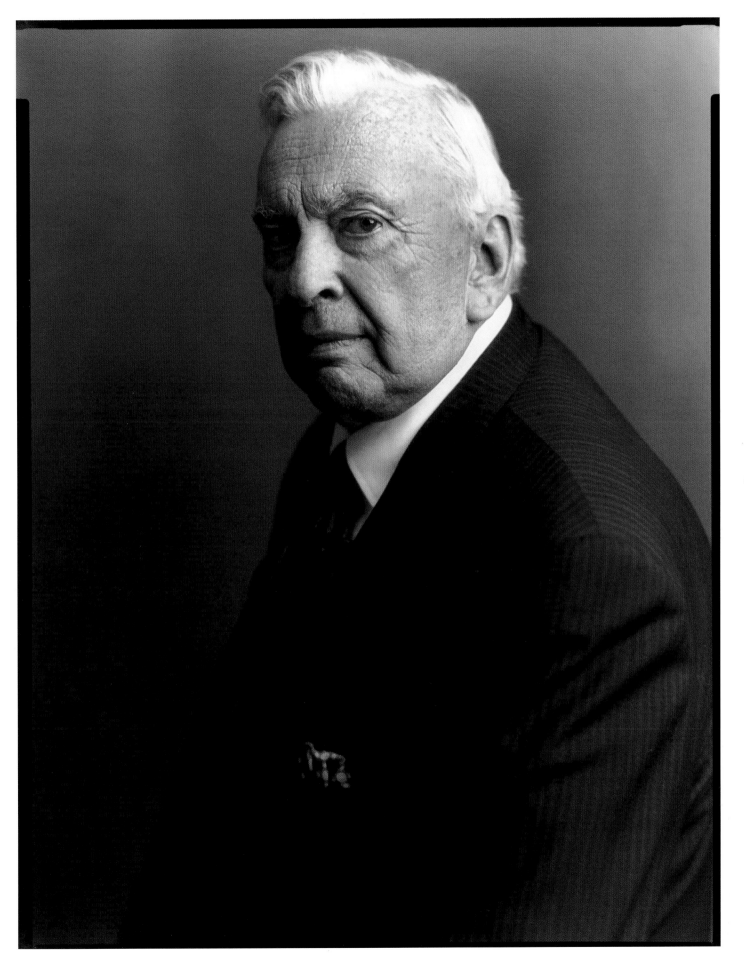

Gore Vidal, writer, 2003, black and white contact print, 8 x 10 inches

William Wegman, artist, 1988, color Polaroid, 20 x 24 inches

Richard Hamilton, artist, 1990, color Polaroid, 20 x 24 inches

Elaine de Kooning, artist, 1980, black and white contact print, 11 x 14 inches

Willem de Kooning, artist, 1986, black and white contact print, 11 x 14 inches

Robert Rauschenberg, artist, 1992, color Polaroid, 20 x 24 inches

Roy Lichtenstein, artist, 1992, color Polaroid, 20 x 24 inches

Chuck Close, artist, 1992, color Polaroid, 20 x 24 inches

Bridget Riley, artist, 1992, color Polaroid, 20 x 24 inches

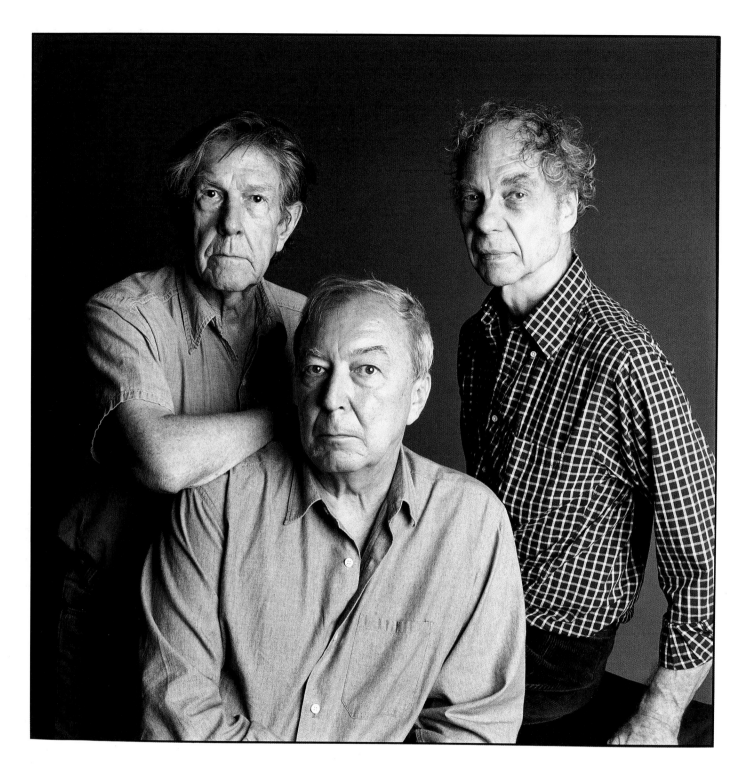

John Cage, **Jasper Johns**, **Merce Cunningham**, artists, 1989, black and white print, 14 x 14 inches

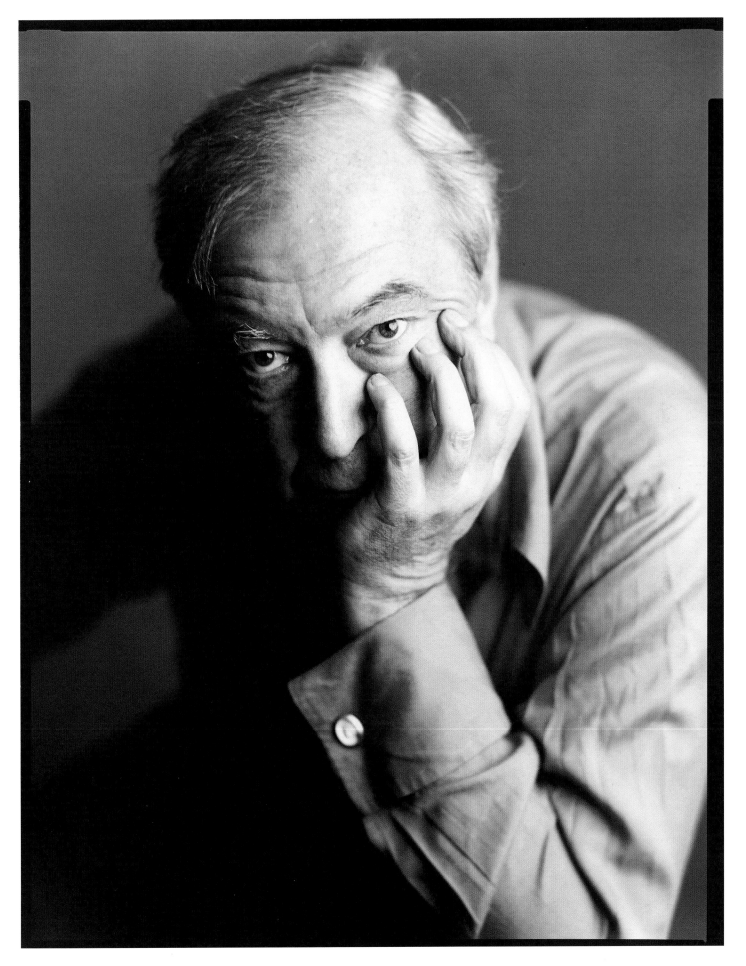

Jasper Johns, artist, 1992, black and white contact print, 11 x 14 inches

94

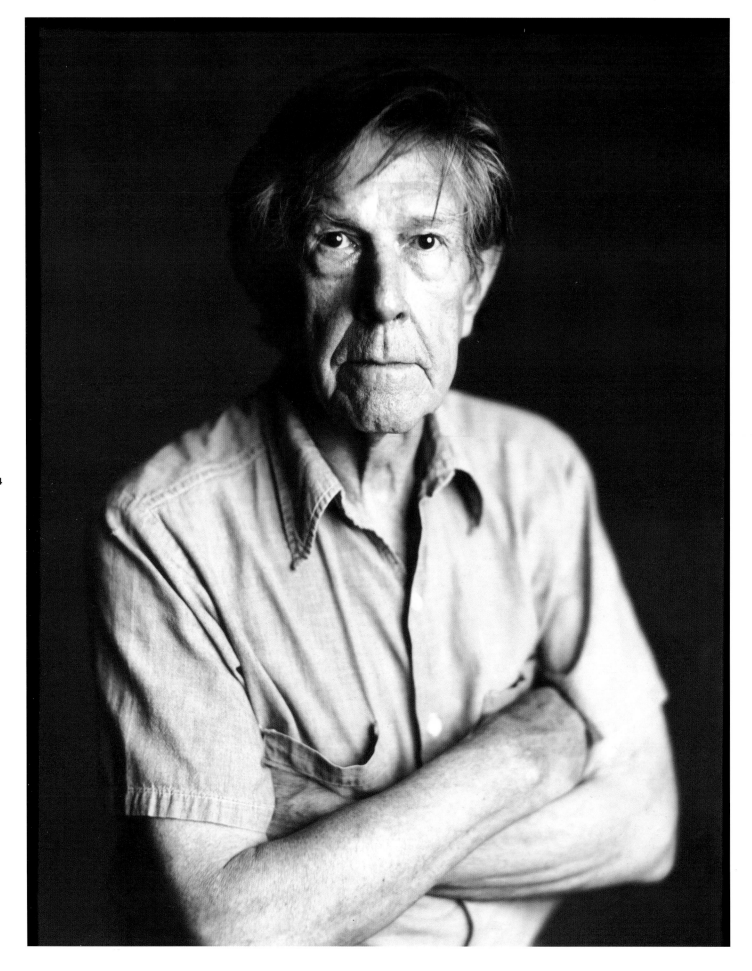

John Cage, artist, 1989, black and white contact print, 11 x 14 inches

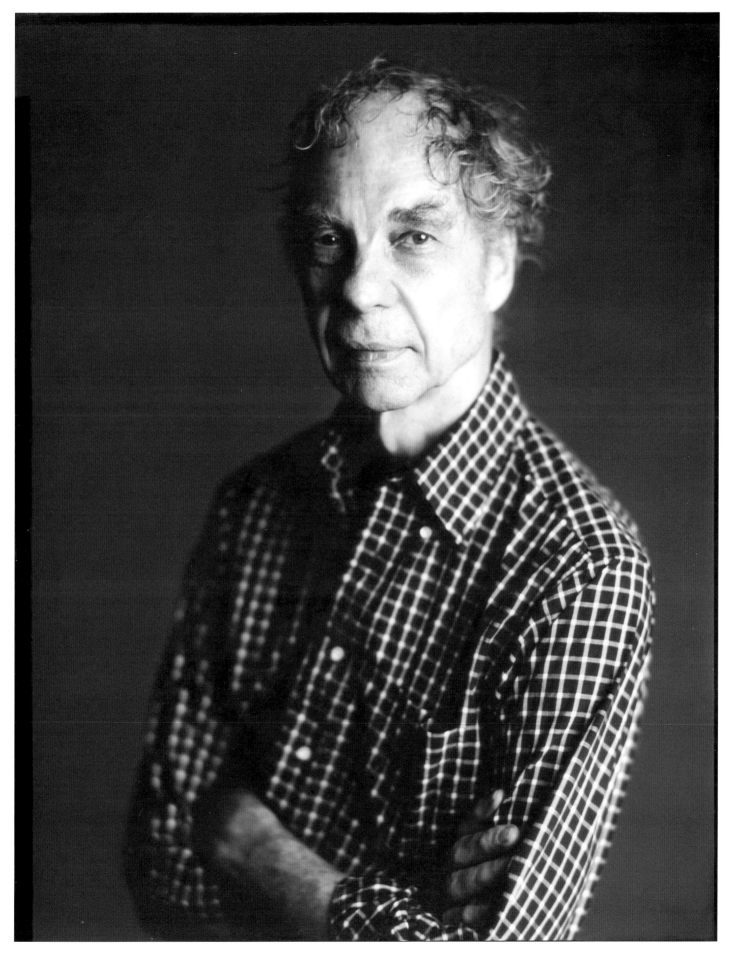

Merce Cunningham, dancer, 1989, black and white contact print, 11 x 14 inches

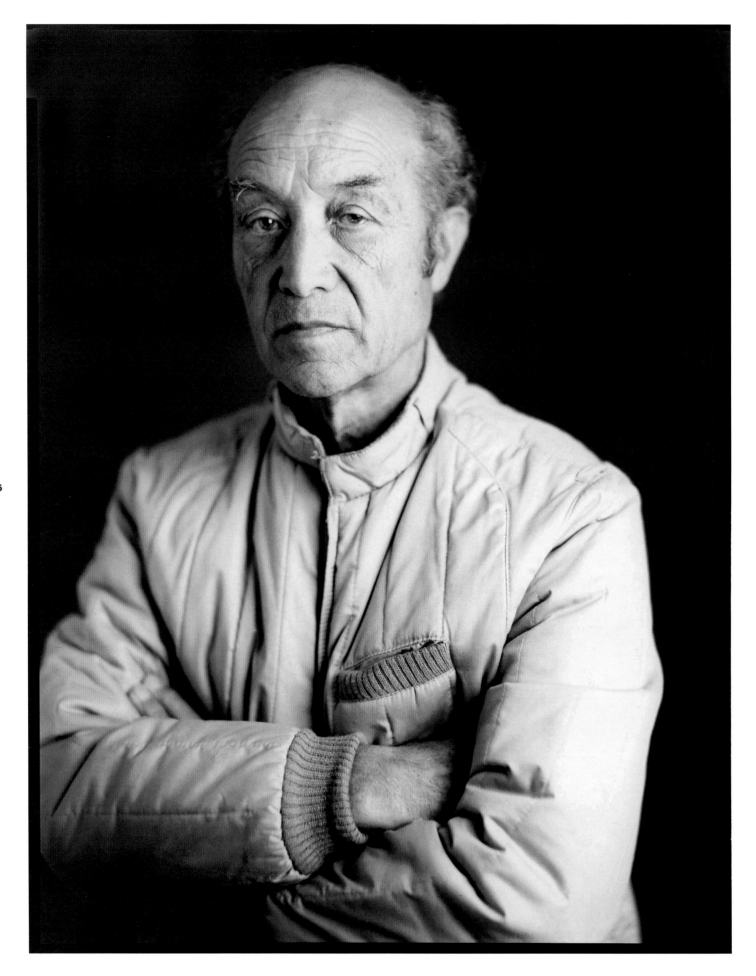

96

Isamu Noguchi, artist, 1981, black and white contact print, 11 x 14 inches

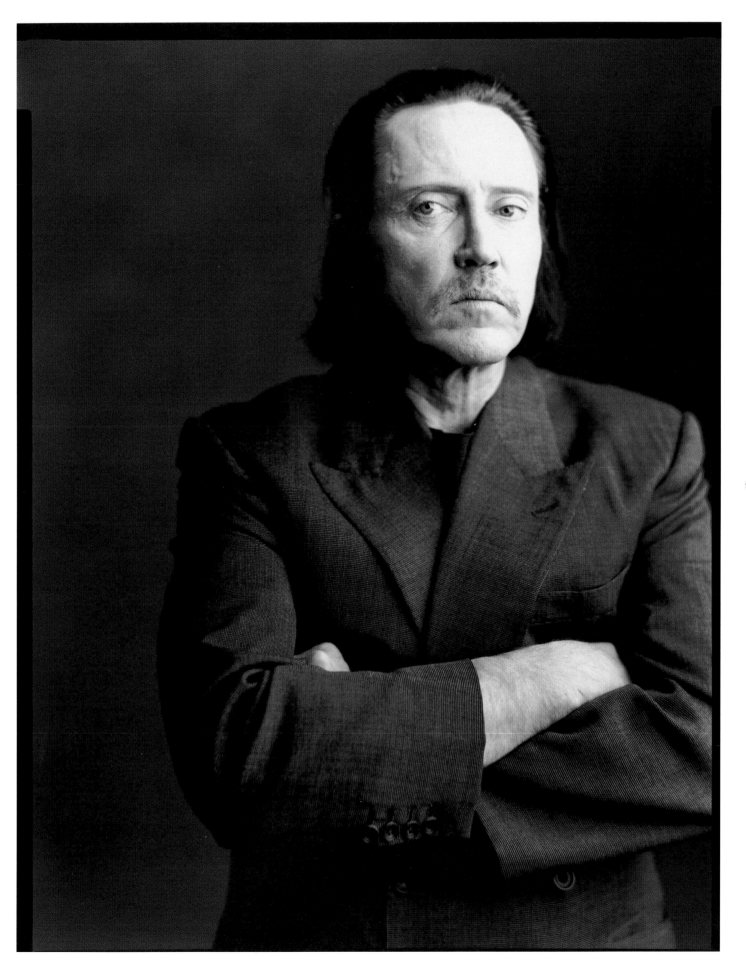

Christopher Walken, actor, 1995, black and white contact print, 11 x 14 inches

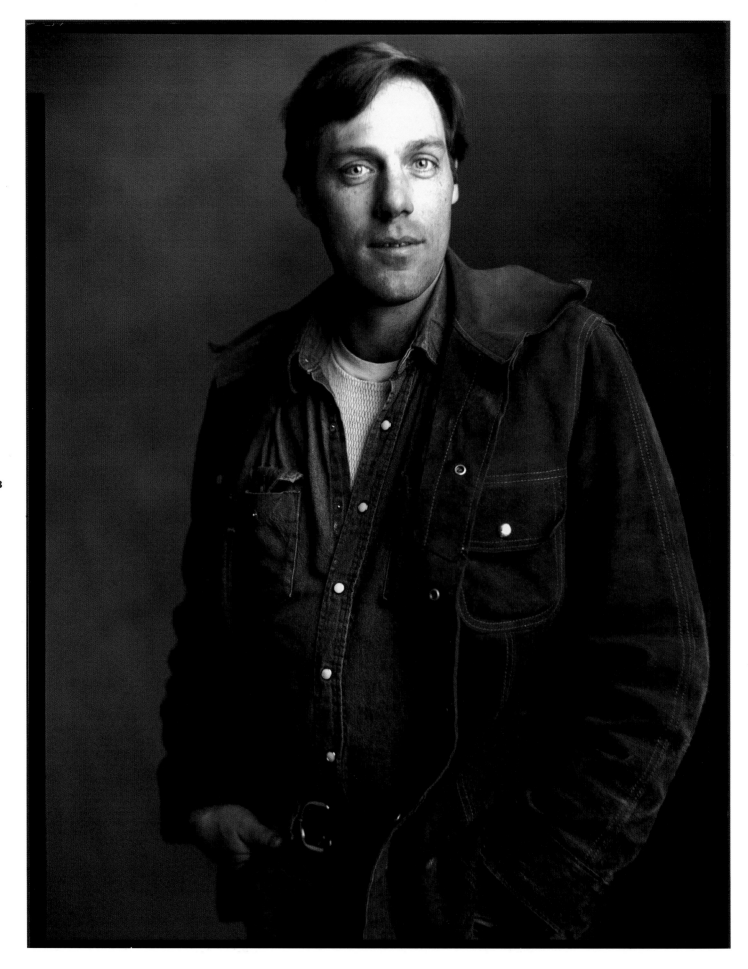

98

John Sanders, sculptor, 1993, black and white contact print, 11 x 14 inches

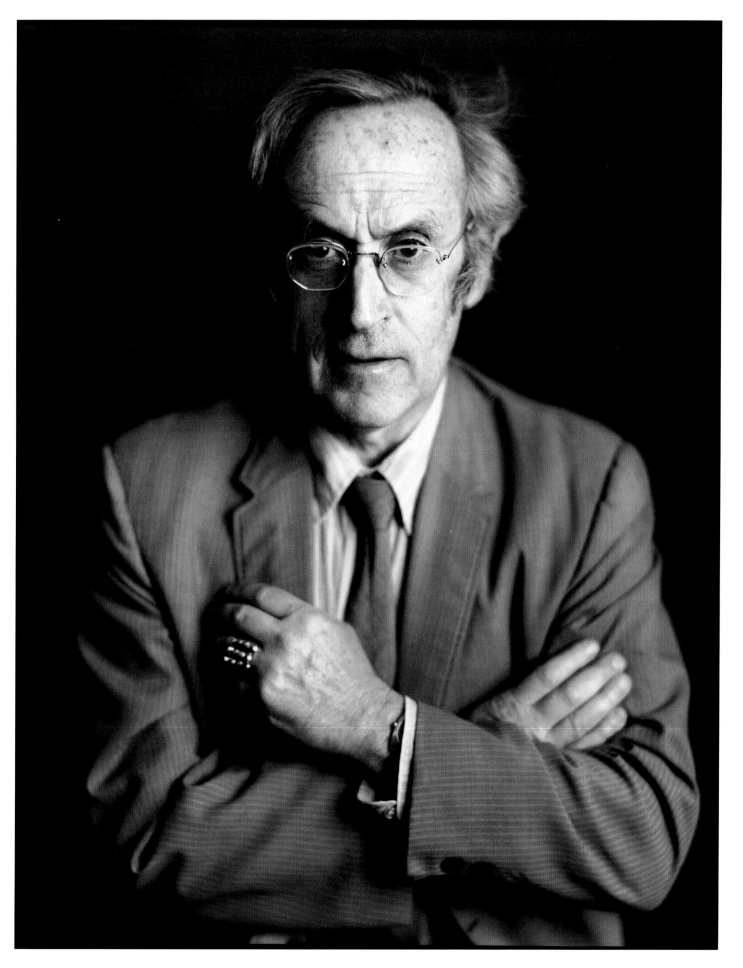

Joop Sanders, artist, 1980, black and white contact print, 11 x 14 inches

Lee Krasner, artist, 1980, black and white contact print, 11 x 14 inches

Robert Motherwell, artist, 1981, black and white contact print, 11 x 14 inches

102

David Hammons, artist, 1980, black and white contact print, 11 x 14 inches

Philip Glass, musician, 2002, black and white contact print, 11 x 14 inches

Robert Wilson, theater director / artist, 1995, black and white contact print, 11 x 14 inches

Richard Serra, artist, 1986, black and white contact print, 11 x 14 inches

Julian Schnabel, artist / filmmaker, 1980, black and white contact print, 11 x 14 inches

Francesco Clemente, artist, 1982, black and white contact print, 11 x 14 inches

Nan Goldin, artist, 1997, black and white contact print, 11 x 14 inches

Robert Mapplethorpe, artist, 1981, black and white contact print, 11 x 14 inches

Keith Haring, artist, 1986, black and white contact print, 11 x 14 inches

David Salle, artist / filmmaker, 1986, black and white contact print, 11 x 14 inches

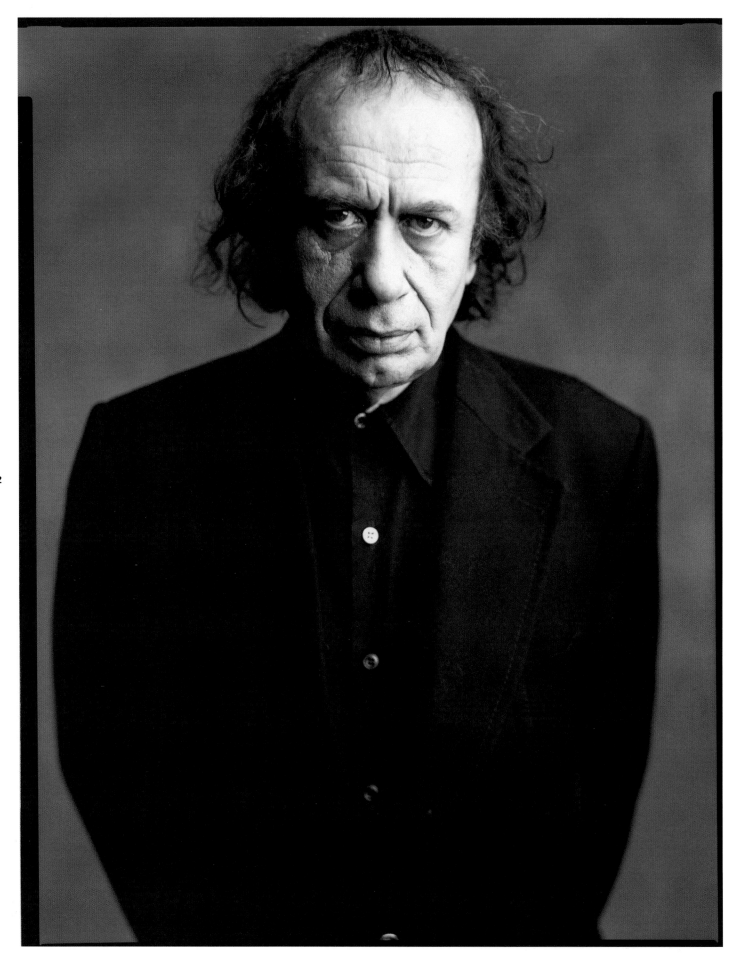

Vito Acconci, artist, 1995, black and white contact print, 11 x 14 inches

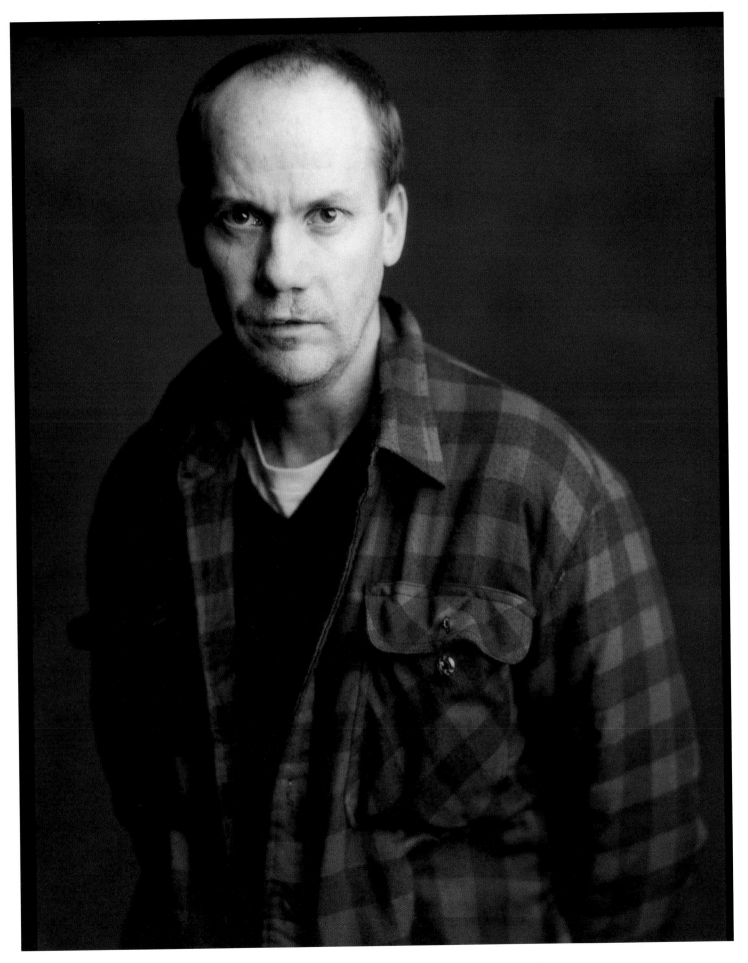

Richard Prince, artist, 1992, black and white contact print, 11 x 14 inches

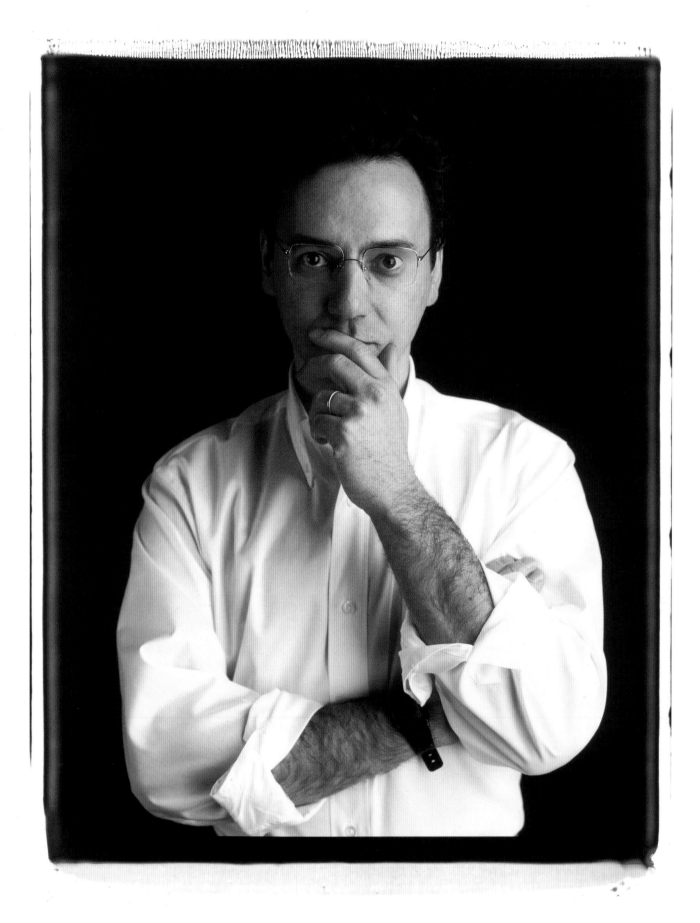

Peter Halley, artist, 1992, color Polaroid, 20 x 24 inches

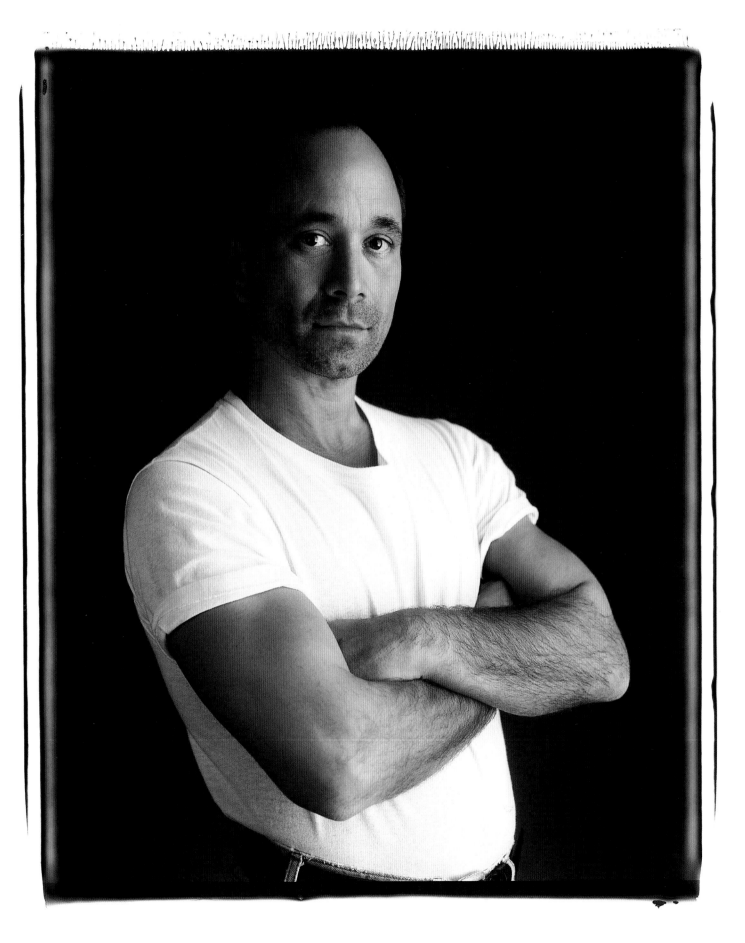

Ross Bleckner, artist, 1992, color Polaroid, 20 x 24 inches

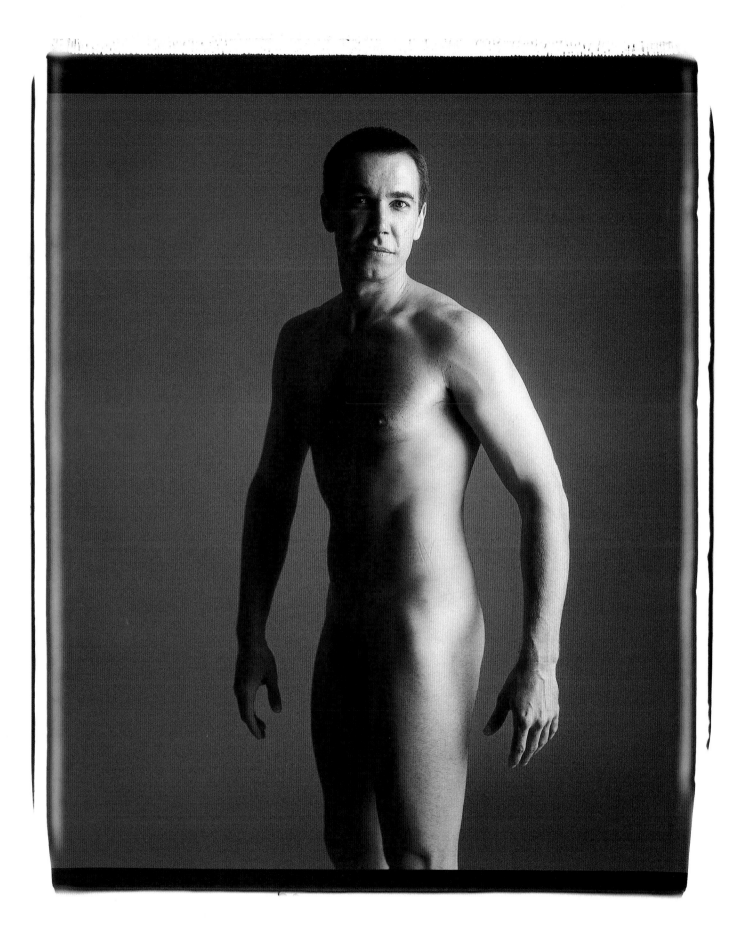

Jeff Koons, artist, 1991, color Polaroid, 20 x 24 inches

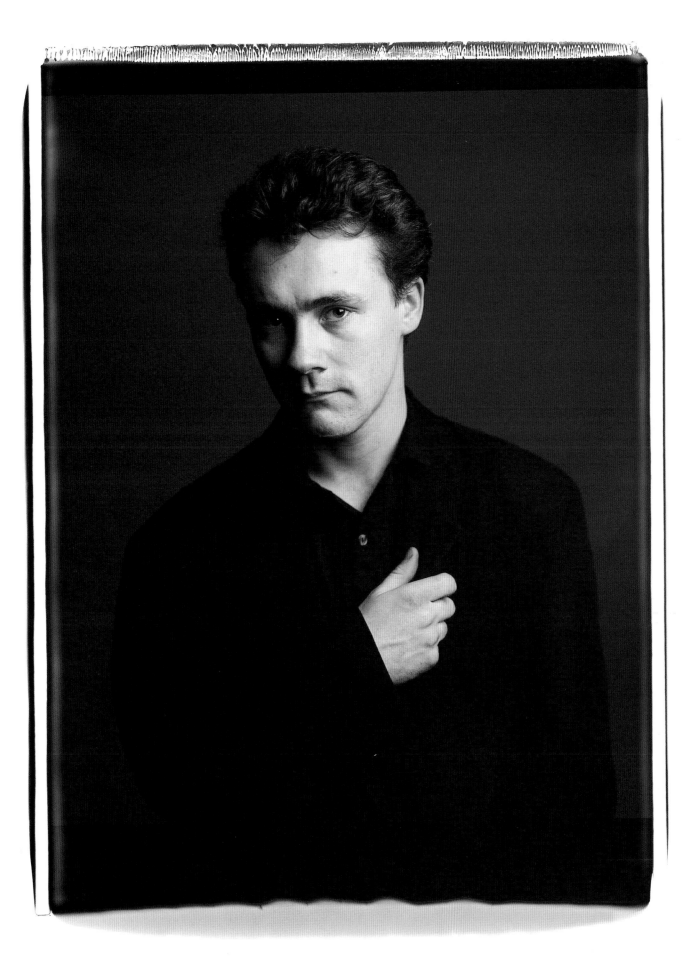

Damien Hirst, artist, 1990, color Polaroid, 20 x 24 inches

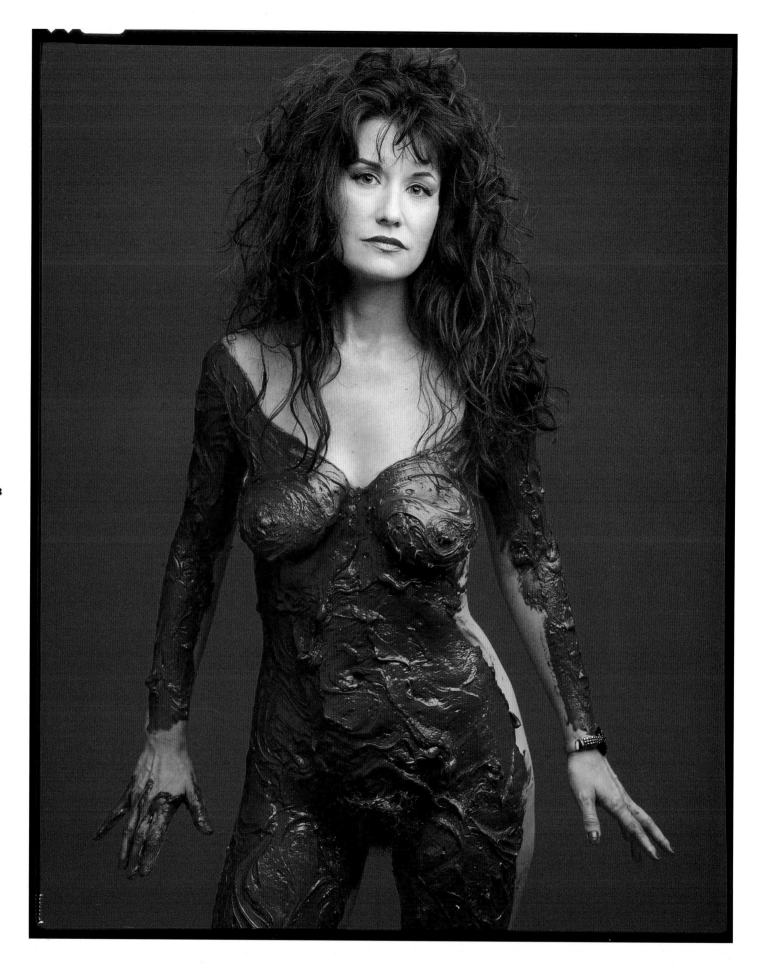

Karen Finley, performance artist, 1998, color transparency, 8 x 10 inches

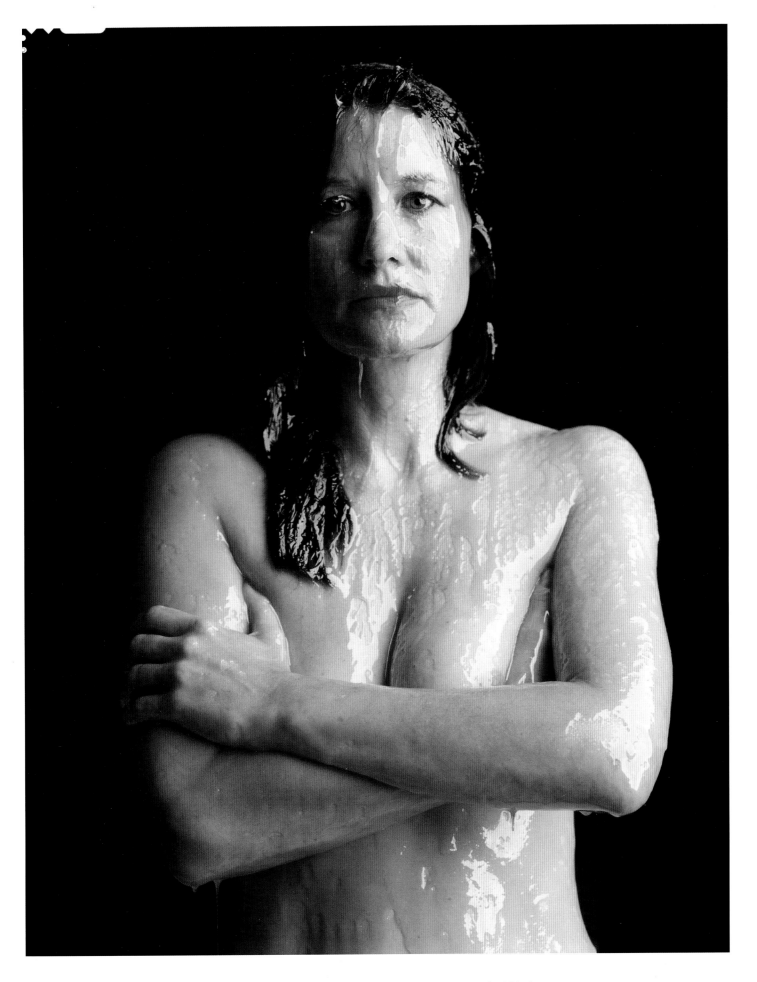

Karen Finley, performance artist, 2001, color transparency, 8 x 10 inches

Guy Pierce, actor, 1999, color Polaroid, 20 x 24 inches

Mike and **Doug Starn**, artists, 2002, color Polaroid, 20 x 24 inches

Marc Quinn, artist, 2004, black and white contact print, 11 x 14 inches

Christy Turlington, model, 2003, color transparency, 8 x 10 inches

Takashi Murakami, artist, 2001, black and white contact print, 11 x 14 inches

Anish Kapoor, artist, 2001, black and white contact print, 11 x 14 inches

Edit de Ak, art critic, 1981, black and white contact print, 11 x 14 inches

Ronnie Cutrone, artist, 1998, black and white Polaroid, 20 x 24 inches

128

Rei Kawakubo, fashion designer, 1992, black and white print, 10 x 10 inches

Agnes Martin, artist, 1992, black and white print, 14 x 14 inches

Mark Strand, poet, 1982, black and white contact print, 11 x 14 inches

Edward Ruscha, artist, 1987, black and white contact print, 11 x 14 inches

Georg Baselitz, artist, 2002, black and white contact print, 11 x 14 inches

Dennis Hopper, actor, 1995, black and white contact print, 11 x 14 inches

Danny Glover, actor, 1989, color Polaroid, 8 x 10 inches

Steve Buscemi, actor, 1995, black and white contact print, 11 x 14 inches

Vanessa Redgrave, actress, 1997, color Polaroid, 20 x 24 inches

Glenn Close, actress, 1999, color Polaroid, 20 x 24 inches

John Huston, actor / film director, 1980, black and white contact print, 11 x 14 inches

Mike Nichols, film director, 2001, black and white contact print, 8 x 10 inches

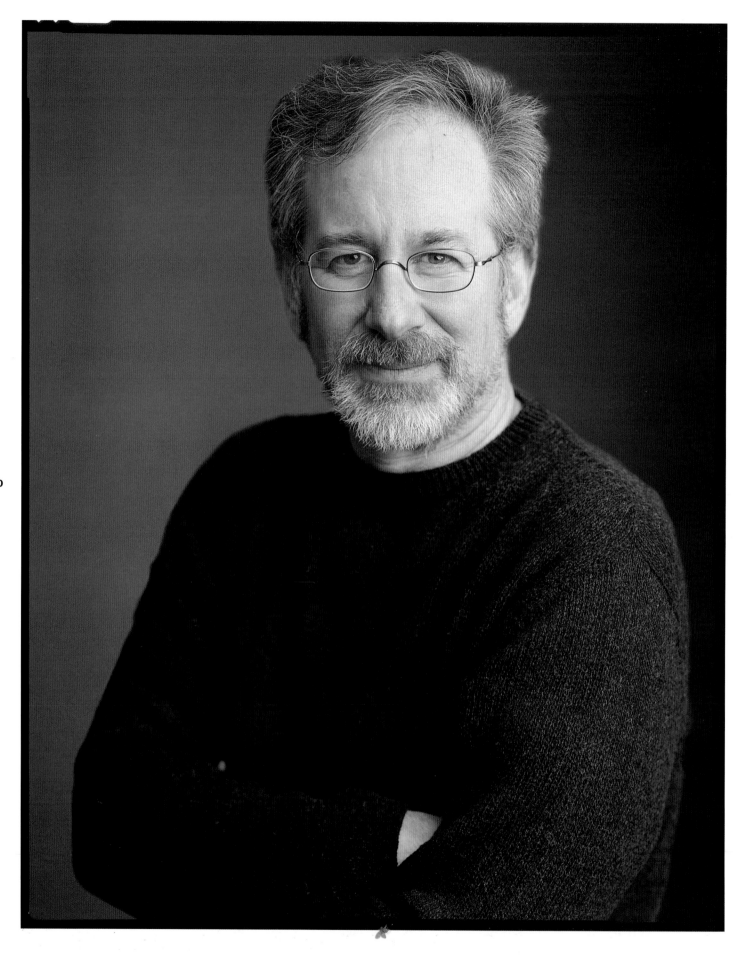

140

Steven Spielberg, film director, 1998, color transparency, 8 x 10 inches

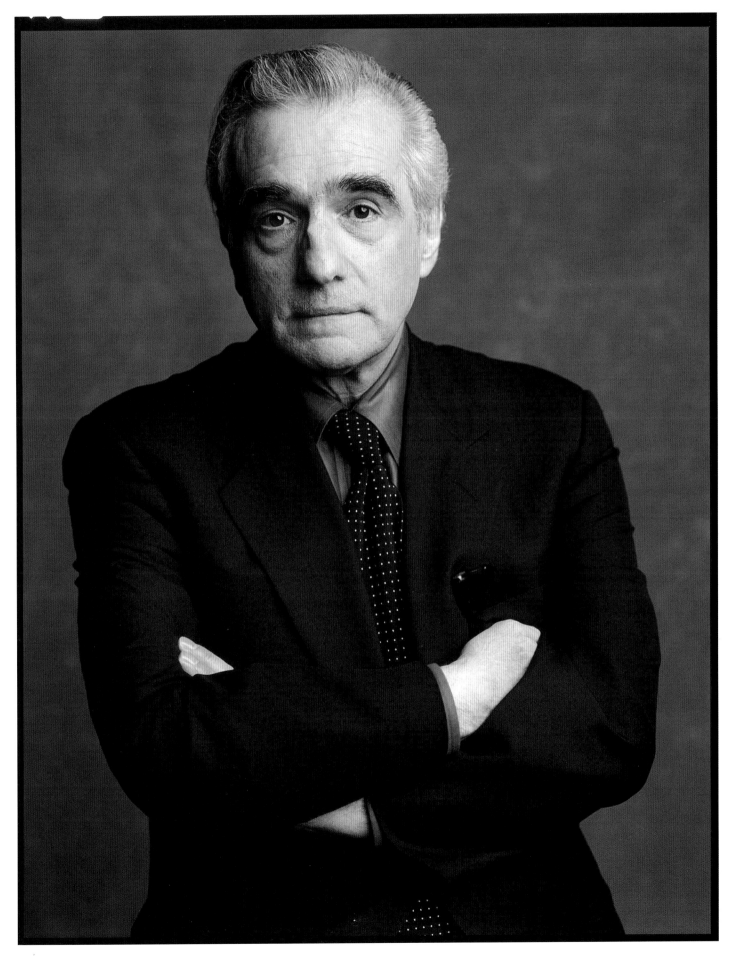

Martin Scorsese, film director, 2003, color transparency, 8 x 10 inches

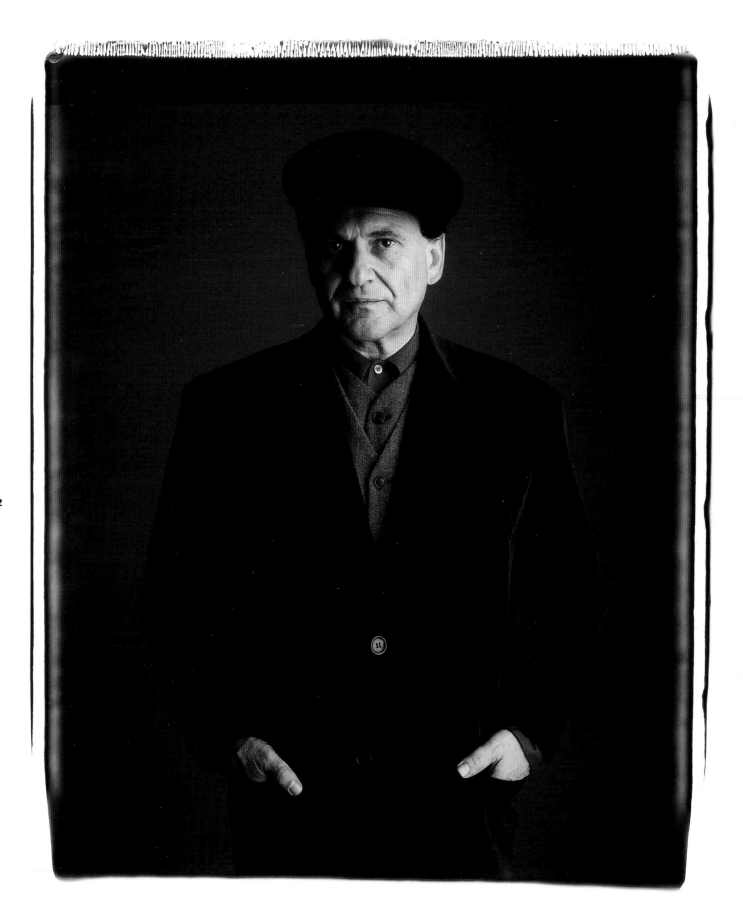

Joe Pesci, actor, 1991, color Polaroid, 20 x 24 inches

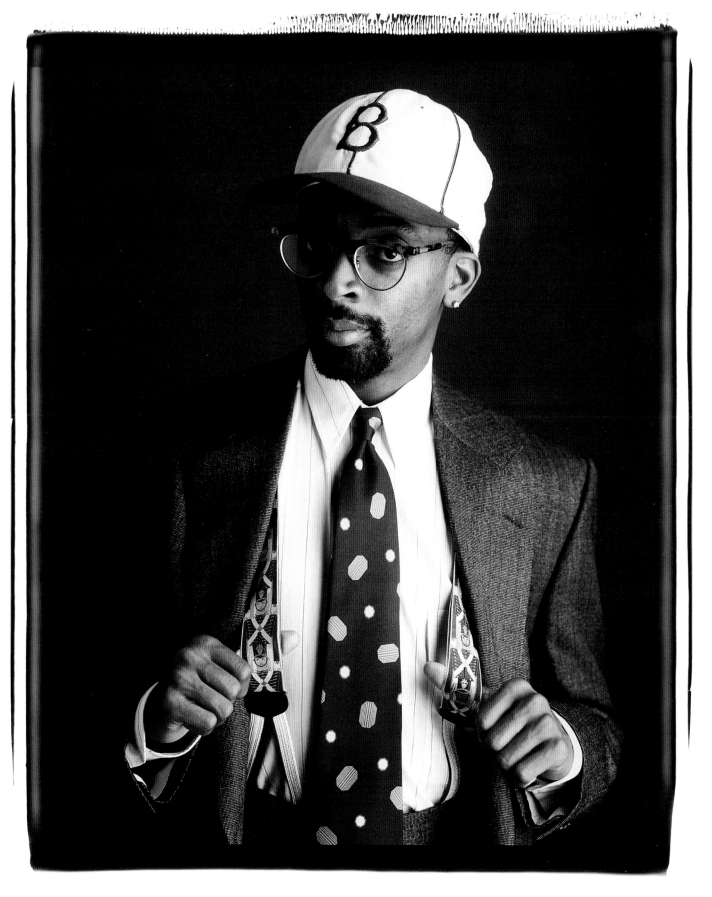

Spike Lee, film director, 1989, color Polaroid, 20 x 24 inches

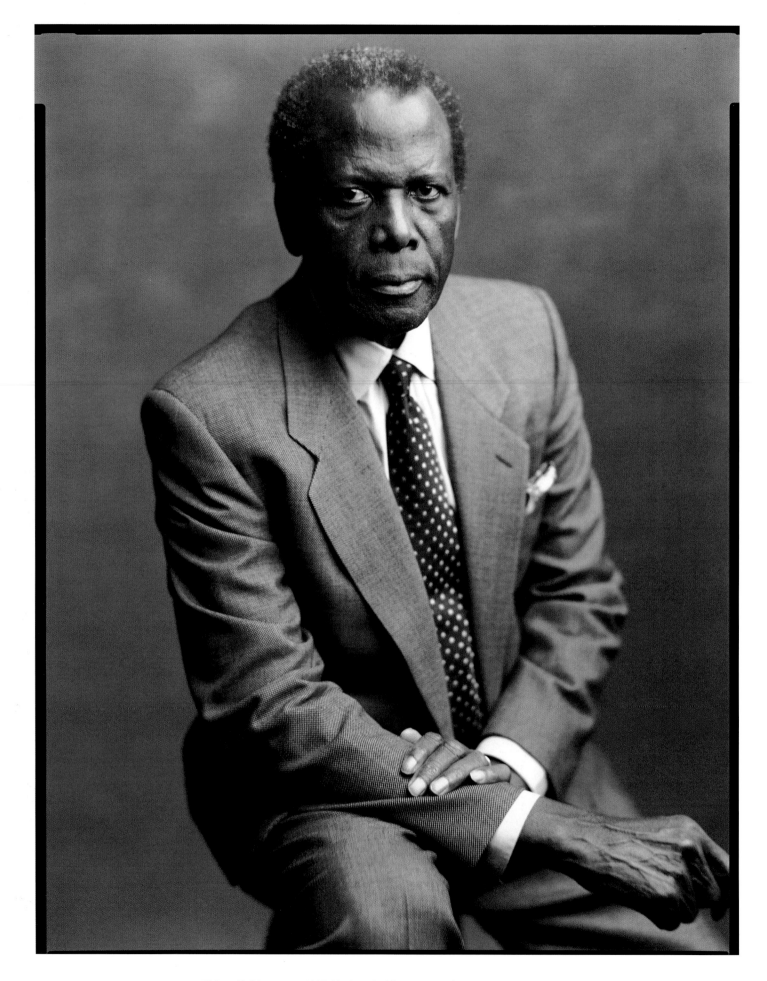

Sidney Poitier, actor, 1998, black and white contact print, 11 x 14 inches

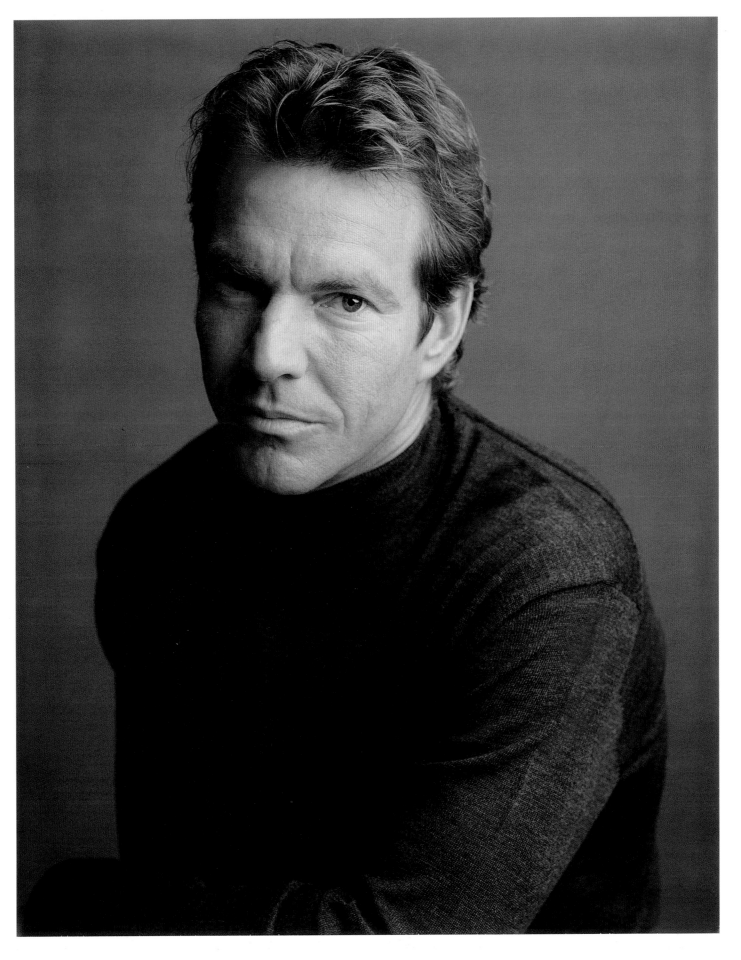

Dennis Quaid, actor, 1998, color transparency, 8 x 10 inches

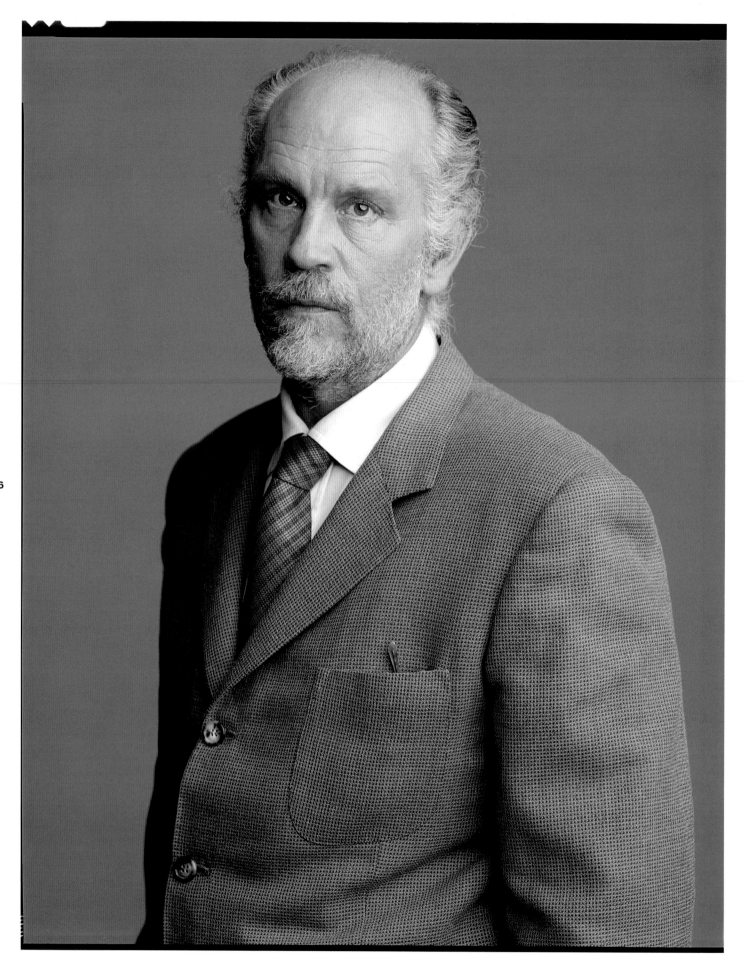

John Malkovich, actor / film director, 2003, color transparency, 8 x 10 inches

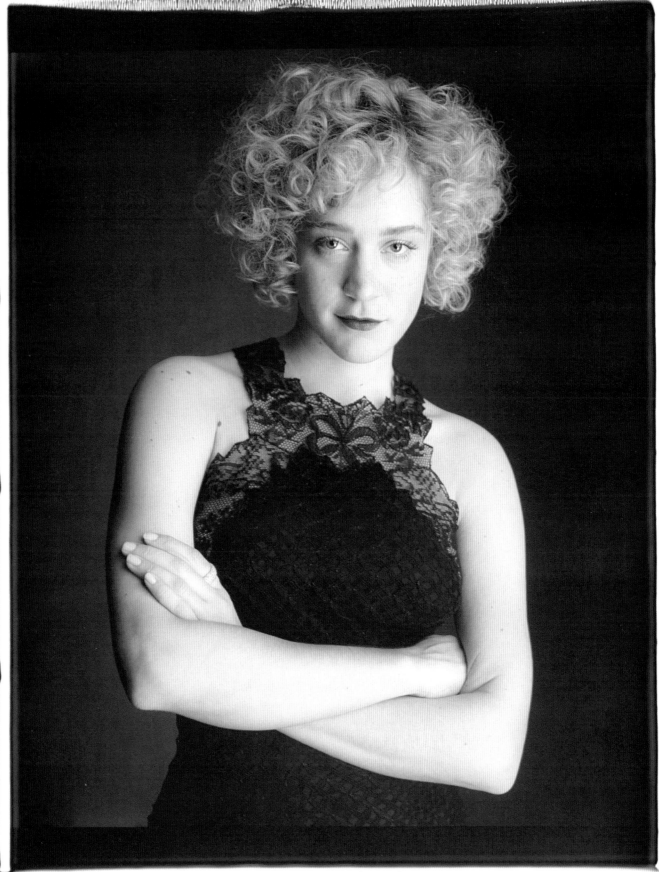

Chloe Sevigny, actress, 2002, color Polaroid, 20 x 24 inches

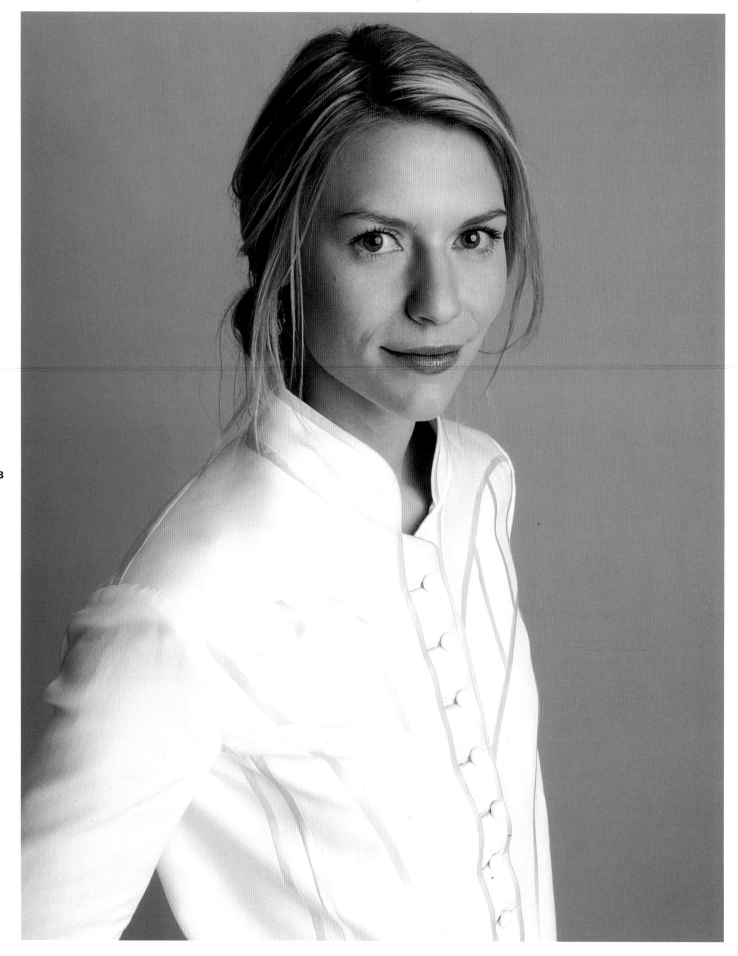

Claire Danes, actress, 2005, color transparency, 2¹/₄ x 2¹/₄ inches

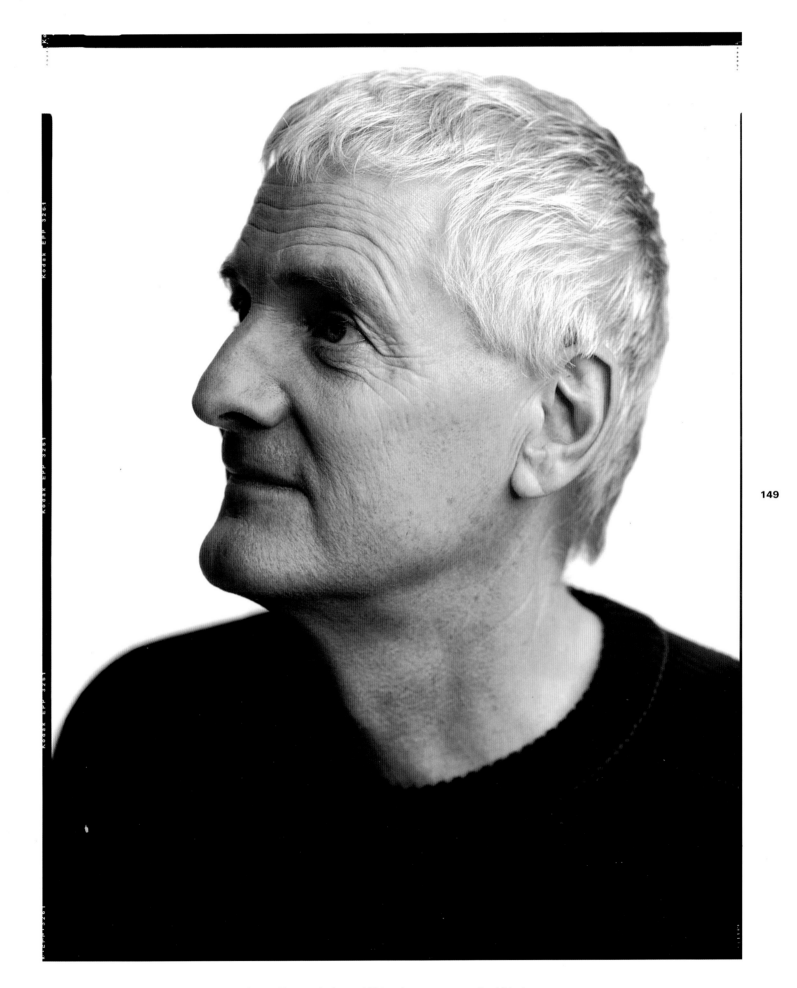

James Dyson, designer, 2004, color transparency, 8 x 10 inches

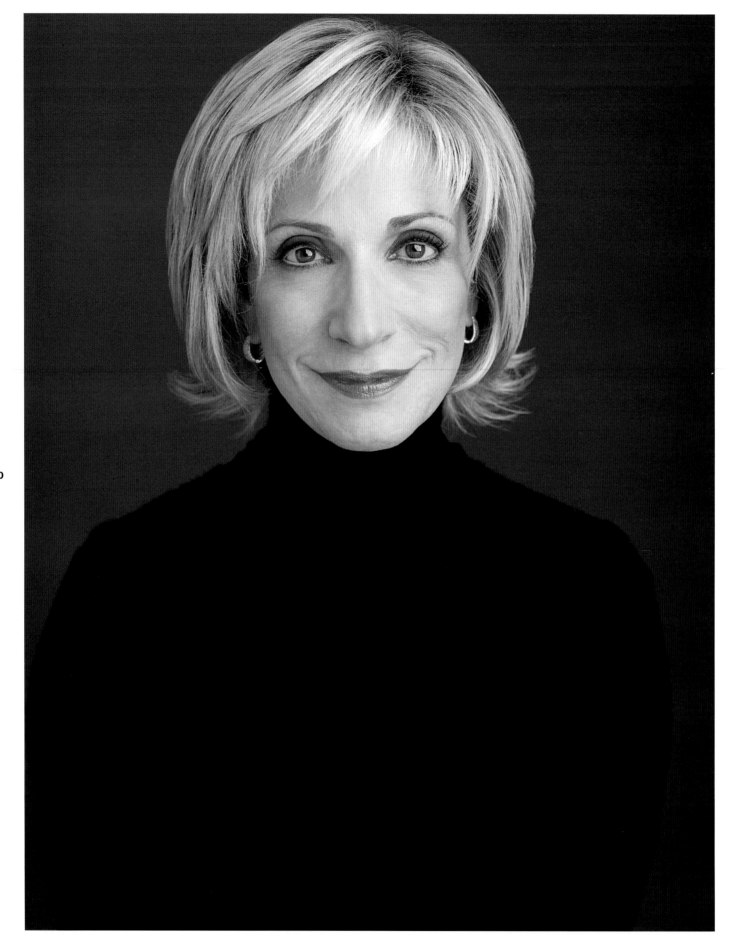

150

Andrea Mitchell, journalist, 2004, color transparency, 8 x 10 inches

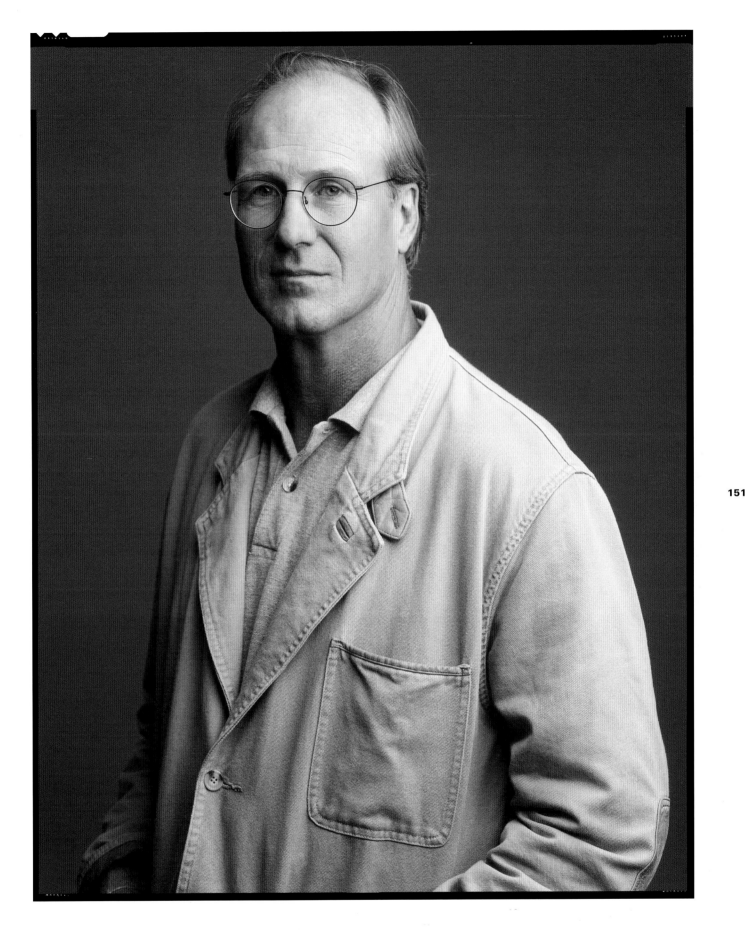

William Hurt, actor, 2003, color transparency, 8 x 10 inches

152

Ben Stiller, actor, 2002, black and white contact print, 11 x 14 inches

153

Bill T. Jones, dancer, 2001, black and white contact print, 11 x 14 inches

154

Randy Harrison, actor, 2002, black and white contact print, 11 x 14 inches

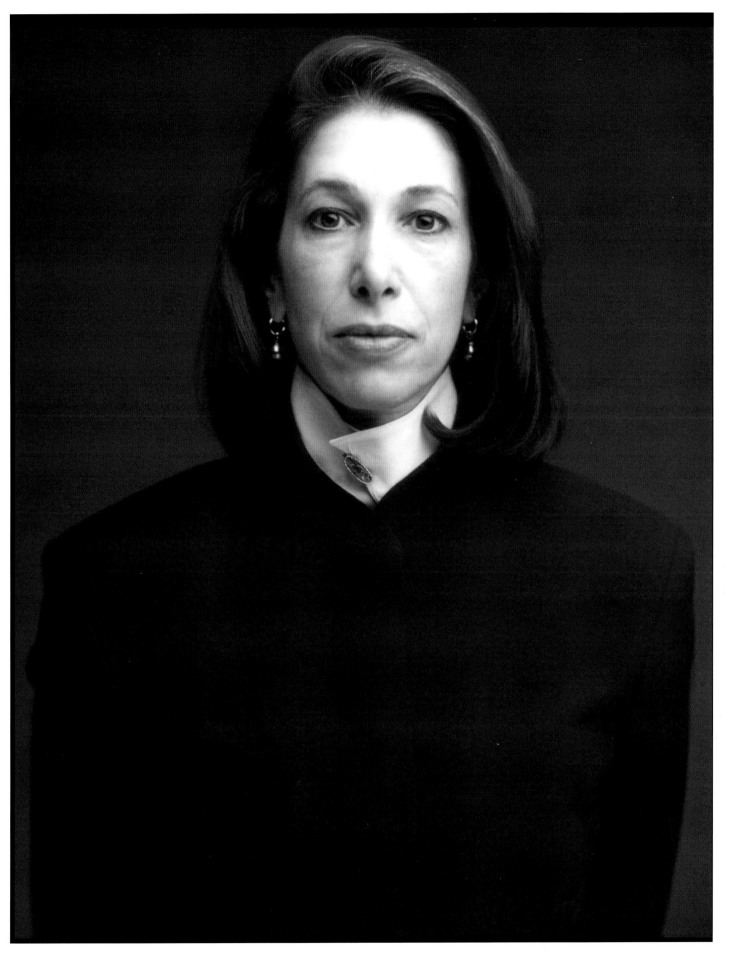

Elyn Zimmerman, artist, 1993, black and white contact print, 8 x 10 inches

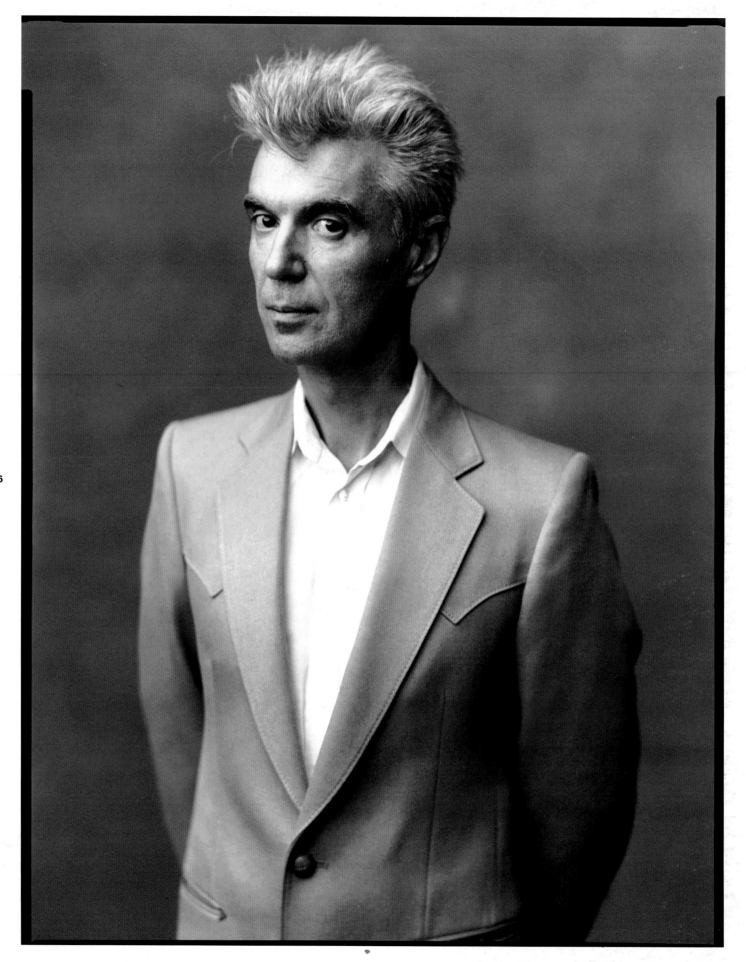

156

David Byrne, musician, 2002, black and white contact print, 11 x 14 inches

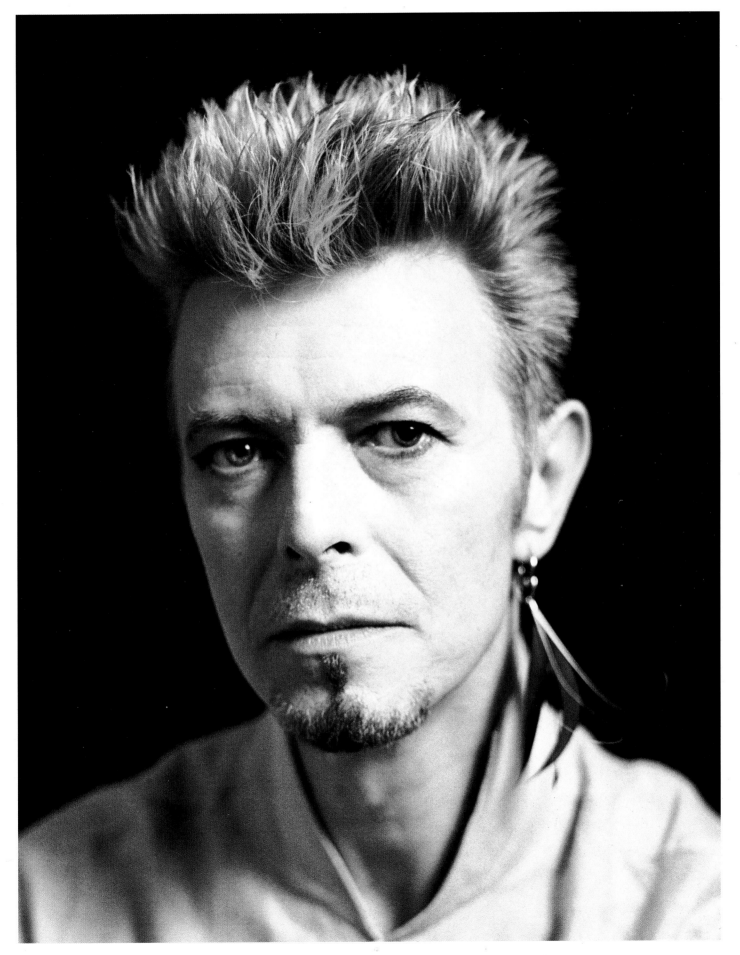

David Bowie, musician, 1997, black and white print, 8 x 10 inches

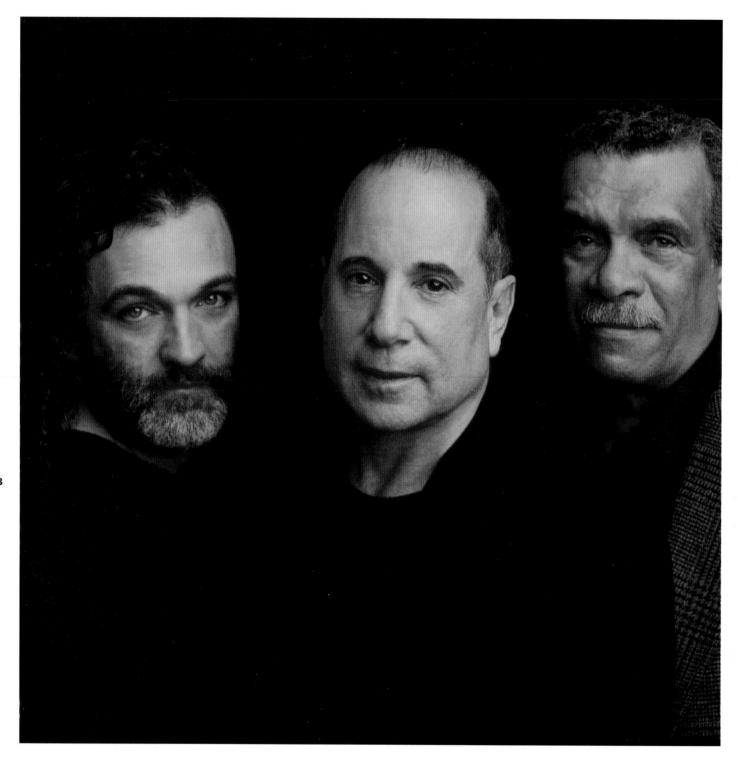

158

Mark Morris, choreographer, **Paul Simon**, musician, **Derek Walcott**, writer, 1997, color transparency, 2¹/₄ x 2¹/₄ inches

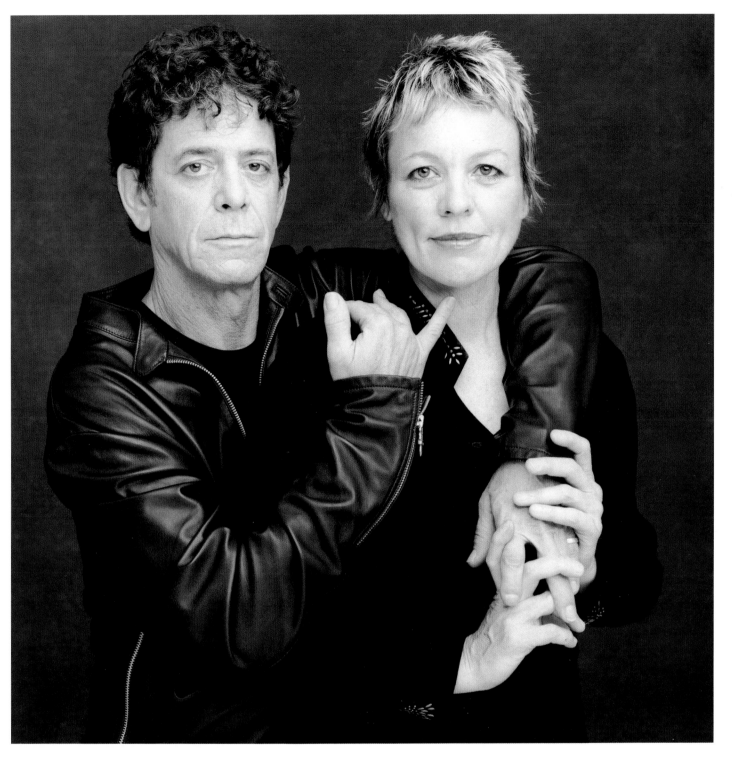

Lou Reed and **Laurie Anderson**, artists, 2000, black and white print, 14 x 14 inches

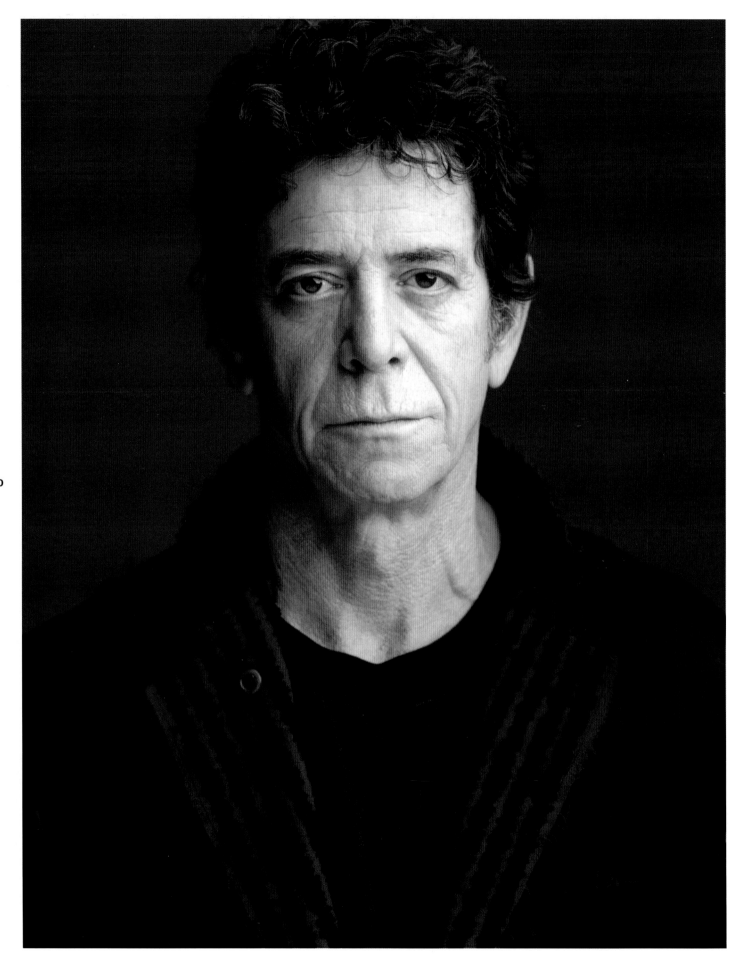

Lou Reed, musican, 2003, color transparency, 8 x 10 inches

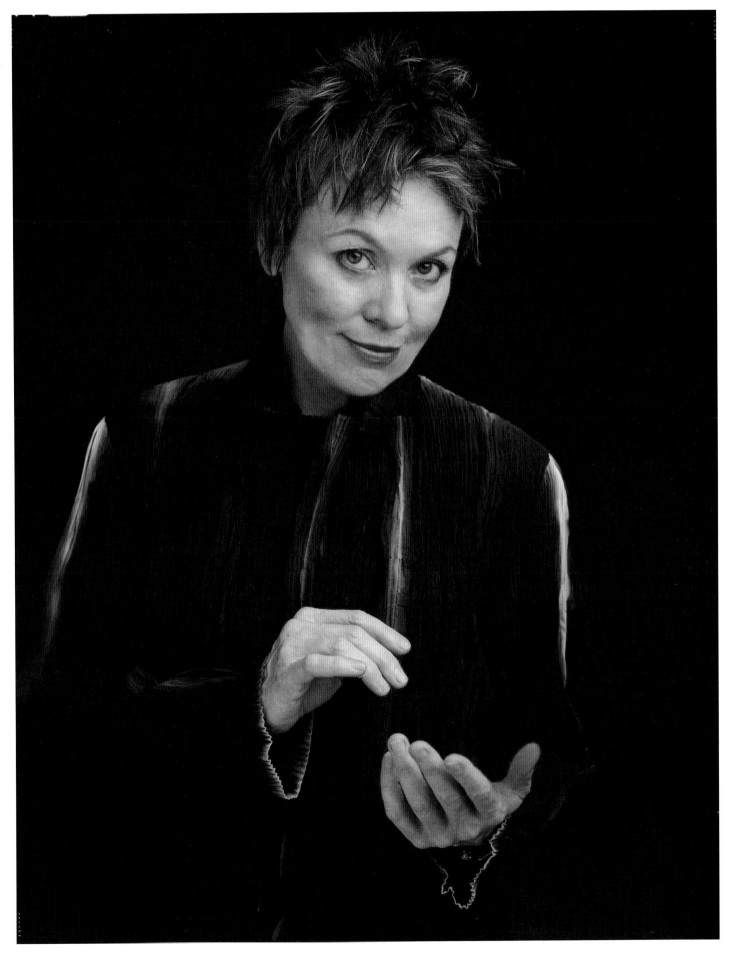

Laurie Anderson, artist, 2005, color transparency, 8 x 10 inches

Moby, musician, 2005, color transparency, 8 x 10 inches

Antony Hagerty, musician, 2003, black and white contact print, 11 x 14 inches

Robert Indiana, artist, 1990, black and white contact print, 11 x 14 inches

Terry Winters, artist, 1990, black and white contact print, 11 x 14 inches

India Arie, musician, 2003, color transparency, 8 x 10 inches

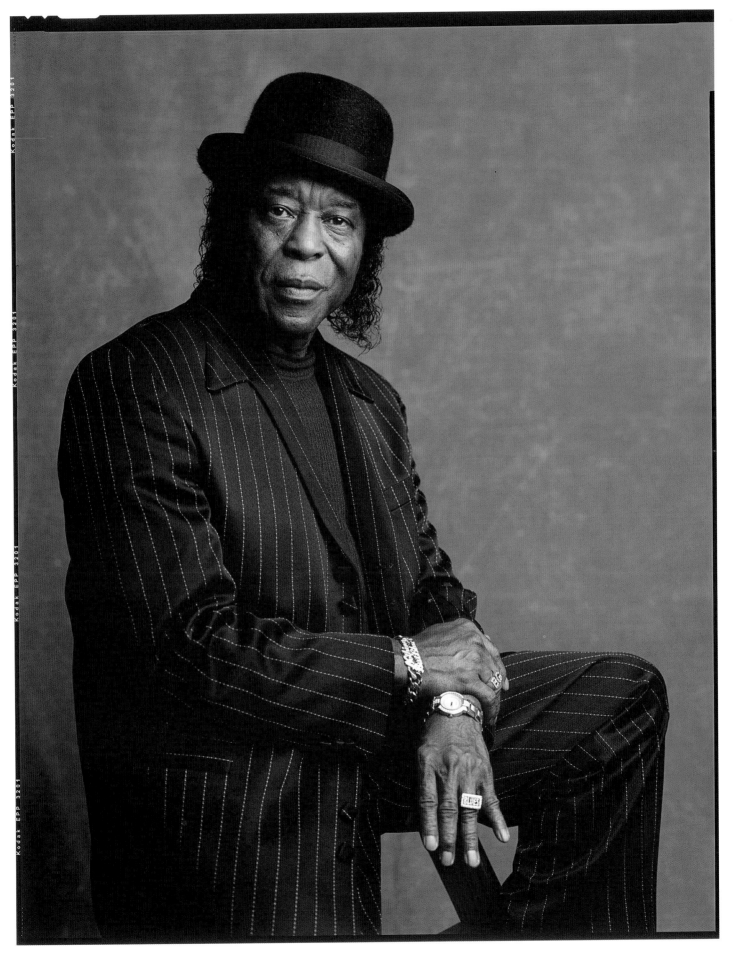

Buddy Guy, musician, 2003, color transparency, 8 x 10 inches

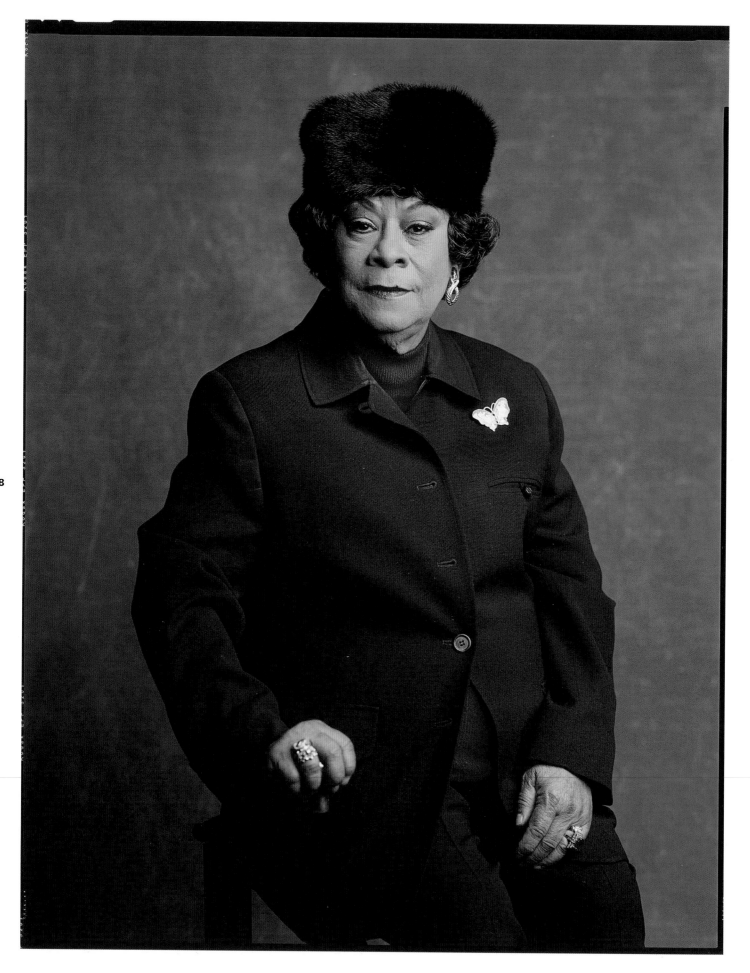

Ruth Brown, musician, 2003, color transparency, 8 x 10 inches

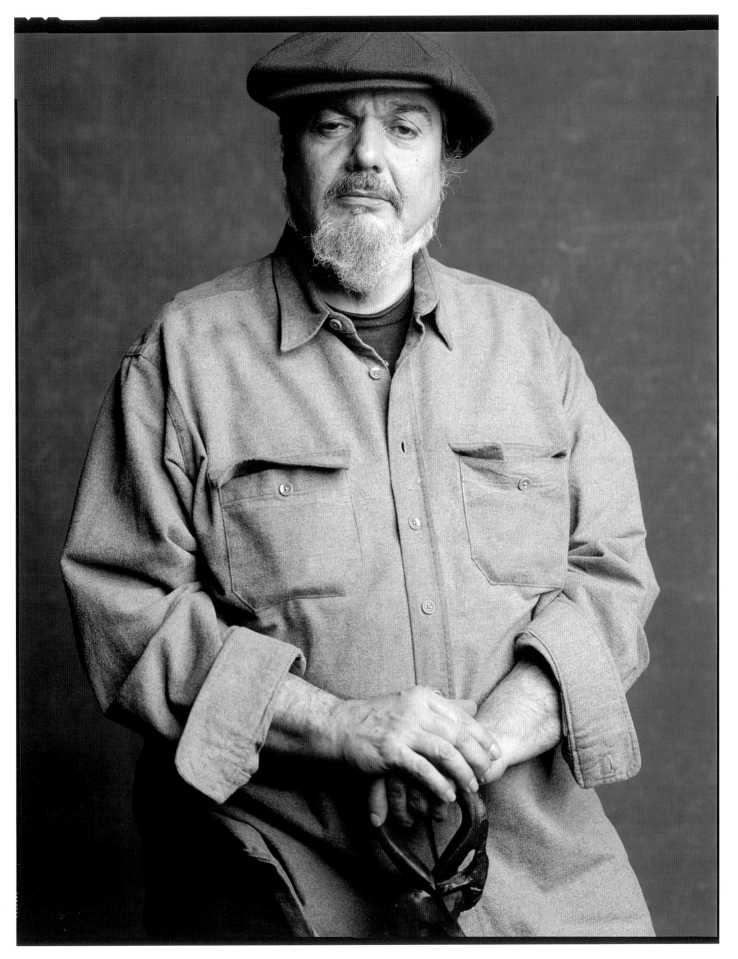

Dr. John, musician, 2003, color transparency, 8 x 10 inches

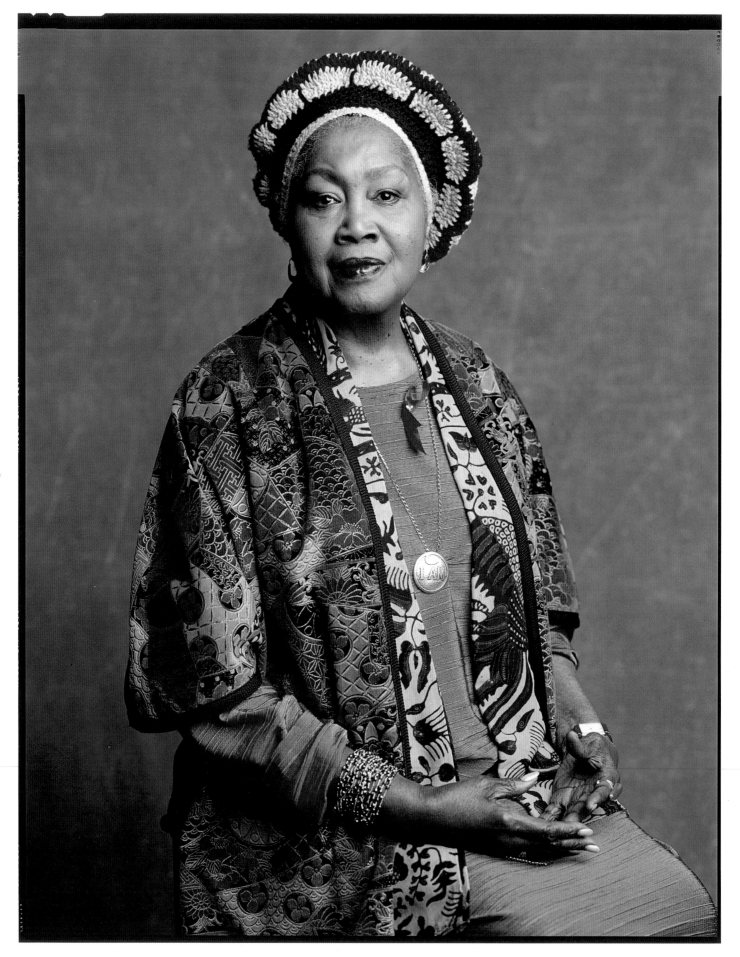

Odetta, musician, 2003, color transparency, 8 x 10 inches

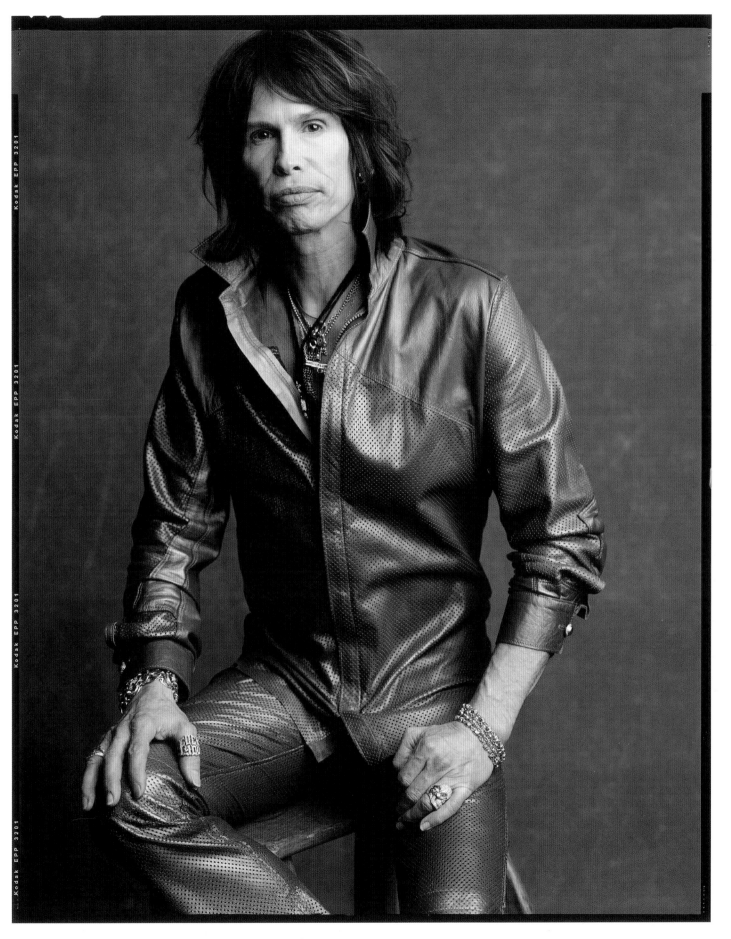

Steve Tyler, musician, 2003, color transparency, 8 x 10 inches

Taylor Mead, poet, 2003, color transparency, 8 x 10 inches

B.B. King, musician, 2003, color transparency, 8 x 10 inches

174

David Johansen, musician, 2003, color transparency, 8 x 10 inches

Mavis Staples, musician, 2003, color transparency, 8 x 10 inches

Clarence Brown, musician, 2003, color transparency, 8 x 10 inches

David Edwards, musician, 2003, color transparency, 8 x 10 inches

Andreas Gursky, artist, 2000, black and white contact print, 11 x 14 inches

Kathleen Chalfont, actress, 2000, black and white contact print, 11 x 14 inches

Annette Lemeiux, artist, 1991, black and white contact print, 11 x 14 inches

Donna Tartt, writer, 2002, black and white contact print, 11 x 14 inches

Futura 2000, artist, 1985, black and white contact print, 11 x 14 inches

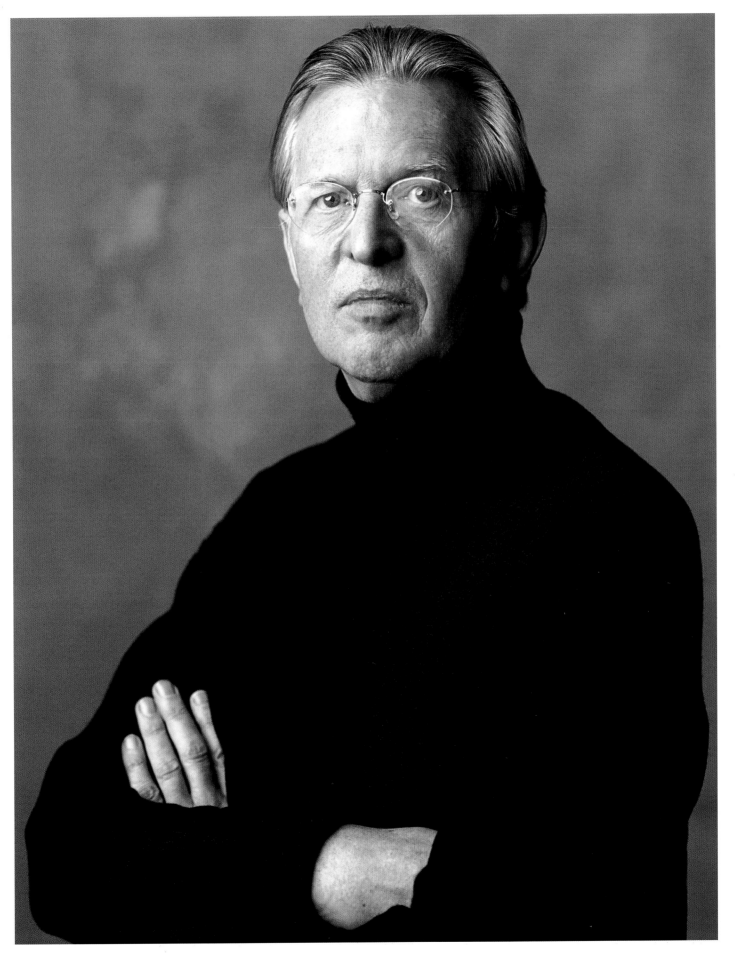

John Elderfield, art historian, 2003, black and white contact print, 8 x 10 inches

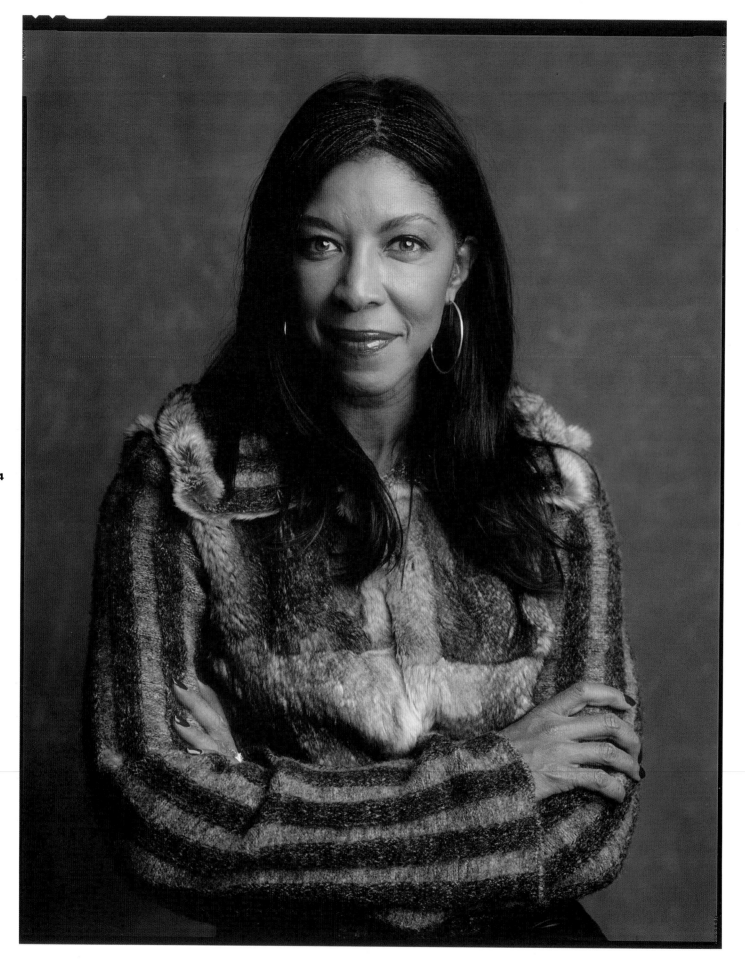

184

Natalie Cole, musician, 2003, color transparency, 8 x 10 inches

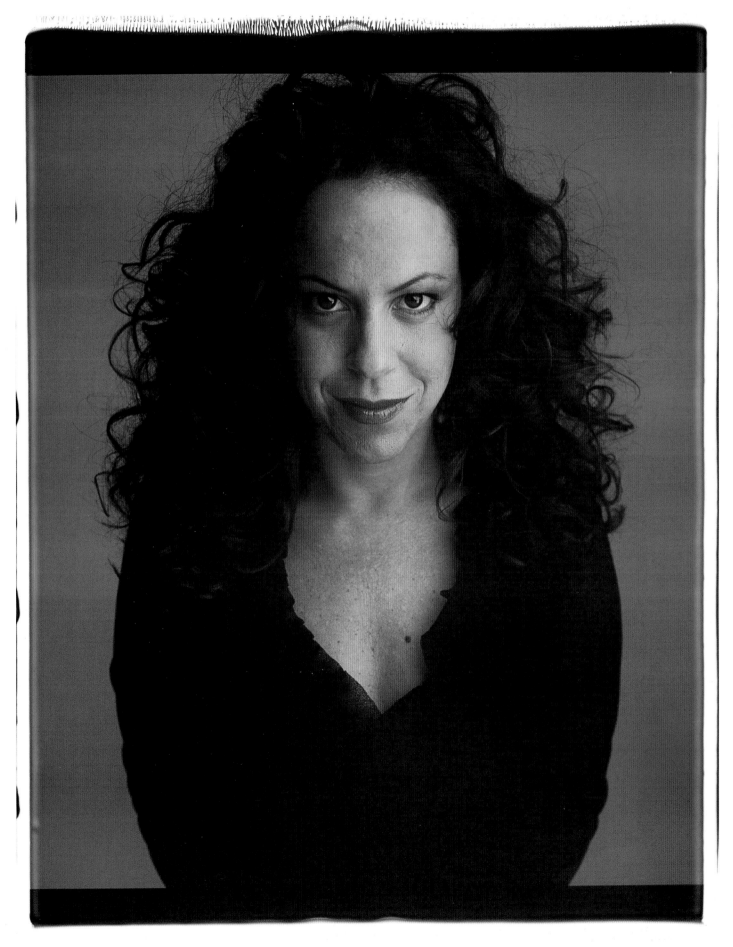

Babel Gilberto, musician, 2002, color Polaroid, 20 x 24 inches

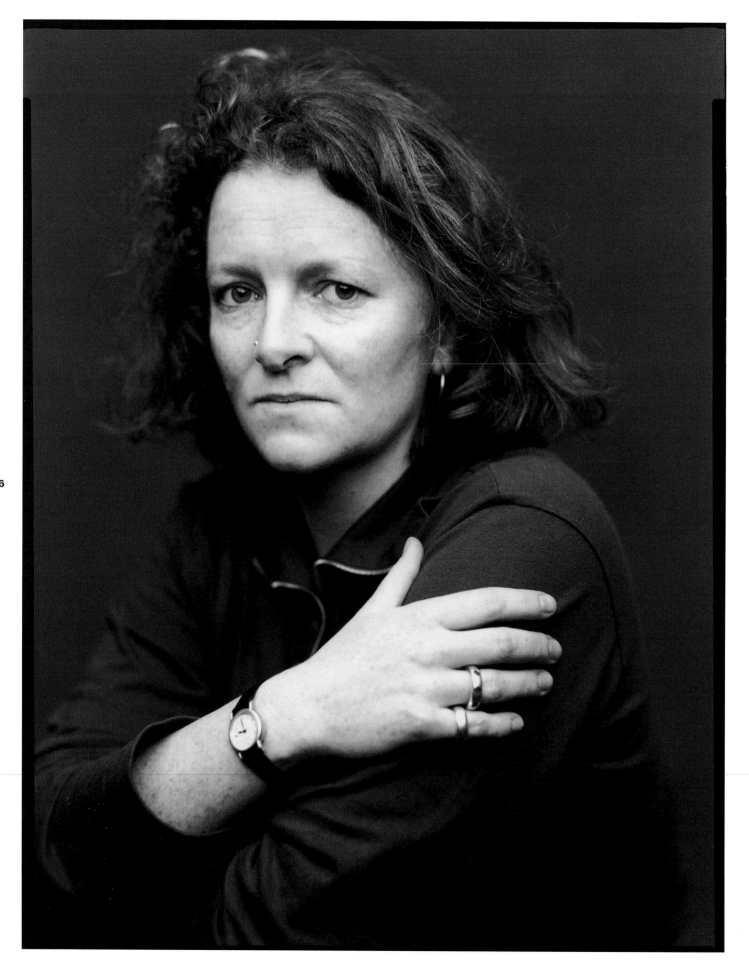

Rachel Whiteread, artist, 1996, black and white contact print, 11 x 14 inches

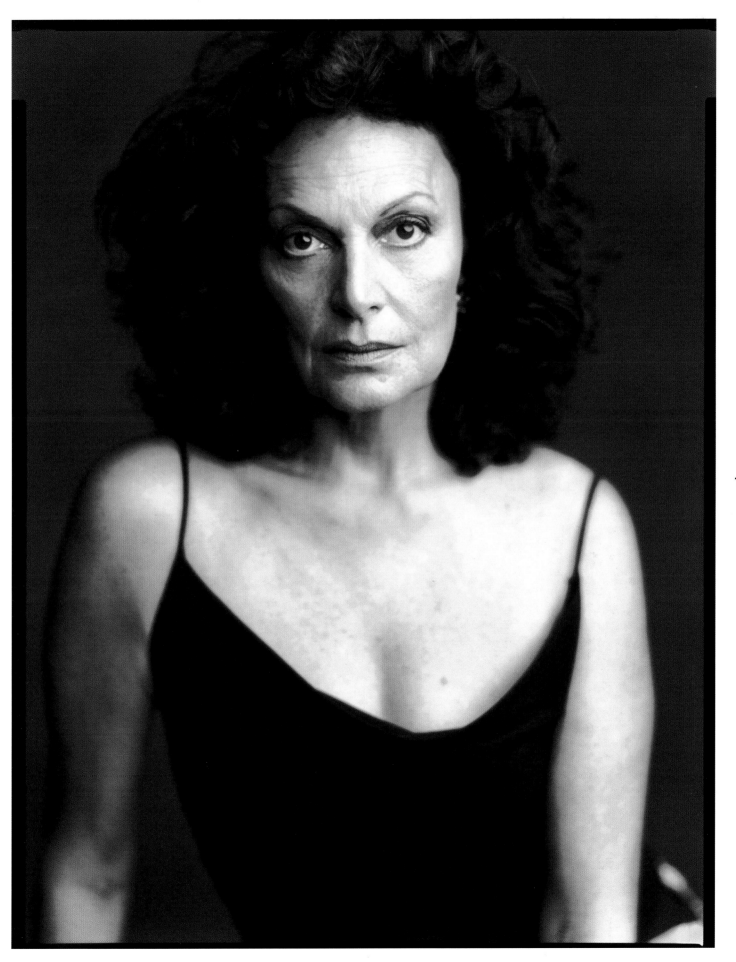

Diane von Furstenberg, fashion designer, 2000, black and white contact print, 11 x 14 inches

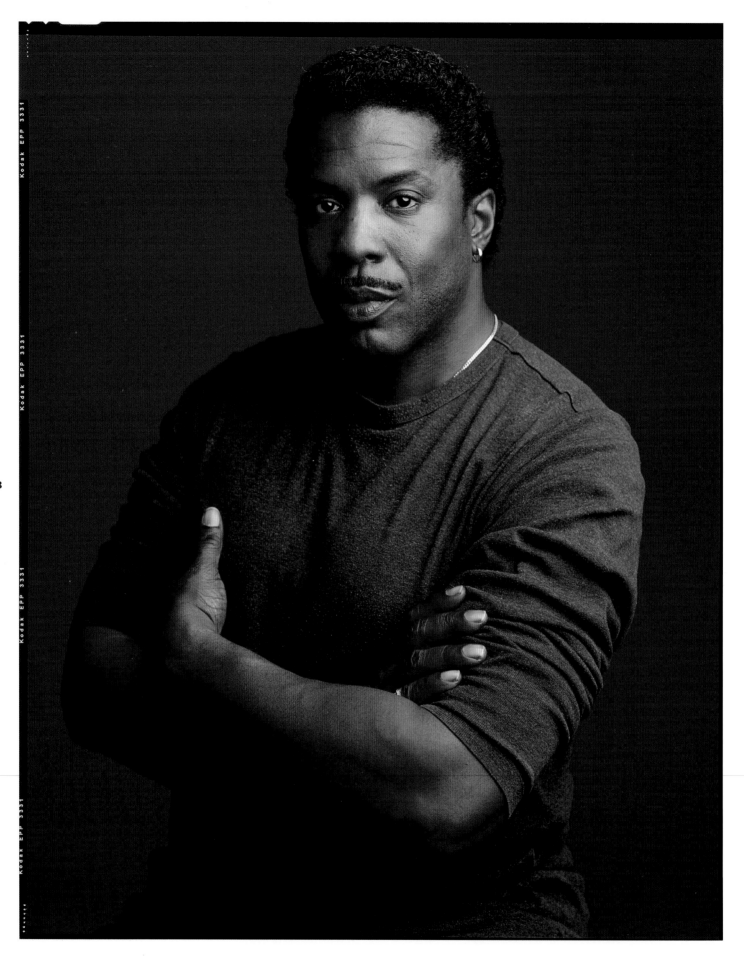

188

Greg Baker, opera singer, 2005, color transparency, 8 x 10 inches

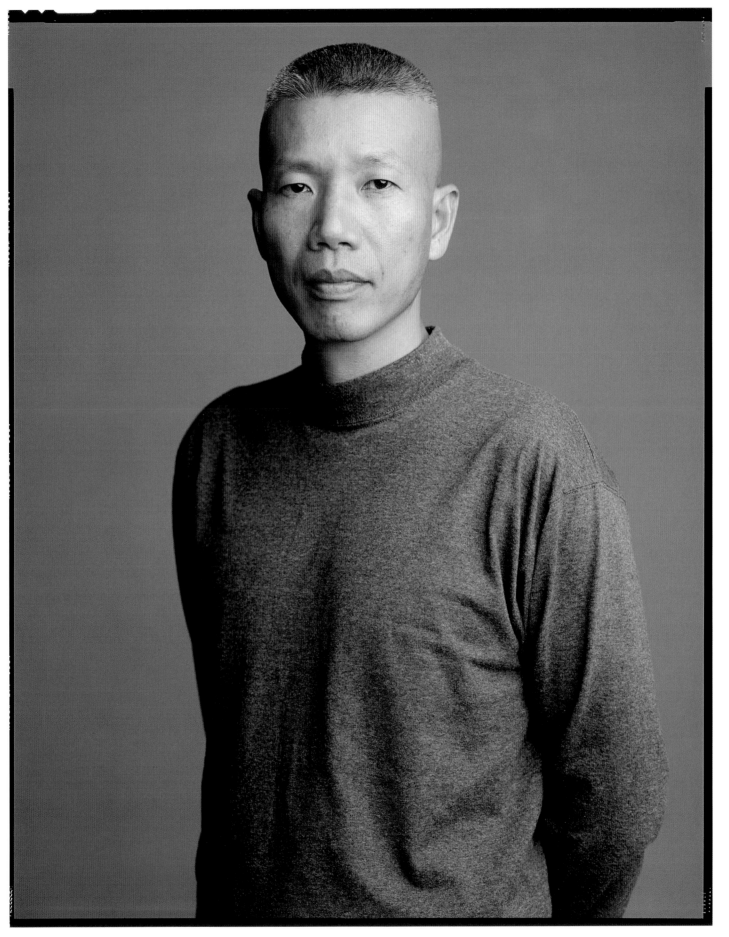

Cai Guo-Qiang, artist, 2003, color transparency, 8 x 10 inches

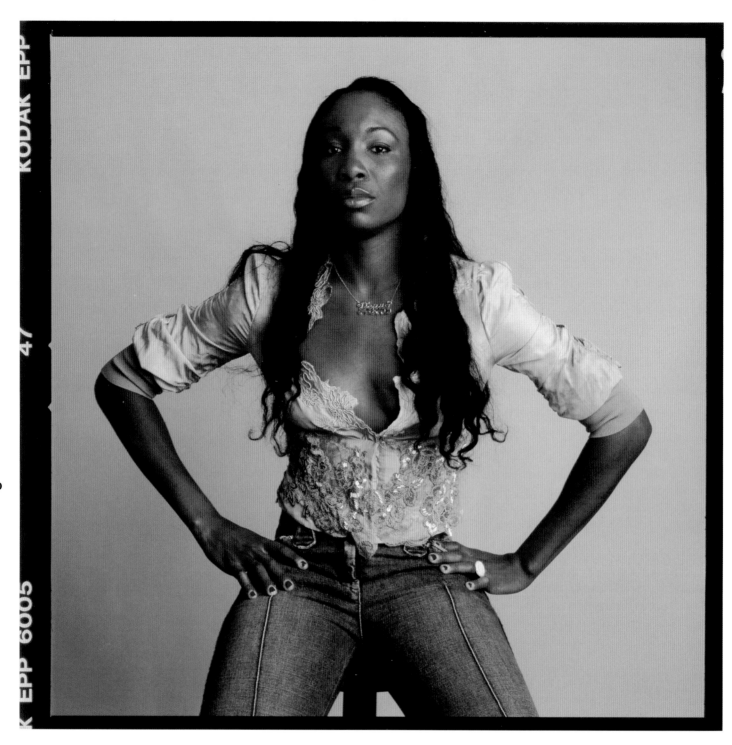

Venus Williams, tennis player, 2005, color transparency, $2^1/_4$ x $2^1/_4$ inches

Beyonce Knowles, musician, 2005, color transparency, $2^1/_4$ x $2^1/_4$ inches

Kate Spade, designer, 2004, color transparency, 8 x 10 inches

Richard Meier, architect, 2004, color transparency, 8 x 10 inches

Ann Magnuson, actress, 2003, color transparency, 8 x 10 inches

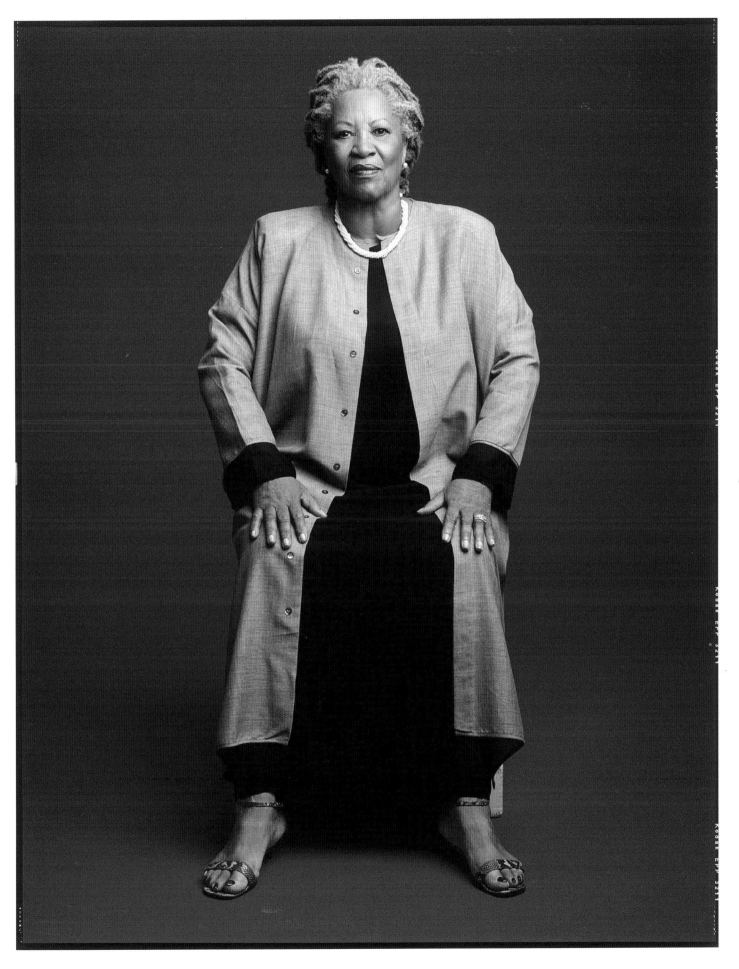

Toni Morrison, writer, 2002, color transparency, 8 x 10 inches

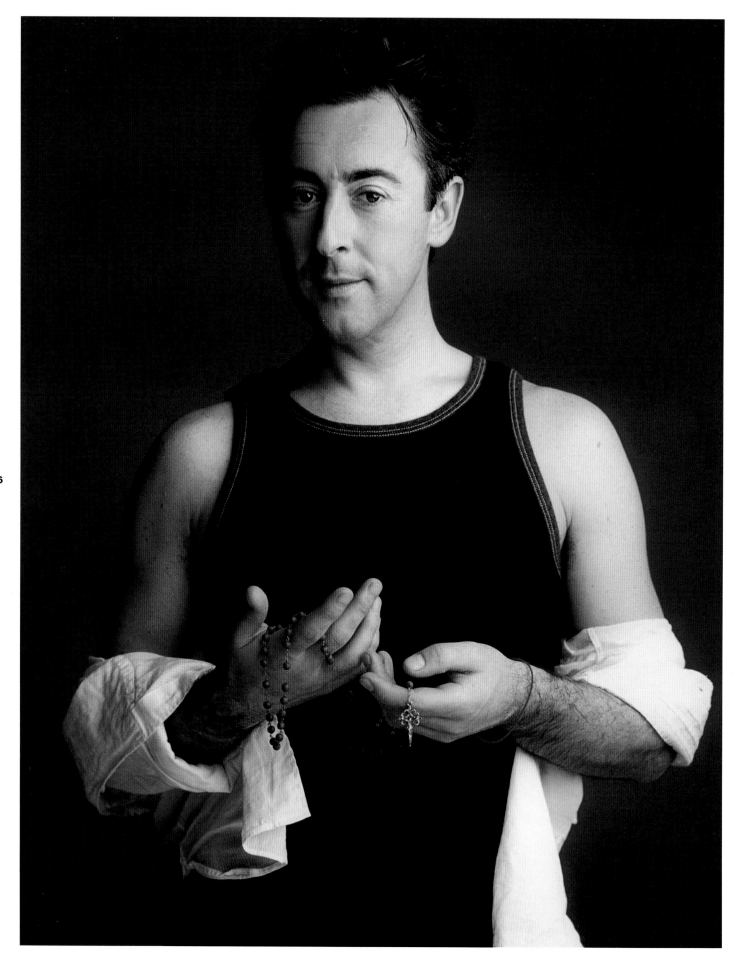

Alan Cumming, actor, 2004, color transparency, 8 x 10 inches

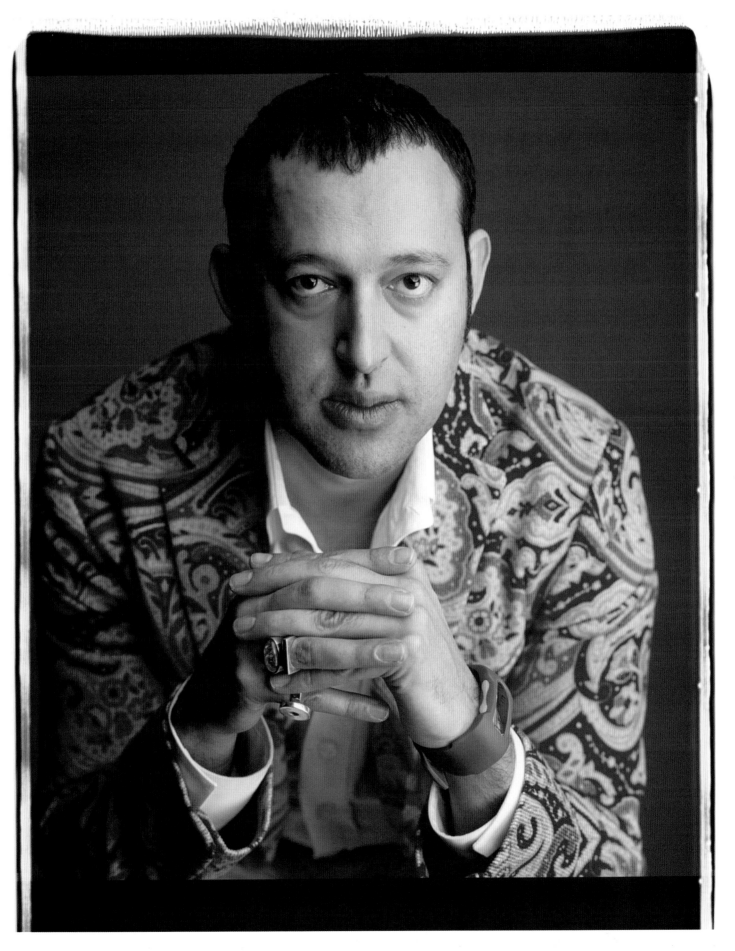

Karim Rashid, designer, 2002, color Polaroid, 20 x 24 inches

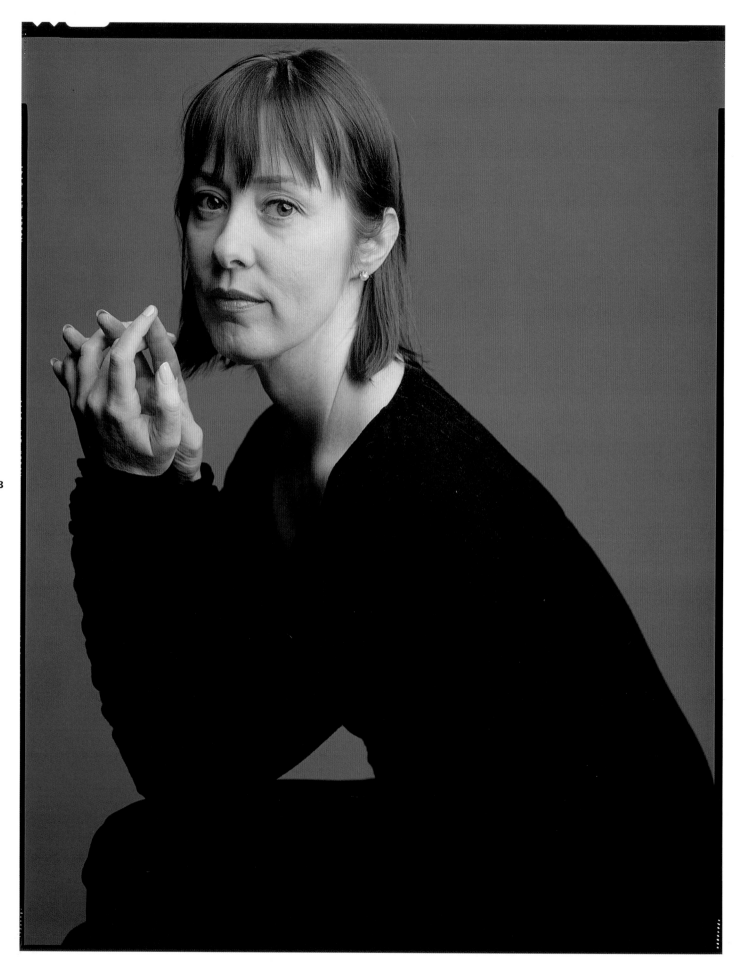

198

Suzanne Vega, musician, 2003, color transparency, 8 x 10 inches

Daniel Libeskind, architect, 2005, color transparency, 8 x 10 inches

200

Yoshio Taniguchi, architect, 2001, color transparency, 8 x 10 inches

Matthew Broderick, actor, 2005, color transparency, 8 x 10 inches

Parker Posey, actress, 2005, color transparency, $2\frac{1}{4} \times 2\frac{1}{4}$ inches

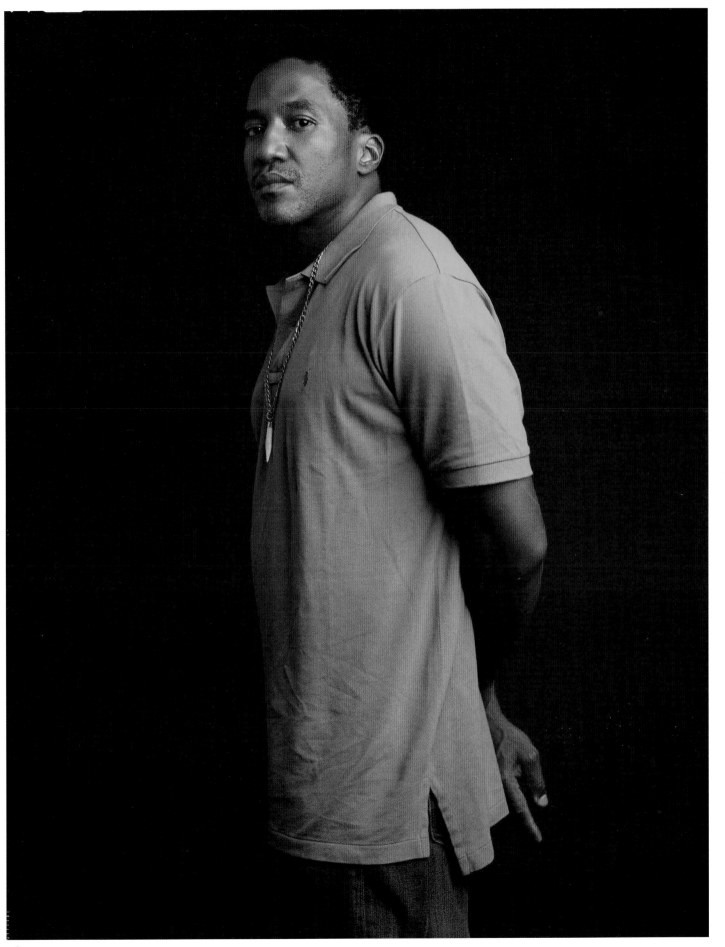

Q-Tip, musician, 2005, color transparency, 8 x 10 inches

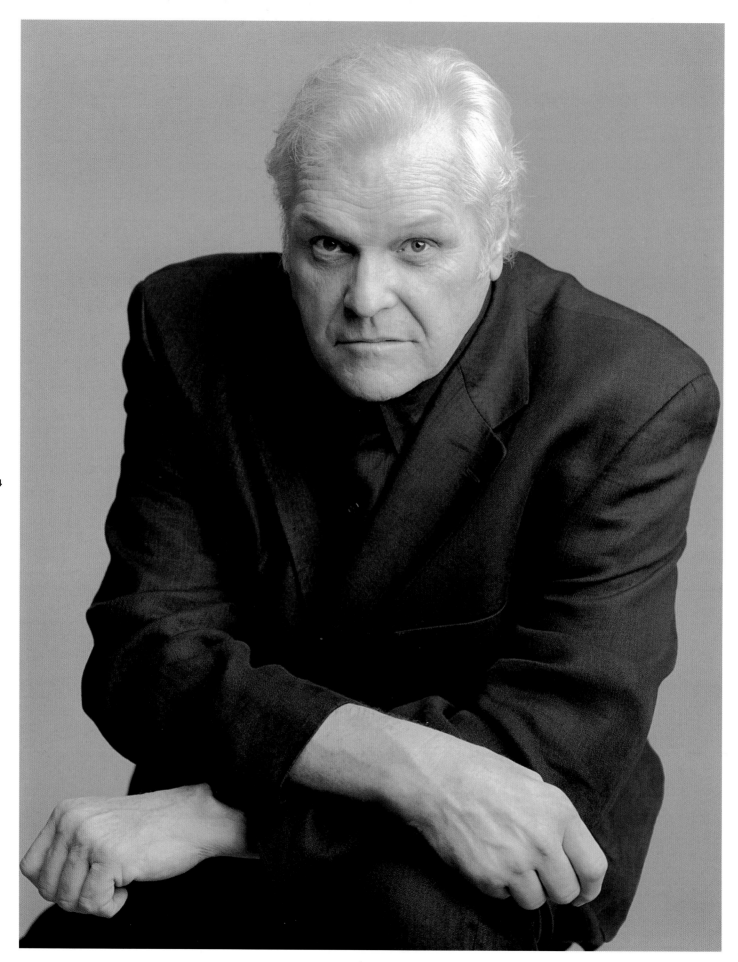

Brian Dennehy, actor, 2003, black and white contact print, 8 x 10 inches

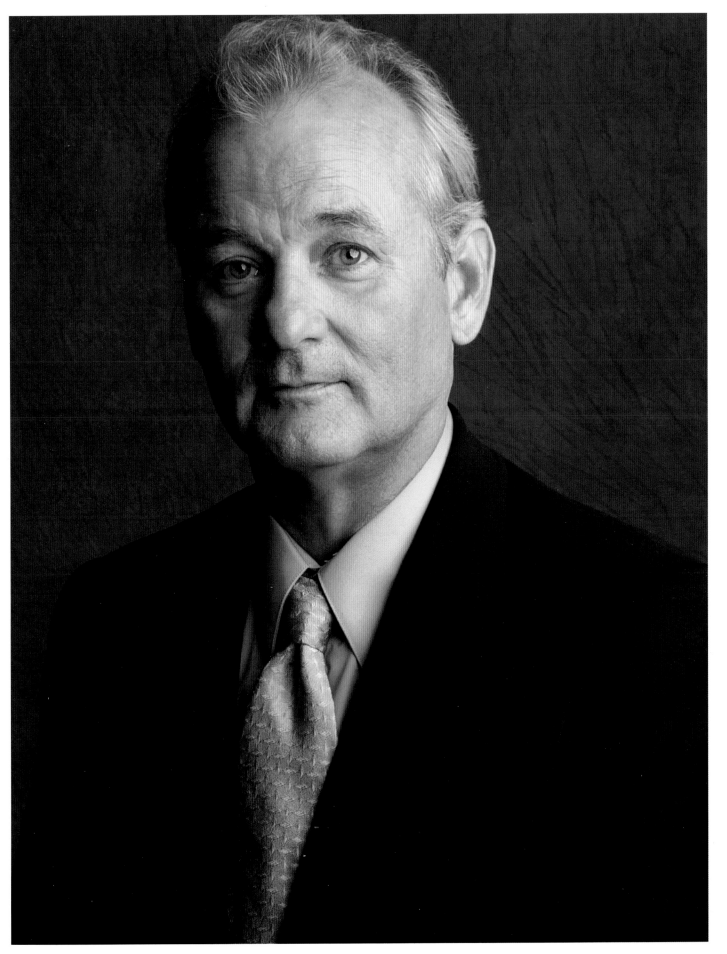

Bill Murray, actor, 2004, color transparency, 8 x 10 inches

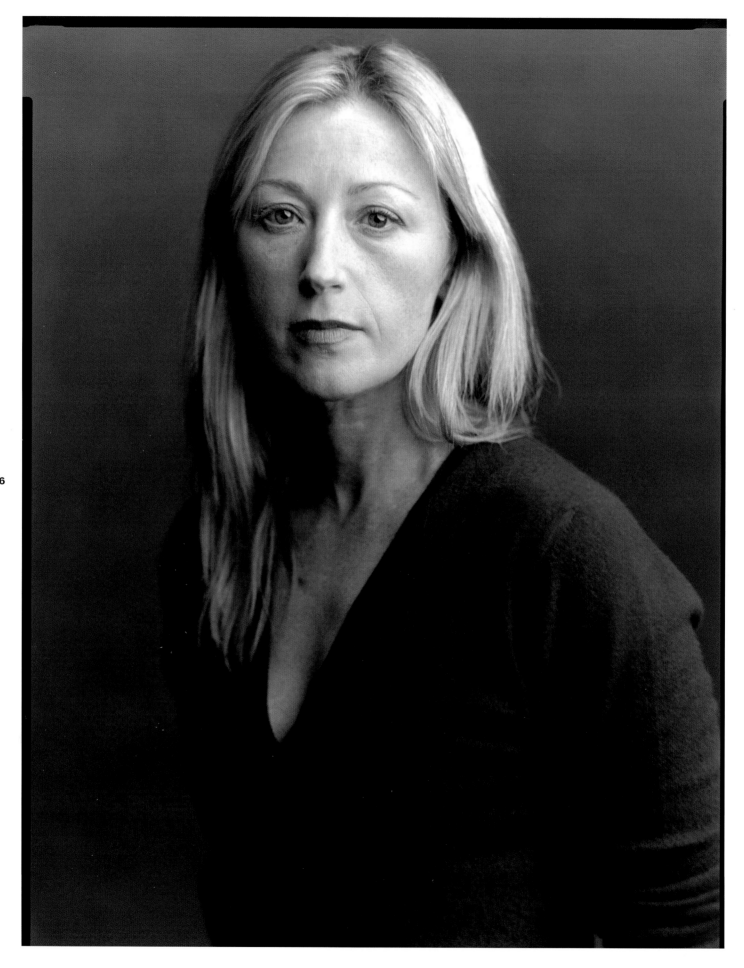

Cindy Sherman, artist, 2002, black and white contact print, 11 x 14 inches

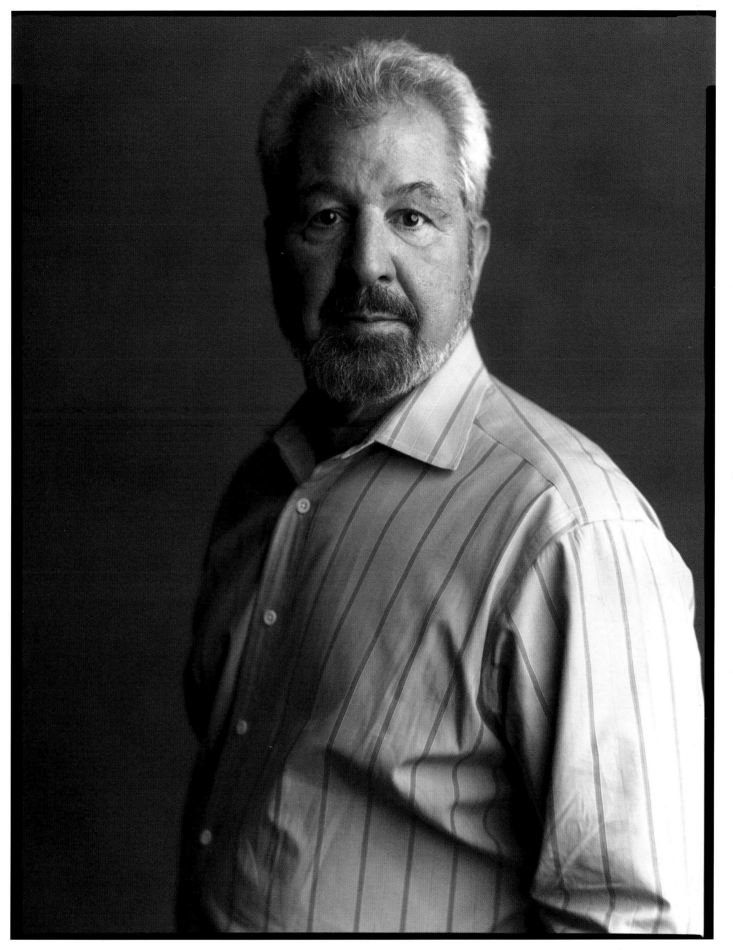

Bob Vila, builder, 2004, black and white contact print, 8 x 10 inches

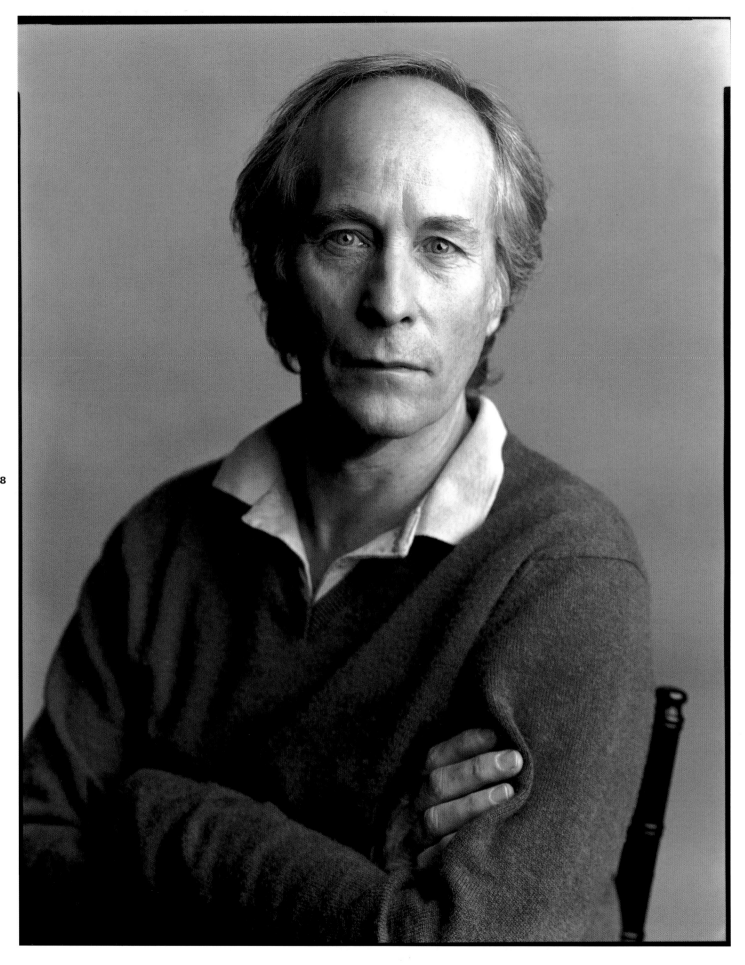

Richard Ford, writer, 2002, black and white contact print, 8 x 10 inches

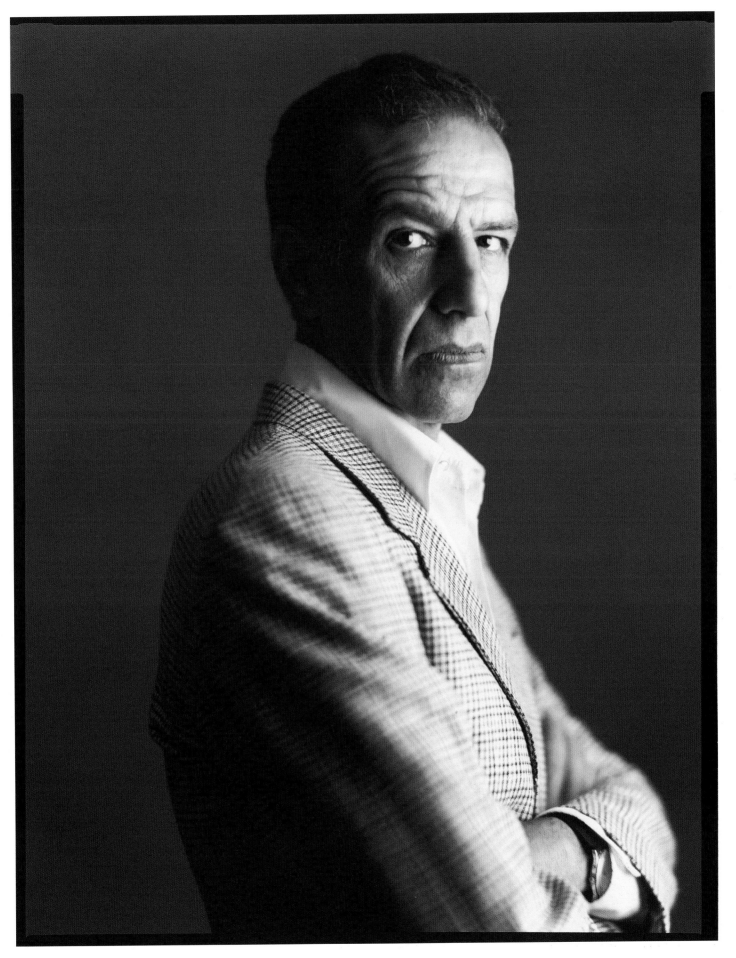

Alex Katz, artist, 1988, black and white contact print, 11 x 14 inches

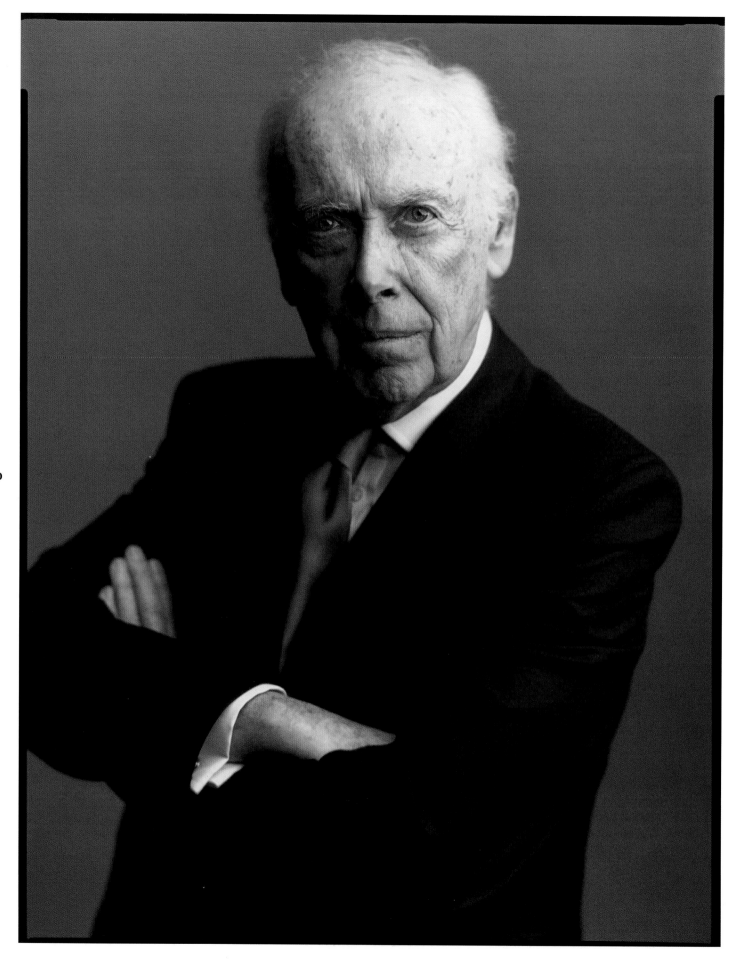

James Watson, scientist, 2003, black and white contact print, 11 x 14 inches

Zaha Hadid, architect, 2002, black and white contact print, 11 x 14 inches

Jeremy Jordan and **Jason Hawke**, porn stars, archival digital print, 58 x 88 inches each print (diptych)

Isca Greenfield-Sanders, artist, 2004, black and white contact print, 11 x 14 inches

Liliana Greenfield-Sanders, filmmaker, 2004, black and white contact print, 11 x 14 inches

Sebastian Blanck, artist, 2001, black and white contact print, 11 x 14 inches

Kiki Smith, artist, 1991, black and white contact print, 11 x 14 inches

Rachel Weisz, actress, 2005, color transparency, 8 x 10 inches

Hugh Jackman, actor, 2005, color transparency, 8 x 10 inches

Biography

Timothy Greenfield-Sanders was born in Miami Beach, Florida, in 1952. He attended Columbia University, NYC, NY and received his Bachelor Degree in Art History in 1974 and in 1977 his M.F.A. degree at American Film Institute, Los Angeles, CA. He lives and works in New York.

Recent solo exhibitions

1999
Mary Boone Gallery, NYC, NY.
2000
Galleria Emilio Mazzoli, Modena, Italy.
2001
Museo di Castel Nuovo, Naples, Italy.
2002
Miami Art Museum, Miami, Florida.
2004
Mary Boone Gallery, NYC, NY.
2005
John Berggruen Gallery, San Francisco, California; Berman / Turner Projects, Santa Monica, California; Galerie Bernd Kluser, Munich, Germany; Tel Aviv Museum of Art, Tel Aviv, Israel; Paolo Curti / Annamaria Gambuzzi Artecontemporanea, Milan, Italy.

Filmography

1998
Lou Reed: Rock and Roll Heart, Director and Producer, Grammy Award for best music documentary.
2004
Honey: Karen Finley, Video Director and Producer.
Thinking XXX, Director and Producer, HBO.

Selected books and catalogues

1996
After Andy: Soho in the Eighties. Text by Paul Taylor. Melbourne, Australia: Schwartz City Press.

1999
ArtWorld: Timothy Greenfield-Sanders. Introduction by Mark Strand, New York, NY: Fotofolio.
2001
Timothy Greenfield-Sanders. Demetrio Paparoni, ed. Milano, Italy: Alberico Cetti Serbelloni Editore.
2004
XXX: 30 Porn-Star Portraits. Introduction by Gore Vidal. New York and Boston: Bullfinch Press.
2005
Timothy Greenfield-Sanders: Portrait Photographs. Arturo Schwarz ed., Tel Aviv, Israel: Tel Aviv Museum.

Selected texts

1991
Robert Pincus-Witten, "Timothy Greenfield-Sanders: Portraits of the Artist," *Timothy Greenfield-Sanders*. Exhibition catalogue. Fort Worth: Modern Art Museum.
1995
Peter Halley, "Timothy Greenfield-Sanders," Peter Halley, ed., *Timothy Greenfield-Sanders, Selected Portraits 1985-1995*, Exhibition catalogue.
1997
Demetrio Paparoni, *Il corpo parlante dell'arte*. Roma: Castelvecchi.
Doug and Mike Starn, "S'io fossi Nadar / If I Were Nadar," *Tema Celeste Arte Contemporanea* and *Tema Celeste International*, n. 61, March-April, pp. 47-49.
1998
Christina Kelly, "Reel Stories: Lou Reed, Rock and Roll Heart," *Index Magazine*, March-April.
Stephen Greco, "Virtuosity," *Arude*, 10.
1999
Wayne Koestenbaum, "Art's Hard Face," *Art World: Timothy Greenfield-Sanders*. New York: Fotofolio.
Robert Pincus-Witten, "TG-S," *Art World: Timothy Greenfield-Sanders*. New York: Fotofolio.

Lou Reed, "Portrait Artist," *Surface*.
Mark Strand, "Preface," *Art World: Timothy Greenfield-Sanders*. New York: Fotofolio.
2000
Jeremy Gilbert-Rolfe, "A supplementary Note on Assertiveness, Pointlessness, and the Sycophantic," *artnet.com online*, 15 January.
2001
Francesco Clemente, "Minister of the Eye." Preface in Demetrio Paparoni, ed., *Timothy Greenfield-Sanders*. Milano, Italy: Alberico Cetti Serbelloni Editore.
Demetrio Paparoni, *History's Icon*. Introductory essay in Demetrio Paparoni, ed., *Timothy Greenfield-Sanders*. Milano, Italy: Alberico Cetti Serbelloni Editore.

Selected recent articles

1999
Ingrid S. Krampe, "Art Meets Technology," *Professional Photographer Storytellers*, January, pp. 36-39.
David Patrick Columbia, "Timothy Greenfield-Sanders," *Avenue*, September.
Lou Reed, Timothy Greenfield-Sanders, "Greenfield-Sanders," *Tema Celeste*, October, pp. 76-81.
Michael Kimmelman, "Art Club: Twenty Years of Superstars and Shooting Stars," *The New York Times Magazine*, 24 October, pp. 82-83.
Mark Strand, "The Art World: Photographs by Timothy Greenfield-Sanders," *Art & Auction*, 15 November, pp. 70-73.
Jerry Saltz, "Collective-Memory Lane," *The Village Voice*, 7 December, p. 123.
2000
Barbara Pollack, "Timothy Greenfield-Sanders," *Art News*, February, p. 163.
Edward Leffingwell, "Timothy Greenfield-Sanders at Mary Boone," *Art in America*, May, p. 164.
2001
Ann Landi, "Fab Faces," *Art News*, November, p. 140.

Self-portrait, 1987, black and white contact print, 11 x 14 inches

2003

Richard Johnson, "Famed lensman tackles porn," *New York Post*, 17 May, p. 10.
Mel Gussow, "Photographing Celebrities, Even Those of an X-Rated World," *The New York Times*, 29 July, pp. E1, E5.
Mel Gussow, "Putting a photo finish on a raw world," *Herald Tribune*, 5 August, p. 18.
Carol Vogel, "Inside Art: An Archive of Faces," *The New York Times*, 7 November, p. E28.

2004

Linda Yablonsky, "How Far Can You Go?," *Art News*, January, pp. 104-109.
George Rush, Joanna Molloy, "Lensman clicks with the lust generation," *Daily News*, 5 August, p. 32.
Edward Wyatt, "Sex, Sex, Sex: Up Front in Bookstores Near You," *The New York Times*, 24 August, pp. E1, E4.
Sam Schechner, "Debbie Does MoMA?," *Black Book*, September, pp. 112-114.
David Rimanelli, "Double Exposure," *Artforum*, September, pp. 21-22.
Alethea Mock, "XXX: 30 Porn Star Portraits: A Conversation with Timothy Greenfield-Sanders," in *View Camera*, September, pp. 16-22.
Sharon Edelson, "Exposing the Exposed," *Women's Wear Daily*, 11 September, pp. 52-53.
Guy Trebay, "What Fashion Owes to XXX," *The New York Times*, 12 September, pp. ST1, ST14.
Carlo Mc Cormick, "Behind the Greenfield Door," *Paper*, October, p. 38.
Ann Landi, "Porn Identity," *Art News*, October, pp. 138-141.
T. Cole Rachel, "Naked Glory," *Next*, 1 October, pp. 12-15.
Dylan Foley, "Porno pixxx," *New York Post*, 10 October.
Darren D'Addario, "Graphic Art," *Time Out New York*, 14 October, pp. 15-18.
Demetrio Paparoni, "XXX: Più star che porno," *Panorama*, 28 October, pp. 154-258.
David Amsden, "Subject: Tera Patrick," *New York Magazine*, 1 November, p. 83.

David Colman, "The Guy in the Invisible Man Suit," *The New York Times*, 7 November, p. ST8.
Matthew Grace, "The Transom: Porn Again," *The New York Observer*, 8 November, p. 3.
Calvin Tomkins, "At The Galleries: Unzipped," *The New Yorker*, 22 November, pp. 38-39.
Megan Rowlands, "XXXpression of art," *Times Leader* (Wilkes-Barre), 8 December.
James Gardner, "Art Attack: Timothy Greenfield-Sanders," *New York Post*, 11 December, p. 27.

2005

Jennie Yabroff, "Behind the Porn Door," *San Francisco Chronicle*, 16 January.
Mary Haus, "Struck By Lightning," *Art News*, February, pp. 112-119.
Lynne Eodice, "The Elegant Portraiture of Timothy Greenfield-Sanders," *Petersen's Photographic*, March, pp. 46-49.
Sarah Valdez, "Body Double," *Art in America*, April, pp. 89-91.
Robert Lanham, "Wearing Nothing but Attitude," *The New York Times*, 1st May, p. ST15.
Kyle Mac Millan, "5 Visions of the World," *Denver Post*, 11 June.

Works in Museum Collections

The Arkansas Art Center, Little Rock, Arkansas
The Australian National Gallery, Canberra, Australia
The Bibliotheque Nationale, Paris, France
The Broad Foundation, Los Angeles, CA
The Brooklyn Museum of Art, NYC, NY
The Chase Manhattan Bank
The Columbia Museum of Art, Columbia, SC
The Corcoran Gallery of Art, Washington, DC
The Detroit Institute of Arts, Detroit, IL
The International Center of Photography, NYC, NY
The Loew Art Museum, University of Miami, Coral Gables, Florida
The Metropolitan Museum of Art, NYC NY
The Museum of Fine Arts, Boston, DC
The Museum of Fine Arts, Houston, Texas
The Museum Ludwig, Cologne, Germany
The Museum of Modern Art, NYC, NY
The National Portrait Gallery, Washington, DC
The Portland Art Museum, Portland, Oregon
The San Francisco Museum of Modern Art, San Francisco, CA
The University of New Mexico Art Museum, Albuquerque, New Mexico
The Victoria and Albert Museum, London, Great Britain
The Whitney Museum of Art, NYC, NY.